healthy
eating

The Confident Cooking Promise of Success

Welcome to the world of Confident Cooking,
where recipes are double-tested by our team
of home economists to achieve a high standard
of success—and delicious results every time.

bay books

TEST KITCHEN PERFECTION

You'll never make a wrong move with a step-by-step cookbook. Our team of home economists has tested and refined the recipes so that you can create fabulous food in your own kitchen. Follow our easy instructions and step-by-step photographs and you'll feel like there is a master chef in the kitchen guiding you every step of the way.

All recipes are double-tested by our team of home economists. When we test our recipes, we rate them for ease of preparation. The following cookery ratings are on the recipes in this book, making them easy to use and understand.

A single Cooking with Confidence symbol indicates a recipe that is simple and generally quick to make—perfect for beginners.

Two symbols indicate the need for just a little more care and a little more time.

Three symbols indicate special dishes that need more investment in time, care and patience—but the results are worth it.

The Publisher thanks the following for their assistance: Chief Australia, Breville Holdings Pty Ltd, Kambrook, Sheldon & Hammond, Southcorp Appliances, Bertolli Olive Oil.

Front cover: Low-fat chicken Caesar salad (page 49).
Inside front cover: Vegetable skewers with salsa verde (page 54).
Back cover: Baked lemon cheesecake (page 103).

CONTENTS

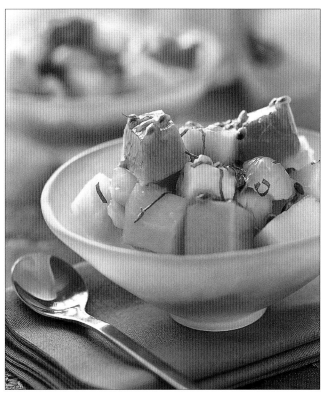

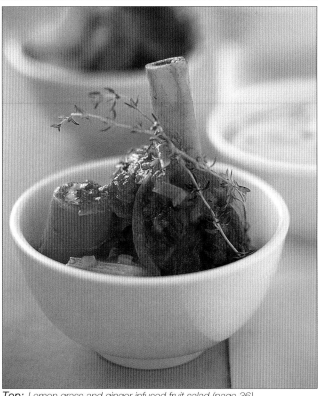

Top: Lemon grass and ginger infused fruit salad (page 36).
Bottom: Slow-cooked lamb shanks with soft polenta (page 84).

HEALTHY EATING FOR LIFE

This book is by no means a quick-fix 'drop a dress size in a week' diet book; rather, it is designed to assist you in making informed and well-balanced food choices that will last a lifetime.

To follow a healthy lifestyle doesn't mean eating bean sprouts and tofu for breakfast, lunch and dinner, nor does it mean cutting out indulgences altogether. The secret is to select from a wide range of foods, in their right proportions. It's about the intake of foods you consume in the whole day that matters, not just one meal. Think about it this way—the wholegrain cheese and salad sandwich you had for lunch means you can have a slice of cake without feeling too bad.

THE HEALTHY DIETARY PYRAMID

Eating foods in correct proportions is best described and illustrated by the healthy dietary 'pyramid' (see facing page). The 'pyramid' shows visually which types of foods you should eat the most, moderately, or the least of, in their right proportions, in order to have a good balance of nutrients (carbohydrates, fat, protein, fibre, vitamins and minerals). Eating the range of foods within each group will increase your chances of consuming a wide range of nutrients—what some foods lack, others have in abundance.

HOW DO COOKING TECHNIQUES HELP?

Choosing nutritious food is just one aspect of following a healthy lifestyle. It's not just a matter of replacing a refined product with a more natural one. For example, when making fried rice, you can easily replace the refined white rice with brown rice (for its extra fibre). Unfortunately, even with those good intentions, the fat from the ham and the oil consumed at the same time will not be ignored by your body. (But not all fat is 'bad', it's the excess consumption of the wrong type of fat that can cause problems.) The good news is that this can also be fixed with a few handy tips, eg. dry-fry the ham in a non-stick frying pan—its own fat content will be enough to cook until golden. Cooking techniques are an important tool in maintaining the flavour of the food without adding any extra fat. Try these tricks when cooking:

- use non-stick frying and saucepans as very little fat (if any) is needed
- lightly spray tins, frying pans and food with cooking oil spray, reducing the chance of adding too much oil
- steam vegetables to retain most of their nutrients and their colour
- cook stir-fry dishes quickly in small amounts of oil
- grill (broil) and barbecue to produce low-fat flavoursome meat
- bake some deep-fried dishes (such as fried chicken and nuggets) in the oven, using far less oil.

WHAT CAN A HEALTHY DIET DO FOR YOU?

- increase your energy
- help to maintain your correct body weight
- reduce the risk of many common health problems
- improve your ability to cope with stress
- help to maintain normal cholesterol and blood sugar levels
- keep your immune system in shape

DIETARY GUIDELINES

- enjoy a wide variety of nutritious foods (including different colours, shapes and textures)
- eat plenty of wholegrain breads and cereals, fruit and vegetables (including legumes)
- eat a diet low in fat (particularly saturated fat)
- have plenty of regular exercise
- limit your alcohol intake
- eat moderate amounts of sugars and foods containing sugars
- use salt sparingly and choose foods that are low in salt
- eat foods containing calcium (for healthy teeth and bones)
- eat foods containing iron

Exercise is also as important an element in good health as healthy eating habits. It helps to increase vitality, raise good cholesterol levels and increase your metabolic rate, making it easier to burn stored fat for energy. For most people, the everyday rat race isn't enough to burn off excess fat in the diet, so the extra amounts of fat are stored as body fat. When exercise is combined with a lower fat intake, the body will use stored fat for energy.

Keep in mind that a healthy diet is not about being on an 'extreme diet'. It's about making a decision to eat the best of everything in its right proportion. Extreme diets favour one nutrient over another, depriving the body of something it needs.

So, here's to your health and turning over a new leaf.

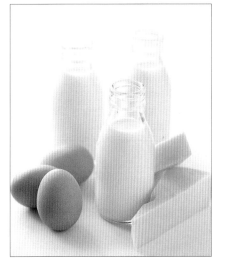

EAT LEAST
Sugar, Butter, Salt

EAT IN MODERATION
Eggs, Milk, Cheese,
Meat, Poultry, Nuts

EAT MOST
Wholegrain bread and cereals,
Fruits, Vegetables, Fish

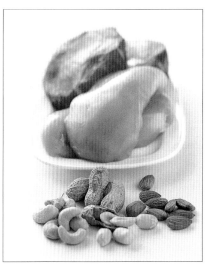

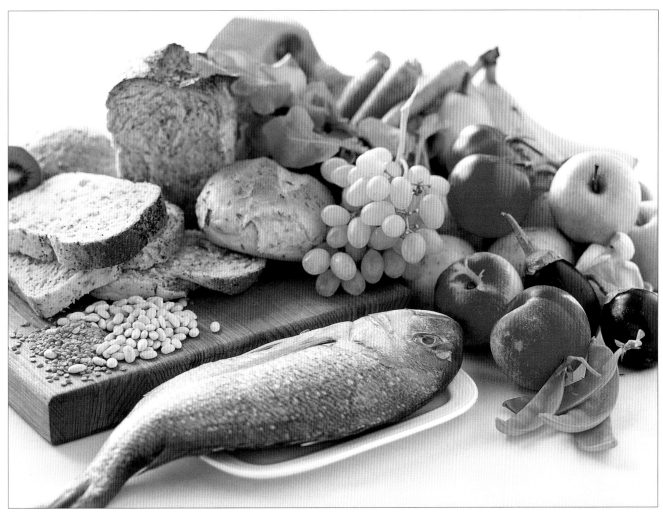

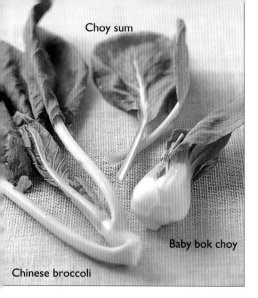

Choy sum

Baby bok choy

Chinese broccoli

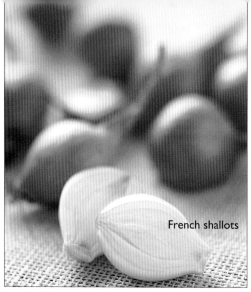

French shallots

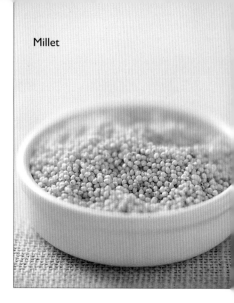

Millet

EXPANDING YOUR PANTRY

You can enjoy cooking healthy food when ingredients such as these are at your disposal.

ASIAN GREENS: CHINESE BROCCOLI (GAI LAN), BABY BOK CHOY (PAK CHOI), CHOY SUM

The Chinese have been using greens for food and medicine since the fifth century. Greens contain a variety of vitamins and minerals—potassium, calcium, magnesium, beta-carotene, vitamin C, folate and other B vitamins. They appear to benefit our immune system. Valuable nutrients are best obtained when the greens are eaten raw, microwaved or stir-fried.

COUSCOUS

Is a low-fat wheat product, high in carbohydrate (starch) with good amounts of niacin, pantothenic acid and some folate.

FRENCH SHALLOTS (ESCHALOTS)

As a member of the onion family, shallots have antibacterial activity and have been used traditionally to treat chest infections and clear nasal passages. They provide lots of flavour but not many calories, and contain vitamin C and small amounts of B vitamins and minerals. They are a fairly good source of beta-carotene and magnesium.

FRESH RICE NOODLES

Are made from a thin dough of rice flour and are steamed, lightly oiled then packaged ready for use. Fresh rice noodles are available thick or thin, or in a sheet which can be cut into desired widths. They are low in fat and contain slowly digested carbohydrate—so they don't send blood sugar levels as high as plain boiled rice—a good alternative to rice for people with diabetes.

MILLET

Contains no gluten, making it suitable for people with coeliac disease (gluten intolerance). A good source of potassium, and phosphorous and silica (two minerals which are good for healthy skin, nails, hair and teeth). Low in fat and high in carbohydrate. Some naturopaths claim it causes fewer problems with indigestion and flatulence than other grains.

MIRIN

Is a low-alcohol, sweet Japanese cooking wine made from glutinous rice and is used most commonly in marinades, glazes and simmered dishes. May be less likely to cause asthma or migraines than red wine (that's only relevant for rice wine drunk in place of red wine, not used in cooking). The alcohol content is removed altogether during cooking, leaving only the flavour.

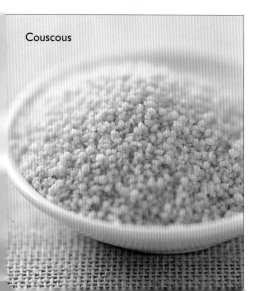

Couscous

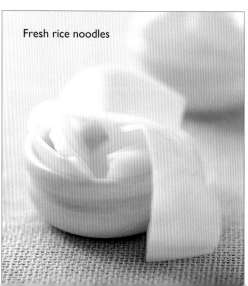

Fresh rice noodles

Mirin

Pearl barley

Porcini mushrooms

Shiitake mushrooms

PEARL BARLEY
Is a very healthy grain that contains slowly digested carbohydrate and soluble fibre, so it has a low glycaemic index rating. Eating barley regularly can help control blood sugar levels in people with diabetes and decrease blood cholesterol levels in people with high cholesterol. You can eat it in place of rice or make a mixture of half rice, half barley. It contains more magnesium, thiamine and niacin than rice and provides some folate and selenium. It has been traditionally used for treating urinary tract infections.

POLENTA
Is good for people with coeliac disease as it contains no gluten. It is also low in fat and sodium. Good source of potassium, vitamin A and beta-carotene and a fair source of thiamine and magnesium.

PORCINI MUSHROOMS
Also known as cèpe mushrooms, they are used in Italian and French cooking. Available fresh or dried, the dried mushrooms must be soaked in warm water and rinsed well before use—the soaking liquid is also often used to add flavour to the dish. Porcini mushrooms provide a very concentrated meaty flavour and add few calories and no fat. They also provide potassium, phosphorous and selenium.

SHANGHAI NOODLES
Are pale in colour, texture and are dusted lightly with flour to prevent them sticking together. They are lower in fat than Hokkien (egg) noodles. Shanghai noodles contain less gluten and have a softer texture than noodles made from durum wheat flour. They provide a little vitamin A, magnesium and selenium.

SHIITAKE MUSHROOMS
Traditionally used for medicinal purposes in Japan and China for the treatment of depression or decreased immune function. Like porcini mushrooms, the soaking liquid is used as a flavoursome stock. They are a good source of folate, pantothenic acid, potassium and selenium.

SILVERBEET (SWISS CHARD)
Provides calcium and iron and is a good source of beta-carotene (an antioxidant) and folate. It also contains other beneficial plant compounds, which may promote immune functioning or protection against cancer, if eaten regularly as part of a low-fat diet with lots of fruits and vegetables. Like other dark green leafy vegetables, it is a valuable food to eat if you're trying to fall pregnant (folate) or want to reduce your risk of cancer.

Polenta

Shanghai noodles

Silverbeet

FIBRE

Dietary fibre consists of the cellulose and gums found in fruits, vegetables, grains, nuts and legumes—there is no fibre at all in any animal products. Fibre is important for health and ensures proper digestive functioning.

There are many misconceptions surrounding the consumption and benefits of fibre. As people turned to 'health foods' in the last few decades, it was thought that large amounts of 'roughage', such as bran, were needed in the diet. Some of the roughage that was consumed was fairly unpalatable, and this is probably where health foods and vegetarian diets earned a reputation for being wholesome but boring and unappetizing.

With greater knowledge over the last few years, we now realize just how wrong this perception is.

Fibre is present in many different foods that we probably already consume on a daily basis, so the addition of 'roughage', such as bran, to other foods is not really necessary, and in fact can be detrimental as it can inhibit the absorption of minerals (for example, iron). Remember to eat a variety of different types of foods containing fibre so that you get the variety of health benefits they produce.

SOLUBLE AND INSOLUBLE FIBRE

Fibre is the indigestible part of plants that is found in skin, seeds and husks. This is why it is commonly called 'roughage'. Dietary fibre may be classified as soluble or insoluble.

Soluble fibre is abundant in legumes, oats, barley and most fruits and vegetables. It has the consistency of a gel and tends to slow digestion time, preventing blood sugar levels from rising too high—this is particularly important for diabetics. And, if eaten regularly, it also helps reduce high blood cholesterol levels.

Insoluble fibre is found in fruit and vegetable skins and the bran coating around grain kernels. Wholegrains (especially wheat and rice), vegetables and nuts are good sources of insoluble fibre. Insoluble fibre passes through the digestive tract largely unchanged and helps food move through the gut and keeps our bowels healthy.

SOURCES

Foods that provide both soluble and insoluble fibre are apples, dried fruits and wholegrains. Remember, it is important to have a variety of soluble and insoluble fibre in the diet because each type of fibre has a different function.

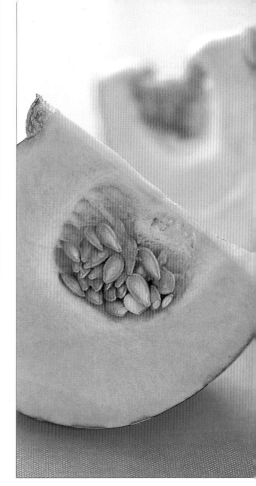

- Soluble fibre

Oats, barley, beans, pectin, psyllium, fruit with the skin left on (such as apples), citrus fruit, sugar beet, soy and mung beans, chickpeas, lentils and seaweed.

- Insoluble fibre

Wholegrain cereal products, dried fruit, cabbage family, legumes, grains, vegetables, fruit, wheat bran, root vegetables (potato, swedes/rutabaga), pumpkin/squash, brown pasta and rice, burghul/bulgar and buckwheat.

BENEFITS

There are many benefits from a high-fibre diet. Insoluble fibre is important for preventing constipation by increasing stool bulk and making it softer and easier to expel.

However, dietary fibre is not just important for efficient bodily functions and for comfort—it also helps to lower cholesterol (which helps prevent heart disease), and reduce the incidence of constipation and haemorrhoids (preventing bowel cancer and other bowel disorders). The more unrefined the source of

fibre, the more effective it is for improved gastrointestinal health.

Vegetarians have the edge over meat eaters when it comes to fibre intake, as the bulk of a vegetarian diet, such as cereals and beans, along with fruit and vegetables, is generally rich in fibre.

The main thing to remember is to eat from a wide variety of foods, thereby ensuring that a range of dietary fibre—both soluble and insoluble—is consumed.

DEFICIENCY

Diets that lack regular wholesome high-fibre cereal products and fresh fruits and vegetables, and instead contain an abundance of refined foods together with high-fat animal products (which contain no fibre), appear to increase the risk of diabetes, cardiovascular disease, diverticulitis, bowel and rectal cancer. So, if you have a family history of any of these health problems, try to make fruits, vegetables and fibre-rich foods a feature of your diet.

DAILY INTAKE

Nutritionists recommend an intake of 30–40 g (approximately 1–1½ oz) fibre per day (although most people eat less than 20 g/¾ oz). To get the recommended levels of dietary fibre from a typical serving of grains, fruits or vegetables, you need to consume at least 10 or more servings of fibre-rich foods daily.

HINTS AND TIPS

- Where possible, leave the skin on fruit and vegetables, such as apples and potatoes.
- Eat whole pieces of fruit and vegetables rather than consuming them as juices.
- Choose wholegrain products such as breads, breakfast cereals, wholemeal pasta and brown rice.
- Drink plenty of water during the day to get the full benefit of fibre (8 glasses is recommended).
- Snack on fruit (fresh or dried) and vegetables instead of biscuits or cakes.

CARBOHYDRATES

Carbohydrate is the body's main source of energy and should make up 50–60% of your diet. It plays a vital role, providing fuel for both the muscles and the brain. Carbohydrates in foods consist of different starches and sugars and are found in grains and their products, as well as legumes, fruits and starchy vegetables.

WHAT ARE THEY?

Carbohydrates are present in foods as sugars and starches, which are both digested into glucose sugar in the body. This glucose is absorbed from the gut into the bloodstream and delivered to the brain and other organs and tissues. The glucose is taken up into cells where it is used as fuel or stored as glycogen (in muscles and the liver) for use as fuel in between meals and during exercise.

Generally, carbohydrates can be classified into three simple groups: sugars, starches and fibres. Previously, carbohydrates were classified as being 'simple' or 'complex', but this only described their physical structure. Over two decades of research has shown that these terms are not very accurate or sufficient. Scientists now use the following terms:

AVAILABLE CARBOHYDRATES

Refers to sugars and most starches which are digested and absorbed in the small intestine. They can be separated further according to the rate at which they are digested, which in turn determines how high they send your blood sugar (glucose) level after eating—either rapidly digested (fast-release or high glycaemic index) or slowly digested (slow-release or low glycaemic index).

UNAVAILABLE CARBOHYDRATES

Refers to fibres and resistant starch which are not digested or absorbed in the small intestine.

GLYCAEMIC INDEX

Low glycaemic index (GI) carbohydrates are digested at a slower rate, releasing glucose into the bloodstream at a rate that ensures your blood sugar level doesn't go up as high. These low-GI carbohydrates are much healthier for us.

Our ancestors would have eaten mostly low-GI carbohydrates (tubers,

DAILY INTAKE

Health authorities recommend we consume 50–60% of our daily calorie intake as carbohydrates. The amount depends on your weight and level of activity.

Activity level	Continuous exercise	Carbohydrate/kg body weight per day
Light	< 1 hour/day	4.0–4.5 g
Light–moderate	1 hour/day	4.5–5.5 g
Moderate	1–2 hours/day	5.5–6.5 g
Moderate–heavy	2–4 hours/day	6.5–7.5 g
Heavy	4–5 hours/day	7.5–8.5 g

Example: A man who weighs 90 kg and does less than 1 hour continuous light exercise each day needs 360–405 grams of carbohydrate per day.

Note: To convert grams to ounces, multiply by 0.035. To convert kilograms to pounds, multiply by 2.2046.

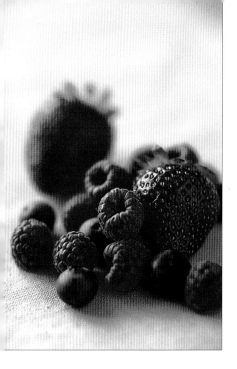

legumes, coarse grains), but advances in food processing and the use of highly refined flours means that many modern starch foods have a high-GI value (cornflakes, rice cakes, white bread). We now know that the long-term consumption of a high-GI value diet can increase the risk of developing heart disease, diabetes and some cancers. It also makes you store more body fat. The world health organisation now recommends:

• we eat more low-GI carbohydrates
• that the food industry makes more low-GI breads, cereals etc.
• that GI values be added to the nutrition panel on food labels.

Carbohydrate-rich foods with a low GI, particularly those that are less refined and/or high in fibre, are digested at a relatively slow rate, maintain blood sugar levels above fasting levels for a longer time and are usually more filling than similar foods with a high-GI value. They can also keep you more alert than the same calorie portion of a high-GI food.

As for sugar, nutritionists aren't as against it as they once were. Sugar is either 'natural' or 'added' in foods and because it tastes good and hasn't got as many calories per gram as fat, it can help people stick to a low-fat diet—but, don't eat more than you need. Choose healthy sources of sweeteners in place of less nutritious sweet foods and drinks, so you get more nutrients per mouthful.

Fat in solid foods (like biscuits and chocolate) can also stop us from tasting its sugar content, as the fat stops some of the sugar from dissolving into our tastebuds.

CARBOHYDRATE-RICH FOODS
Bread, fresh and dried fruit, corn, muesli, polenta, couscous, pasta, lentils, oats, baked beans, berries, rice, noodles, bananas, pumpkin, potatoes, yoghurt and vegetables.

BENEFITS
Starchy carbohydrates give substance to a meal by filling you up. Where possible, choose the least refined and nutritious (low-GI) carbohydrates.

Wholegrain toast and unprocessed cereals (porridge or muesli) are particularly important at breakfast to help keep you full for longer, alert and productive throughout the day.

DEFICIENCY
In recent times, we've seen a few fad diets promoting low-carbohydrate, high-protein/high-fat diets for weight loss. By drastically reducing your carbohydrate intake, you're forcing your body to run on its fat and protein stores, so you lose weight.

These diets usually cut your normal calorie intake down by 30% or more, so you can experience 'fast' weight loss initially (on the scales). This loss is mostly water which is released from the muscles and the liver as you use up the stored glycogen—if your calorie intake falls very low, you'll lose muscle too. Lack of carbohydrates produces side effects such as dizziness, nausea, lack of concentration, tiredness, lack of energy and irritability.

EXCESSIVE INTAKE
If you eat too much food in general, whether it's from fat or carbohydrate, you will gain body fat. Eating too much carbohydrate specifically can stop you using body fat as fuel. The body has less room to store carbohydrates than fat, so will burn off excess carbohydrates first.

HINTS AND TIPS
• All carbohydrates have less than half the amount of calories per gram than dietary fat has.
• Fresh or dried fruits may be sweet and high in sugar, but they also contain valuable fibre.
• Avoid processed sugar with no nutritional value (often accompanied by lots of fat and found in snack foods).

FATS

Fats are our most concentrated dietary energy source. They provide more than double the energy of carbohydrates and protein. Although it's important that we don't eat too much fat, we should concentrate on eating a healthy amount of good-quality fats.

WHAT DOES IT DO?

Everyone needs a certain amount of fat in their body to help with growth and development. Fats supply and enhance the absorption of the fat-soluble vitamins A, D, E, K, and they are involved in the conversion of beta-carotene to vitamin A. Fats also supply essential fatty acids needed for the brain, nerves, healthy cell membranes, many hormones and to protect our internal organs.

DIFFERENT TYPES

There are three main types of fats: saturated, monounsaturated and polyunsaturated.

- **Saturated** fats are responsible for dietary fat's bad reputation. They are usually solid at room temperature and are derived primarily from animal sources—meat and dairy foods—but they are also found in coconut and palm oils. The body uses saturated fats mainly for storage, insulation and body heat or energy. An excess consumption of saturated fats tends to raise blood cholesterol level and cause fatty deposits in the arteries and blood vessels. This can lead to hardening of the arteries, elevated blood pressure and the formation of blood clots—greatly increasing the risk of heart disease and stroke.

The best fats are unsaturated fats, which are usually liquid at room temperature and are derived from vegetable, nut or seed sources. There are two different types of unsaturated fats:

- **Monounsaturated** fats do not increase cholesterol levels. They are found in significant amounts in most nuts, olives, olive oil, canola oil and margarine. Other good vegetarian sources are avocados, chickpeas, eggs and sesame seeds.

- **Polyunsaturated** fats are found in nuts, grains and seeds and are usually soft or liquid at room temperature. These are the most important group of fats as they are the only source of omega-3 and omega-6 fats, which provide essential fatty acids. It's important to get an adequate intake of these fats, as they protect against cardiovascular disease, promote healthy skin and are necessary for normal functioning of the nervous and immune systems.

Good quantities of omega-3 fats are found in tuna, salmon, mackerel and herring which is why nutritionists advise us to eat two or more fish meals each week. Vegetarian sources come from walnuts and some vegetable oils such as soya, canola, mustard seed and flaxseed. Omega-6 can also be found in vegetable oils such as safflower, sunflower, sesame and soya bean oil.

Cholesterol is another type of fat. It is a wax-like substance present in all animals but not in plants. It is an essential element for good health and is part of every living cell of the human body, but too much can be harmful to health. It is not necessary to obtain cholesterol from dietary sources as it can be made in the body to make hormones. It is also required for the nervous system, and is essential for the breakdown and elimination of fats. Vegetarian foods that are high in cholesterol include egg yolks and dairy foods. Research has shown that a high saturated fat intake will cause the body to make more cholesterol.

LOW-FAT SNACK IDEAS
- Fresh fruit and vegetables (but go easy on the avocado).
- Fresh fruit and vegetable juices.
- Skim milk and low-fat milk drinks; low-fat yoghurt.
- Pasta with tomato-based sauces.
- Steamed rice with vegetables.
- Baked jacket potato with low-fat yoghurt and low-fat cheese.
- Wholegrain bread and rolls.
- Rice cakes.

To reduce a high blood cholesterol level, cut down your intake of saturated fat and maintain a healthy diet. Don't increase your intake of monounsaturated and polyunsaturated fats—use sensible reduced amounts in place of saturated fats that you would normally eat.

DAILY INTAKE
Health authorities recommend that we eat no more than 30% of our diet as fat, with less than 10% from saturated fat. Many people eat more than this. Nutritionists estimate that most people living on a Western diet consume twice the amount of fat they need. For an average man, no more than 50–80 g (approx. $1^3/4$–3 oz) of fat per day is recommended, and no more than 40–60 g (approx. $1^1/2$–$2^1/4$ oz) for a woman.

EXCESSIVE INTAKE
A high-fat diet, particularly one with a high intake of saturated fat, is linked with an increased risk of weight gain, heart disease, high blood pressure, diabetes and some cancers. Fat in the diet is readily stored as body fat, and high body-fat levels further increase the risk of these diseases.

REDUCING FAT INTAKE
- Switch from full-fat to low-fat and reduced-fat dairy products. But be careful—this doesn't mean you can eat larger portions.
- Trim any fat and skin off meat and poultry.
- Limit your intake of fried foods and hidden fats (in biscuits, cakes, crackers, chocolate, muesli and health bars).
- Use low-fat ingredients in recipes in place of high-fat ones (yoghurt not cream, light coconut milk etc.), and cook with minimal amounts of fat and oil. Use low-fat cooking methods (steaming, stir-frying, microwaving, roasting on a rack etc.).
- Use low-fat dressings (vinegar, lemon/lime juice) instead of drowning foods in butter, oil or greasy dressings. Reduce the amount of butter/margarine you spread on bread or substitute with salsa, mustard or light mayonnaise.
- Get into the habit of reading food labels to choose low-fat foods.

PROTEIN

Protein provides the basic structure for the human body—it is a major component of our cells, tissues, muscles, nails, hair, skin, bones, blood and internal organs. We need protein to make and repair cells and tissues, and to create hormones, enzymes, antibodies and neurotransmitters (nerve messengers). It is also needed for the regulation of the body's internal environment, including the balance of the body's fluids.

WHAT IS PROTEIN?

Proteins are large molecules made up of small compounds known as amino acids. Different proteins are made of chains of amino acids in different combinations and lengths. There are over 20 different amino acids that are combined in countless ways to produce many different proteins.

Of the 20 different amino acids, eight cannot be made in the adult body and must be consumed (from foods) in the diet. These are called 'essential' amino acids. The other 12 amino acids are called 'non-essential', not because they are less important, but because we can make them in our bodies.

SOURCES

Proteins from animal foods (meat, poultry, egg, fish, seafood and dairy products) contain all of the amino acids, including the essential amino acids, to meet the body's needs. For this reason, they are called 'complete' proteins or proteins with a 'high biological value'.

Plant foods (grains, vegetables, nuts, legumes) generally contain smaller quantities of protein, and this protein is deficient in one or more of the essential amino acids. They are therefore called 'incomplete' or 'low biological value' proteins. However, vegans and vegetarians can obtain adequate amounts of protein and all of the essential amino acids by making

sure they consume a mix of protein-rich foods each day. By combining either grain products (bread, pasta, buckwheat, rice, barley, burghul/bulgar) with eggs, legume products (soy milk, soya beans, lentils, chickpeas) or dairy products (milk, cheese, yoghurt), or perhaps legumes with nuts/seeds (sunflower seeds, sesame seeds) or milk products, they can get all the essential amino acids they need. This method is particularly important for vegans.

BENEFITS

Unlike meat, plant foods provide protein together with fibre and carbohydrates, which gives them a number of health benefits.

Animal proteins contain iron and zinc. Iron is a mineral found in every cell of the body and is vital for good health and for our mental and physical well-being. It is needed to carry oxygen around the body. Without iron, you'll find it hard to concentrate, remember things and learn; you'll also feel tired and irritable. It is also needed to fight infection and to produce energy from food.

Zinc is needed for the function of more than 300 enzymes and is involved in a wide range of body functions such as the immune system, healthy brain function, tissue growth and repair, growth, night vision, and reproduction and development.

DAILY INTAKE

Our daily requirement of protein is approximately 12–15% of our total calorie intake, depending on an individual's size, weight, levels of stress and activity, and health. Extra protein is needed during periods of growth: childhood, adolescence, pregnancy and lactation. Most people in Western countries easily eat enough protein each day.

DEFICIENCY

Insufficient protein in the diet may result in anaemia, lethargy, muscle weakness and wasting, dry and dull hair, dry skin, poor wound healing, weak nails, outbursts of temper, decreased immunity to infection and, in severe cases, amenorrhoea (absence of menstruation).

Children with protein deficiency may not reach their full growth potential. Extreme cases of protein deficiency in children will result in the often fatal disease, kwashiorkor.

However, people in Western countries, including vegetarians and athletes, usually consume far more protein than they need, and protein deficiency is uncommon. In fact, in most Western diets, there is a much greater chance of consuming an excess of protein than there is of not consuming enough.

EXCESSIVE INTAKE

Excess protein consumption can result in fluid imbalance, with symptoms such as diarrhoea, tissue swelling and frequent urination, which can lead to dehydration. Too much protein can be dangerous for children as the excess nitrogen resulting from protein metabolism can strain their kidneys. High protein intakes can also increase your fat intake and your blood cholesterol level, and increase your body's absorption of calcium.

*Note: To convert grams to ounces, multiply by 0.035. To convert kilograms to pounds, multiply by 2.2046.

RECOMMENDED DAILY INTAKE OF PROTEIN

Protein/kg body weight/day*	
Infants 0–6 months	2.0 g
Bottle fed 7–12 months	1.6 g
Children 4–18 yrs	1.0 g
Men and women	0.75 g
Pregnant women	+ 6.0 g
Lactating women	+ 16.0 g

SALT

For centuries, salt has been used to preserve foods or enhance their natural flavours, textures and colours, but take care—if you add too much, the food's unique flavours can be lost.

WHAT IS SALT?

Common table salt is a chemical compound made up of two elements: 40% sodium and 60% chloride. (A teaspoon of salt weighs about 5 g (approx. ¹/₈ oz) and contains about 2 g (approx. ¹/₁₆ oz) of sodium.)

Sodium and chloride are both minerals that have important roles in the body. Sodium is needed for the regulation of the body's fluid balance, blood pressure and proper functioning of nerves and muscles. Chloride is also needed to maintain normal fluid balance and blood pressure, and is an essential component of our digestive stomach acid.

VARIETIES OF SALT

Salt is mined from seams of rock salt trapped underground or can be made by evaporating sea water.

ROCK SALT is unrefined large crystals of salt from natural deposits. Often used in salt grinders (but, unlike pepper, freshly ground rock salt is not more flavoursome than pre-ground table salt).

TABLE SALT is produced by evaporating rock salt under vacuum pressure to produce smaller crystals or a finer grain salt. Iodized salt is table salt with added iodine. The addition of iodine to table salt has virtually eliminated iodine deficiency in Australia and many other countries, because so much salt is added to processed foods.

SEA SALT is produced by the evaporation of clean, filtered sea water. The crystals are large and often flaky.

SEASONED SALT is table salt with added flavouring agents such as celery, garlic and dried herbs to further enhance the flavour of food.

USES IN COOKING

● To draw out moisture. This is used particularly when preparing vegetables such as eggplant (aubergine). Slices are covered in plenty of salt to draw out their bitter juices—this process is called degorging. However, fresh meat should not be salted before frying or grilling (broiling), as the moisture brought to the surface will prevent it from searing and browning. Salt should be added halfway through cooking once the meat has been seared.

● To toughen food. This is an advantage when pickling with vinegar; food salted before being pickled will not go soft and soggy in the jar. But, this is a disadvantage

when braising or stewing meat (and with pulses).
• To add colour. Salt enhances the colour of bread crust.
• To enhance flavours. A low level of salt can enhance natural flavours.

SOURCES

Salt occurs naturally (in relatively small amounts) in most foods, but is often added in much larger amounts to foods during cooking and processing. Traditionally used to preserve foods such as fish, olives and meat, salt is now used extensively in food processing. Varying amounts of sodium are added to foods, but not always in the form of table salt (sodium chloride). Common food additives, such as baking soda, some preservatives, and monosodium glutamate (MSG), also contain sodium. Processed foods that contain particularly high levels of salt (sodium) per serving include: salted crackers, chips, snack foods, sausages, processed meats, cheese, salami, fast foods, smoked fish, many canned foods and some breakfast cereals. Fresh fruit and most vegetables,

rolled oats, puffed wheat, unsalted nuts and butter, salt-reduced breads, cottage cheese and salt-free canned foods are relatively low in salt.

DAILY INTAKE

Salt is vital for the healthy functioning of our bodies, but most people consume more than they need. The recommended intake for adults is 0.9–2.3 mg per day or a maximum of 1 teaspoon of salt. However, in the West, many people consume more than 5 g (approx. $^1/_8$ oz) a day (more than a hundred times the recommended amount). It is important to try to avoid consuming large amounts of salt because high salt intakes appear to increase the risk of developing high blood pressure (hypertension), particularly in people who are genetically more sensitive to the effects of sodium (up to 20% of the adult population). Most people do not need to add salt to food or take salt tablets, although in special circumstances, such as excessive sweating and diarrhoea, higher levels may be needed (only under medical supervision).

Unless recommended by a doctor, there is no need to increase salt intake in hot weather or when exercising, because the body has mechanisms which carefully adjust the salt content of sweat according to the body's salt balance. In fact, consuming more salt than necessary under these conditions can increase your risk of dehydration and cramps.

REDUCING YOUR SALT INTAKE

• Resist the urge to add table salt to meals before or after cooking.
• Reduce your intake of very salty processed foods and take-away meals.
• Gradually cut back your salt by using salt-reduced products (margarine etc.) to give your tastebuds time to adjust.
• Look for the words 'reduced-salt', 'salt-free' or 'no added salt' on food labels to help you choose canned foods, cheeses, breads, sauces and other processed foods with less salt.

CALCIUM

Calcium is an important nutrient in maintaining strong healthy bones and teeth. Our skeleton is a living tissue where calcium is stored as well as removed on a daily basis—this process is called 'remodelling'. It is because of this continual removal process that health authorities recommend we eat calcium-rich foods every day to replenish our bones. Dairy products are a rich source of dietary calcium, supplying about 70 per cent of our daily calcium needs—the remaining 30 per cent is supplied primarily by grains, vegetables and canned salmon (with the bones).

AVERAGE CALCIUM CONTENT OF COMMON FOODS

Serving size	Calcium (mg)
200 g (7 oz) tub low-fat yoghurt	420
200 g (7 oz) tub natural yoghurt	340
250 ml (1 cup) skim milk	310
100 g (3½ oz) canned salmon with bones	300
250 ml (1 cup) regular milk	285
35 g (1¼ oz) cube reduced-fat Cheddar	282
35 g (1¼ oz) cube full-fat Cheddar	271
340 g (1 cup) cooked spinach	170
100 g (3½ oz) low-fat cottage cheese	77
30 g (1 oz) almonds with skin	75
50 g (1¾ oz) natural muesli	52
100 g (3½ oz) three-bean mix	43
100 g (3½ oz) cooked broccoli	29
30 g (1 slice) white or wholemeal bread	15

SOURCES

Milk and other dairy products such as cheese and yoghurt are the richest sources of calcium. Only three serves of dairy products a day supplies all of the calcium most people need. 1 serve = 250 ml (1 cup) milk, 200 g (7 oz) tub yoghurt, or a 35 g (1¼ oz) wedge of hard cheese. There are many different dairy products to suit everyone's tastes and low-fat varieties for those trying to reduce fat and cholesterol intake. Other sources of calcium include calcium-enriched soy-milk and tofu; fish such as canned salmon or sardines that are eaten with their bones; some green vegetables (broccoli and Chinese cabbage or

RECOMMENDED DAILY INTAKE OF CALCIUM

	mg calcium per day
Infants 0–1 years	300–550 mg
Children 1–7 years	700–800 mg
Girls 8–11 yr/12–15 yr/16–18 years	900 mg/1000 mg/800 mg
Boys 8–11 yr/12–15 yr/16–18 years	800 mg/1200 mg /1000 mg
Men 19–64+ years	800 mg
Women 19–54 years	800 mg
Pregnant women	1100 mg
Lactating women	1200 mg
Women after menopause/ Young women with amenorrhoea	1000 mg

Source: Recommended dietary intakes for use in Australia NHMRC 1991.

wong bok); dried figs; spinach; sweet potatoes; and grains. However, calcium in dairy foods is more readily absorbed by the body than calcium in cereals and vegetables. Calcium absorption is enhanced by milk sugar (lactose) and impaired by compounds in grains and vegetables (tannins, fibre, oxalates).

BENEFITS

Calcium is the most abundant mineral in the human body. Over 99% of calcium in the body is found in our skeleton and teeth, where it is needed, along with phosphorous and vitamin D, to keep these living tissues healthy and strong. The remaining 1% is present in our blood and body fluids, where it plays important roles in regulating nerve and muscle functions, blood pressure and the heartbeat, the release of hormones, and normal blood clotting.

DEFICIENCY

Calcium can be removed or returned to the bones in accordance with the need for calcium in other parts of the body. If our bones don't receive enough calcium, as we age, they will become porous and fragile and can fracture more easily—this is called osteoporosis. As it develops, the outer shell covering our bones becomes thin and weak, and the inner structure develops large holes. Osteoporosis affects men and women over the age of 60; however, it often occurs more commonly in women as the decrease in oestrogen which accompanies menopause can result in a substantial loss of bone mass.

REDUCING THE RISK OF OSTEOPOROSIS

- Eat calcium-rich foods daily.
- Take regular weight-bearing exercise like walking, to help keep your bones strong.
- Don't smoke.
- Consume moderate amounts of alcohol, salt or caffeine.
- Women who diet or exercise excessively should not lose so much body fat that their oestrogen levels fall and their menstrual period stops (amenorrhoea).

SUGAR

Sugar, like starch, is a carbohydrate, which serves as the body's main energy source. Like salt, sugar is found naturally in foods (intrinsic or natural sugar) or can be added to foods (extrinsic or refined sugar). Taste is only one of the important roles sugar plays in food. It is also used to preserve (jams, cakes, drinks), add texture and colour (to baked goods and dairy products), and is a source of energy for yeast that causes bread to rise. It also helps balance acidity in tomato sauces and salad dressings.

DIFFERENT TYPES

Sugar is a fundamental energy source for plants and animals, and exists in one form or another in all living creatures. There are many different sugars—some consist of two individual sugar units attached together (disaccharides) and others have one sugar molecule (monosaccharides). The different varieties include the following:
GLUCOSE is a monosaccharide that occurs naturally in fruits and vegetables, but is usually found as part of a disaccharide (often sucrose) or starch.
FRUCTOSE is a monosaccharide that tastes sweeter than glucose. It is naturally present in fruits and vegetables and makes up more than half the sugar in honey. It is very sweet.
GALACTOSE occurs mostly as a component of lactose (the sugar in milk) and is rarely found as a monosaccharide in foods.
SUCROSE (WHITE, REFINED TABLE SUGAR) is a disaccharide of glucose linked to fructose. It is found in sugar cane, sugar beets, honey and maple syrup, and is the most widely used form of sugar—added to foods and for cooking. It is 99% pure sucrose.
MALTOSE is a disaccharide and is made whenever starch is broken down.
LACTOSE (OR MILK SUGAR) is a disaccharide (glucose linked to galactose). It is the only sugar naturally found in animal foods and contributes to about 30% of the calories in whole cow's milk and 40% in human breast milk.

Contrary to popular belief, there is little nutritional difference among these sugars. During digestion, all sugars and starches are broken down into glucose and fructose (except lactose, which is broken down into galactose and glucose). Glucose and fructose are small enough to be absorbed through the small intestine into the bloodstream and then delivered to the body's cells for immediate use as energy or storage as glycogen (in muscles or the liver) to be broken down for later fuel needs.

DAILY INTAKE

As part of a balanced, healthy diet, you can enjoy sugars in moderation. There is no specific recommended daily intake currently given for sugar intake, but table sugar and 'junk' foods containing added sugar (but few vitamins and minerals) remain at the top of the dietary pyramid and should only be eaten occasionally.

IS SUGAR BAD FOR YOU?

Claims about the adverse health effects of sugar have shown to be

myths. Research has shown that sugar does not cause obesity, hypoglycaemia or hyperactivity, and is only one of many factors that promote tooth decay.

Both sugars and starches can contribute to tooth decay. Foods that stick to your teeth such as lollies, dried fruits, bread or foods that are slowly munched or sipped on are the worst. The longer your teeth are in contact with the carbohydrate in these foods, the greater the risk of tooth decay.

Eating sugar will not necessarily make you gain weight. Weight gain results from eating more calories than you need over a period of time. Dietary fat contains more calories per gram than sugar, so you are more likely to eat an excessive amount of calories from high-fat foods rather than sugar-rich foods. Foods like sweet pastries, chocolate, ice cream and biscuits are often called sugary foods, but most of their calories come from fat. Recent surveys found that people who consume more fat and relatively less sugar are more likely to be overweight than people who consume less fat and more sugar. However, this doesn't mean you can eat all the sugar you want and not gain weight.

SUGAR SUBSTITUTES

The food industry now uses many sweet-tasting substances instead of sugar to produce sugar-free foods—this includes sugar alcohols (sorbitol, mannitol, xylitol, maltitol, maltitol syrup, lactitol), isomalt and hydrogenated starch hydrolysates.

Sugar alcohols are used to sweeten 'diet' products, as they are not completely absorbed and therefore provide fewer calories than normal sugars. They occur naturally in plums, apples, and other foods, or can be produced commercially from carbohydrates such as sucrose, glucose and starch.

Sugar alcohols also add bulk and texture to foods, provide a cooling effect or aftertaste, and help retain moisture in foods. When consumed in large amounts, sugar alcohols can have a laxative effect.

Sucralose is the only low-calorie sweetener made from sugar (sucrose) and can't be digested or absorbed in the body. It is about 600 times sweeter than sugar, so it can be used in minute amounts. It is used in drinks, bakery products, ice cream, dairy products and confectionery. Foods containing sucralose are safe for consumption by healthy adults and children and people with diabetes (in appropriate quantities).

Then there are artificial sweeteners: ASPARTAME is an added sweetener and as an ingredient in breakfast cereals, soft drinks and desserts. It enhances fruit flavours, saves calories and doesn't contribute to tooth decay.

SACCHARIN is only sold for use as an added sweetener. Saccharin was the first low-calorie sweetener developed and has been used to sweeten foods and drinks for more than 40 years. It tastes 300 times sweeter than sugar, but has a slightly bitter aftertaste.

HINTS AND TIPS
- A small amount of sugar added to healthy low-fat meals, such as porridge, can help make a low-fat diet palatable and easier to stick to.
- Reducing or cutting out sugar added to drinks and meals will help you reduce your calorie intake.
- Choose treats such as fruit bread, fruit or low-fat yoghurt when you want to snack.
- Take care of your teeth by brushing properly and using dental floss. Drink water that contains some fluoride.

VITAMINS

VITAMINS	FUNCTIONS	DEFICIENCY SIGNS	GOOD SOURCES
Vitamin A	Promotes healthy eyes, skin and hair and also maintains the mucous membranes of the nose, throat, lungs and gut. Is important in the body's immune system.	Eye, skin and hair problems, poor night vision, impaired bone growth and increased susceptibility to infections.	Eggs, dairy foods (but not low-fat milk), butter, margarine, liver, kidneys, fish liver oil.
Beta Carotene (can be converted by the body to Vitamin A in older children and adults)	Provides the yellow and orange colours in fresh produce. A powerful antioxidant, it improves immunity.	Increased susceptibility to infections. A relatively low intake of carotene from fresh fruits and vegetables may result in less protection against heart disease and cancer.	Yellow, green, orange and red vegetables and fruit: carrots, English spinach, mangoes, pumpkin, apricots, pawpaw, broccoli, red capsicum (pepper), tomatoes.
Vitamin B group (8 vitamins)	Are needed for the processes that release the energy in carbohydrates, fats and proteins consumed in the diet. Also needed for the nervous system, formation of red blood cells, healthy skin and heart.	Fatigue, nerve problems, decreased ability to cope with stress, depression and skin problems.	Yeast, wholegrain breads and cereals, legumes, eggs, milk, nuts, leafy green vegetables, liver, kidneys, meat, poultry, fish, seafood, yeast extract (such as Vegemite), fortified breakfast cereals.
Folate (a B-group vitamin)	Essential for DNA synthesis, protein synthesis and red blood cell production.	Anaemia. A low intake prior to conception and during pregnancy can increase the risk of spinal tube defects in the baby.	Brewer's yeast, wheat germ, bran, leafy green vegetables, avocados, oats, liver, tomatoes, oranges, melons.
Vitamin B_{12}	Works with folate. Essential for the functioning of all cells and protein, fat and carbohydrate metabolism as well as healthy nerves.	Anaemia, nervous system disorders (tingling and weakness in feet), depression, poor memory.	Only found in animal foods: dairy products, organ meats, eggs, red meat and seafood. Vegans may need to take a supplement (consult your doctor).
Vitamin C	Needed for healthy skin, bones, cartilage and teeth. Helps the body to absorb iron and has antioxidant effects, helps protect against infection and chronic diseases.	Tissue breakdown, easy bleeding and bruising, fatigue.	Fruit and vegetables: capsicum (pepper), guava, brussels sprouts, pawpaw, kiwi fruit, melon, mangoes and especially citrus fruits, berries, broccoli, pineapple and cabbage.
Vitamin D	Needed to absorb calcium for healthy bones and teeth. Sunlight also helps the body make its own Vitamin D. Needed to make hormones.	Muscle and bone weakness. Rickets in children. Osteomalacia in adults.	Egg yolk, cheese, margarine, milk, vegetable oils, oily fish (tuna, salmon, sardines), liver.
Vitamin E	An antioxidant. Needed for healthy blood vessels and tissues, including the heart. Works with other antioxidant vitamins and minerals to protect against disease.	Deficiency is rare. Prevents normal growth.	Egg yolks, nuts, seeds, wholegrain cereals, wheat germ, vegetable oils and margarine, meat, peanut butter.
Vitamin K	Needed for the normal clotting of blood (ie. to stop bleeding wounds). Essential for the formation of protein substances in the bones and kidneys.	Nose bleeds, excessive bleeding.	Broccoli, lettuce, cabbage, English spinach, cauliflower, legumes, liver.

MINERALS

MINERALS	FUNCTIONS	DEFICIENCY SIGNS	GOOD SOURCES
Calcium	Essential for strong bones and teeth. Regulates nerve and muscle function and may help reduce high blood pressure.	Rickets, osteoporosis, osteomalacia, cramps, muscle problems, high blood pressure and heart arrhythmias.	Dairy products, almonds, brewer's yeast, dried figs, salmon and its bones, sardines, tahini, calcium-enriched soy milk and tofu.
Iodine	Needed for thyroid hormone production, regulation of metabolic rate, proper growth, sex hormones, healthy skin, nails, hair and teeth.	Goitre (enlarged thyroid gland, swelling in the neck), hypothyroidism, bulging eyes, low libido, brittle nails, fatigue, weight gain, constipation.	Iodized salt, kelp, clams (vongole), prawns (shrimp), haddock, oysters, salmon, sardines, Cheddar, pineapple, onions.
Iron	Needed to make haemoglobin—the compound in red blood cells allowing them to carry oxygen; and myoglobin—the oxygen-carrying compound in muscles.	A relatively common deficiency. Fatigue, poor circulation, anaemia, depression, less able to concentrate, decreased physical and mental performance.	Red meats are the richest source—liver, chicken, turkey and fish are not as rich. Wholemeal/grain bread, legumes (including canned beans and lentils), dark-green leafy vegetables, eggs, nuts, apricots, sunflower seeds.
Magnesium	Essential for the proper function of nerves and muscles, including the heart. It also catalyses many essential enzymes and their reactions.	Weakness, fatigue, anxiety, agitation, confusion, muscle tremors, cramps, convulsions and heart rhythm disturbances.	Wholegrain cereal products, wheat germ, brewer's yeast, almonds, molasses, seafood, kelp, leafy green vegetables, nuts, legumes.
Phosphorus	Essential for healthy bones and teeth. Helps nutrient absorption, energy production, nerve transmission, metabolism and muscle contraction.	Deficiency is rare. Anxiety, fatigue, muscle weakness, bone pains, osteoporosis, rickets and osteomalacia.	Dairy products, eggs, wholegrains, legumes, garlic, nuts, seeds.
Potassium	Essential for the normal functioning of nerves and muscles and promotes normal blood pressure and heartbeat. Works with sodium to maintain the body's normal fluid balance.	Fatigue, heart disturbances, extreme thirst. It is rare, but can occur with excessive vomiting or diarrhoea.	Vegetables, fruit, avocados, wholegrain cereals, seeds, dates, raisins, nuts, potatoes, pulses.
Selenium	An antioxidant which works together with other antioxidants (eg. vitamin E), to prevent or inhibit the damaging effects of antioxidants.	Premature ageing, muscle degeneration, liver disease.	Butter, wheat germ, barley, wholewheat bread, garlic, brazil nuts, cider vinegar.
Sodium	Needed for nerve and muscle functions, and for regulating the balance of fluid in the body.	Deficiency is rare. Dehydration, vomiting and cramps.	Salt, yeast extract, salted nuts, bread, cheese, margarine, some take-away foods, olives, celery, peas, leg ham, sausages, bacon.
Zinc	Needed for healthy eyes and skin and improves immunity. Essential for taste, smell, appetite and carbohydrate metabolism. Important for wound healing, normal growth, reproduction and development.	Decreased fertility and libido, poor sense of taste and smell, poor wound healing, less energy, less resistance to infections.	Red meat, eggs, seafood, yeast, milk, wholegrain cereals, liver, cheese, yoghurt, leafy green vegetables, chicken, oats, legumes.

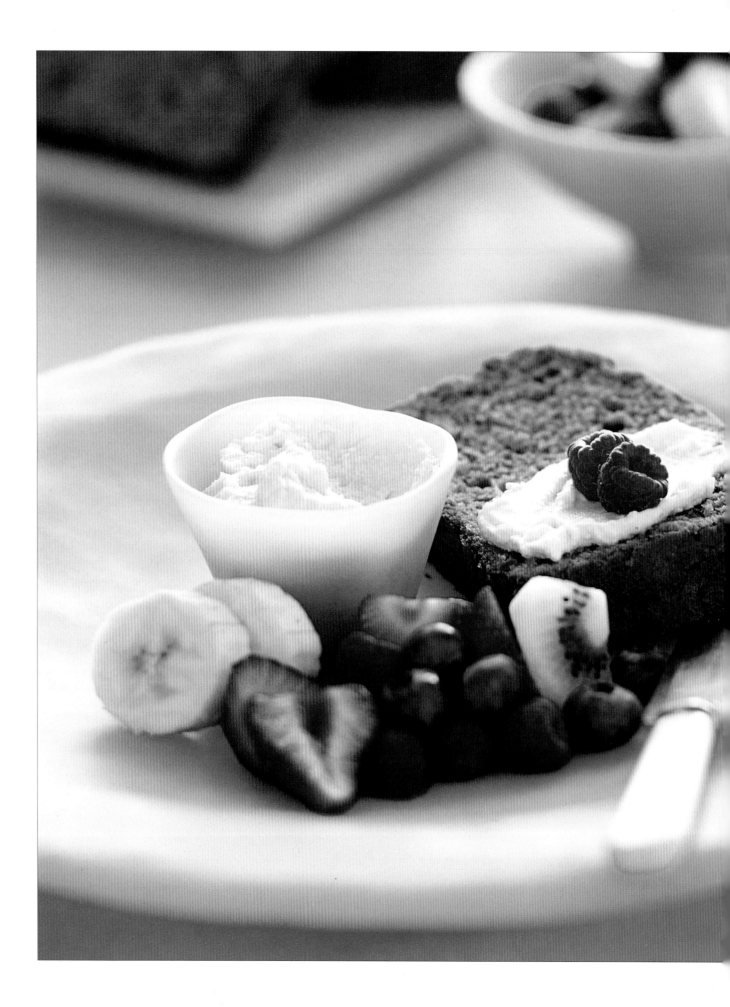

BREAKFAST

LOW-FAT BANANA BREAD WITH MAPLE RICOTTA AND FRESH FRUIT

Preparation time: 10 minutes
Total cooking time: 55 minutes
Makes 10–12 slices

80 ml (1/3 cup) strong coffee
125 g (2/3 cup) soft brown sugar
1 egg
1 egg white
3 tablespoons vegetable oil
1 teaspoon vanilla essence
3 ripe bananas, mashed
 (about 300 g or 1 1/4 cups)
125 g (1 cup) plain (all-purpose) flour
250 g (2 cups) self-raising flour
1/2 teaspoon baking powder
1 teaspoon ground ginger
1/2 teaspoon ground nutmeg
1 teaspoon ground cinnamon
1 teaspoon bicarbonate of soda
fresh fruit (strawberries, banana,
 kiwi fruit, berries), to serve

Maple ricotta
200 g (7 oz) low-fat ricotta
2 tablespoons maple syrup

1 Preheat the oven to 170°C (325°F/Gas 3). Lightly grease a 22 cm x 12 cm (9 inch x 5 inch) loaf tin and line the base with baking paper. Heat the coffee in a small saucepan over low heat, add the soft brown sugar and stir until the sugar has dissolved.
2 Place the egg, egg white, oil and vanilla essence in a bowl and beat together until just combined. Add the sweetened strong coffee and the mashed banana.
3 Sift the plain and self-raising flours, baking powder, ginger, nutmeg, cinnamon and bicarbonate of soda onto the mixture and stir gently to combine—do not overbeat. Spoon the mixture into the prepared loaf tin.
4 Bake for 50 minutes, or until a skewer comes out clean when inserted into the centre. Leave in the tin for 10 minutes before turning out onto a wire rack to cool completely.
5 To make the maple ricotta, place the ricotta and maple syrup in a small bowl and mix until well combined. Cut the banana bread into thick slices and serve with the maple ricotta and fresh fruit.

NUTRITION PER SLICE (12)
Fat 7 g; Protein 8 g; Carbohydrate 45 g; Dietary Fibre 3.5 g; Cholesterol 22.6 mg; 1135 kJ (270 Cal)

COOK'S FILE
Note: This banana bread is delicious served toasted.

Add the sweetened coffee and mashed banana to the egg mixture.

Spoon the bread mixture into the tin, scraping out the bowl with a metal spoon.

DRY-ROASTED GRANOLA MUESLI

Preparation time: 5 minutes
Total cooking time: 20 minutes
Serves 4

125 g (1¼ cups) rolled oats
3 tablespoons slivered almonds
3 tablespoons hazelnuts, roughly
 chopped
3 tablespoons desiccated coconut

30 g (⅓ cup) wheat germ
2 tablespoons sesame seeds
3 tablespoons sunflower seeds
3 tablespoons soft brown sugar

1 Place the oats, almonds and hazelnuts in a large heavy-based frying pan over low heat. Cook for 4–5 minutes, stirring constantly, until the mixture begins to darken.
2 Add the coconut, wheat germ and sesame and sunflower seeds to the pan. Stir together for a further

8–10 minutes, or until it develops a golden toasted look. Add the brown sugar and stir for a further 2–3 minutes. Remove from the heat and cool completely before storing in an airtight container. Serve with cold milk.

NUTRITION PER SERVE
Fat 22 g; Protein 11 g; Carbohydrate 26 g; Dietary Fibre 6.5 g; Cholesterol 0 mg; 1420 kJ (340 Cal)

Chop the hazelnuts into rough pieces with a sharp knife.

Stir the oat and nut mixture continuously until it begins to brown.

Add the coconut, wheat germ, sesame and sunflower seeds.

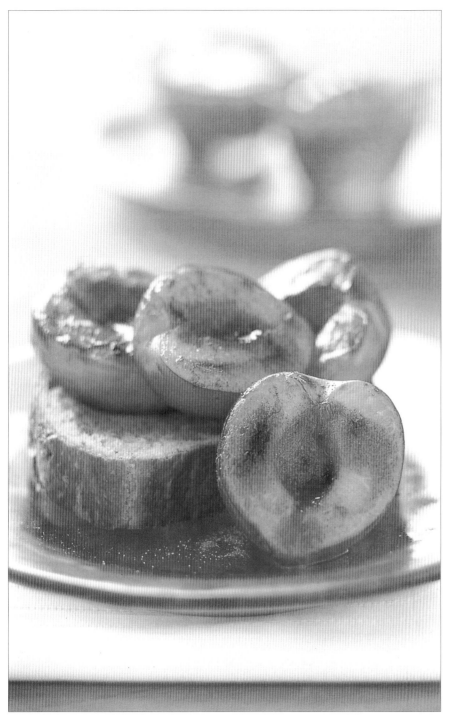

GRILLED STONE FRUITS WITH CINNAMON TOAST

Preparation time: 10 minutes
Total cooking time: 10 minutes
Serves 4

2 tablespoons low-fat margarine
1 1/2 teaspoons ground cinnamon
4 thick slices good-quality brioche
4 ripe plums, halved and stones
 removed
4 ripe nectarines, halved and stones
 removed
2 tablespoons warmed blossom
 honey

1 Place the margarine and 1 teaspoon of the ground cinnamon in a bowl and mix until well combined. Grill the brioche on one side until golden. Spread the other side with half the cinnamon spread, then grill until golden. Keep warm in the oven.
2 Brush the plums and nectarines with the remaining spread and cook under a grill or on a ridged grill plate, (griddle) until the spread is bubbling and the fruit is tinged at the edges.
3 To serve, place 2 plum halves and 2 nectarine halves on each toasted slice of brioche. Dust with the remaining cinnamon and drizzle with the warmed honey. Dollop with a little fromage frais, if desired.

NUTRITION PER SERVE
Fat 13 g; Protein 9 g; Carbohydrate 66 g;
Dietary Fibre 7 g; Cholesterol 41 mg;
1730 kJ (415 Cal)

COOK'S FILE
Note: Tinned plums or apricots may be used in place of fresh stone fruits.

Cut the plums and nectarines in half and remove the stones.

Grill the slices of brioche until both sides are golden.

Grill the plums and nectarines until the cinnamon spread is bubbling.

27

OATY BUCKWHEAT PANCAKES

Preparation time: 10 minutes
Total cooking time: 25 minutes
Serves 4

Berry sauce
60 g (¼ cup) sugar
2 teaspoons lemon juice
250 g (9 oz) raspberries

40 g (⅓ cup) buckwheat flour
100 g (⅔ cup) wholemeal
 (whole-wheat) flour
1½ teaspoons baking powder
25 g (¼ cup) rolled oats
1 egg yolk
375 ml (1½ cups) buttermilk
3 egg whites
extra raspberries, to serve

1 To make the berry sauce, place the sugar, lemon juice and 60 ml (¼ cup) water in a saucepan and bring to the boil over medium heat. Add the raspberries and cook over low heat for 3 minutes. Cool. For a smooth sauce, purée in a food processor for 10 seconds; for a chunky sauce gently mash with a fork.
2 Sift the flours into a bowl and return the husks to the bowl. Add the baking powder and rolled oats and combine. Make a well in the centre. Combine the egg yolk and buttermilk and add to the dry ingredients all at once. Stir to form a smooth batter. Whisk the egg whites until firm peaks form, then fold into the batter.
3 Heat a non-stick frying pan and brush lightly with butter. Pour 60 ml (¼ cup) batter into the pan and swirl to form a 10 cm (4 inch) circle. Cook over medium–high heat for 1–2 minutes, or until bubbles appear on the surface. Turn and cook the other side for a further 1–2 minutes, or until light brown. Transfer to a plate and keep warm. Repeat to make 8 pancakes in total. Serve with the berry sauce and extra raspberries.

NUTRITION PER SERVE
Fat 5 g; Protein 13 g; Carbohydrate 51 g;
Dietary Fibre 7.5 g; Cholesterol 53.5 mg;
1255 kJ (300 Cal)

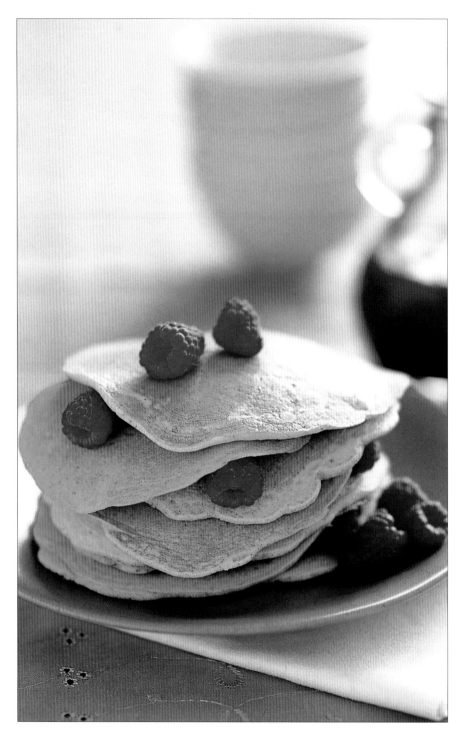

Add the raspberries to the sugar, lemon juice and water mixture and cook for 3 minutes.

Cook the pancake until a few bubbles appear on the surface.

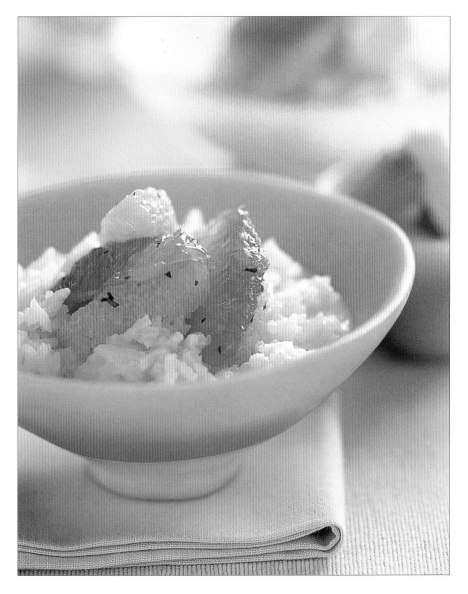

Peel the ruby grapefruit, then cut out the segments with a sharp knife.

Simmer the rice until the milk has been absorbed and the rice is creamy.

Stir the honey and vanilla essence into the rice mixture.

CREAMED RICE WITH MINTED CITRUS COMPOTE

Preparation time: 15 minutes
Total cooking time: 30 minutes
Serves 4

150 g (¾ cup) basmati rice
500 ml (2 cups) milk
4 cardamom pods, bruised
½ cinnamon stick
1 clove
3 tablespoons honey
1 teaspoon vanilla essence

Citrus compote

2 ruby grapefruit, peeled and
 segmented
2 oranges, peeled and segmented
3 tablespoons orange juice
1 teaspoon grated lime zest
3 tablespoons honey
8 mint leaves, finely chopped

1 Cook the rice in a large saucepan of boiling water for 12 minutes, stirring occasionally. Drain and cool.
2 Place the rice, milk, cardamom pods, cinnamon stick and clove in a saucepan and bring to the boil. Reduce the heat to low and simmer for 15 minutes, stirring occasionally, until the milk is absorbed and the rice is creamy. Remove the spices, then stir in the honey and vanilla.
3 To make the compote, combine the ruby grapefruit, orange, orange juice, lime zest, honey and mint and mix until the honey has dissolved. Serve with the rice.

Combine the grapefruit, orange, juice, lime zest, honey and mint.

NUTRITION PER SERVE
Fat 2.5 g; Protein 9 g; Carbohydrate 81 g; Dietary Fibre 3 g; Cholesterol 9 mg; 1575 kJ (375 Cal)

Whisk the egg whites, whole eggs and milk until combined.

Lightly brush the mushrooms with the Worcestershire mixture.

Gently scrape the bottom of the pan with a spatula and cook until the egg has just set.

LIGHT SCRAMBLED EGGS WITH GRILLED MUSHROOMS

Preparation time: 10 minutes
Total cooking time: 15 minutes
Serves 4

4 egg whites
8 eggs
2 tablespoons skim milk
2 tablespoons Worcestershire
 sauce
2 small cloves garlic, crushed
2 teaspoons olive oil
12 field or Swiss brown mushrooms
2 tablespoons chopped parsley

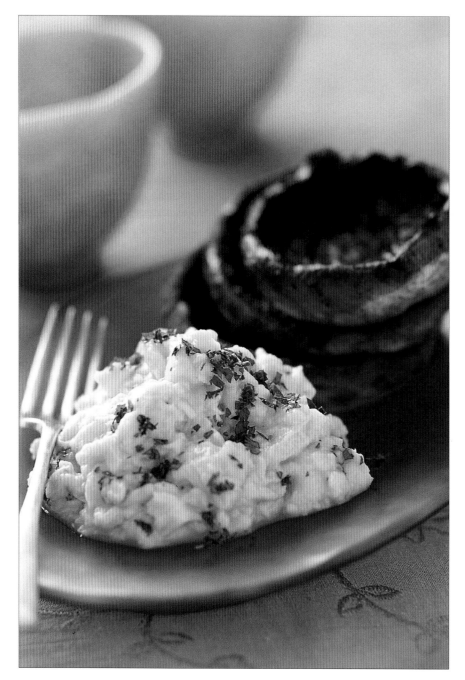

1 Lightly whisk the egg whites in a large bowl. Add the whole eggs and milk and whisk until combined. Season lightly with salt and freshly ground black pepper.
2 Combine the Worcestershire sauce, garlic, olive oil and some freshly ground black pepper. Brush the mushrooms lightly with the Worcestershire sauce mixture, then grill (broil) on medium heat for 5–7 minutes, or until soft. Remove and keep warm.
3 Heat a non-stick frying pan and add the egg mixture, scraping the

bottom gently with a flat plastic spatula to cook evenly. Cook until the egg is just set.
4 To serve, divide the scrambled eggs and mushrooms among four serving plates. Sprinkle the eggs with the chopped parsley and serve immediately.

NUTRITION PER SERVE
Fat 13 g; Protein 18 g; Carbohydrate 4 g; Dietary Fibre 1 g; Cholesterol 375.5 mg; 820 kJ (195 Cal)

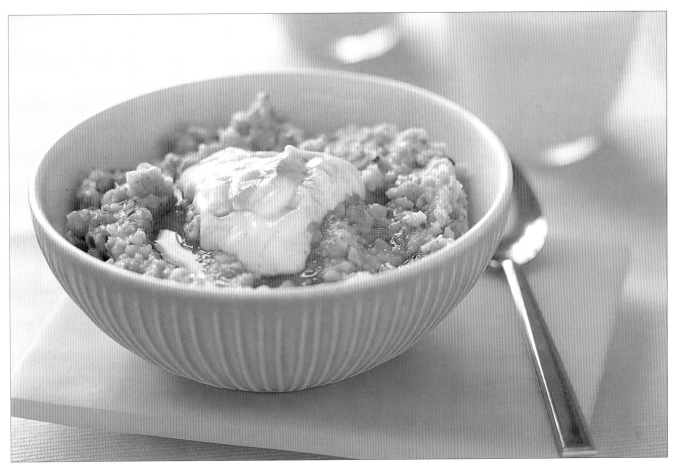

POWER PORRIDGE

Preparation time: 10 minutes
Total cooking time: 20 minutes
Serves 4

400 g (4 cups) rolled oats
105 g (1 cup) rice flakes
130 g (1 cup) barley flakes
130 g (1 cup) rye flakes
205 g (1 cup) millet
2 tablespoons sesame seeds,
 lightly toasted
2 teaspoons linseed (flax)

1 Place the rolled oats, rice flakes, barley flakes, rye flakes, millet, sesame seeds and linseed in a large bowl and stir well. Store in a sealed container until ready to use.
2 To prepare the porridge for four people, place 280 g (2 cups) of the dry mixture, a pinch of salt and 500 ml (2 cups) water in a saucepan, then stir well. Leave for 5 minutes (this creates a smoother, creamier porridge). Stir and add another 500 ml (2 cups) water. Bring to the boil over medium heat, stirring occasionally.

3 Reduce the heat to low and simmer the porridge, stirring frequently, for 12–15 minutes, or until the mixture is soft and creamy and the grains are cooked. Serve with milk or low-fat yoghurt and soft brown sugar.

NUTRITION PER SERVE
Fat 16 g; Protein 22 g; Carbohydrate 127 g; Dietary Fibre 14.5 g; Cholesterol 0 mg; 3115 kJ (745 Cal)

COOK'S FILE
Note: If you like, add 80 g (1/2 cup) sultanas or a mixture of dried fruits to the dry mixture, and cook as above.

Combine the oats, rice flakes, barley flakes, rye flakes, millet, sesame seeds and linseed.

Stir another 500 ml (2 cups) water into the porridge mixture.

Simmer the porridge over low heat until soft and creamy.

BREAKFAST IN A GLASS

Fresh fruit is a superb way to start the day. Packed with carbohydrates, fibre and flavour, fruits contain all the things you need in a nutritious morning starter. Throw a combination of fruit, juice and yoghurt in a blender for a balanced breakfast in minutes or layer fruit with yoghurt and muesli for an attractive 'meal'.

BANANA STARTER

Blend 2 bananas, 100 g (3½ oz) frozen blueberries, 1 cored unpeeled red apple, 300 ml (1¼ cups) apple juice and 2 ice cubes in a blender until smooth.
Pour into serving glasses.
Makes 4 x 200 ml (7 fl oz) glasses.

NUTRITION PER SERVE
Fat 0 g; Protein 1.1 g; Carbohydrate 25 g; Dietary Fibre 2.5 g; Cholesterol 0 mg; 430 kJ (100 Cal)

KIWI DELIGHT

Blend 3 sliced kiwi fruit, 90 g (3¼ oz) peeled and cored pineapple chunks, 1 banana, 250 ml (1 cup) tropical fruit juice and 2 ice cubes in a blender until smooth. Pour into glasses and serve.
Makes 4 x 200 ml (7 fl oz) glasses.

NUTRITION PER SERVE
Fat 0.5 g; Protein 2 g; Carbohydrate 18 g; Dietary Fibre 3 g; Cholesterol 0 mg; 340 kJ (80 Cal)

GET UP AND GO SMOOTHIE

Blend 60 g (2¼ oz) mango flesh (½ mango) cut into chunks, 2 tablespoons oat bran, 500 ml (2 cups) no-fat soy milk, 2 tablespoons honey and 60 g (¼ cup) 99.8% fat-free natural yoghurt in a blender until smooth. Pour the smoothie into glasses and serve with a spoon.
Makes 4 x 200 ml (7 fl oz) glasses.

NUTRITION PER SERVE
Fat 1 g; Protein 7 g; Carbohydrate 25 g; Dietary Fibre 2 g; Cholesterol 1 mg; 560 kJ (135 Cal)

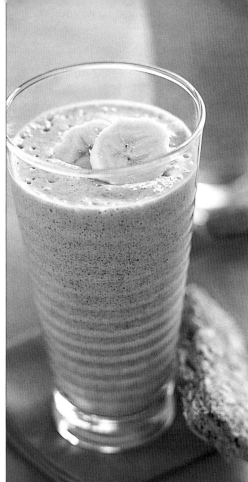
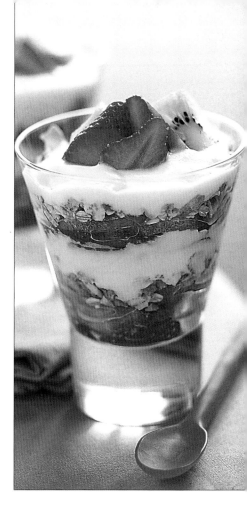

FRUITASIA SMOOTHIE

Blend 100 g (1/2 cup) 99.8% fat-free natural yoghurt, the pulp of 2 passionfruit, 2 bananas, 6 strawberries, 100 g (3 1/2 oz) frozen raspberries, 250 ml (1 cup) apple juice and 2 ice cubes in a blender until smooth. Serve in chilled glasses. Makes 4 x 200 ml (7 fl oz) glasses.

NUTRITION PER SERVE
Fat 0.25 g; Protein 3 g; Carbohydrate 21 g; Dietary Fibre 4 g; Cholesterol 1.5 mg; 415 kJ (100 Cal)

WHEATY STARTER

Blend 2 breakfast wheat biscuits, 2 chopped bananas, 500 ml (2 cups) no-fat soy milk and 60 g (1/4 cup) 99.8% fat-free natural yoghurt in a blender until smooth. Pour into serving glasses.
Makes 4 x 200 ml (7 fl oz) glasses.

NUTRITION PER SERVE
Fat 0.5 g; Protein 6 g; Carbohydrate 21 g; Dietary Fibre 2.5 g; Cholesterol 1 mg; 455 kJ (110 Cal)

BREAKFAST DELUXE

Cut 12 strawberries into thin slices. Peel 4 kiwi fruit and cut into slices. Divide the strawberry slices, kiwi fruit slices, 160 g (5 3/4 oz) low-fat muesli and 400 g (14 oz) 99.8% fat-free natural yoghurt among four glasses. Repeat these layers, finishing with some fruit. Pour 80 ml (1/3 cup) milk into each glass, then drizzle each with 2 teaspoons honey. Serve with a spoon.
Makes 4 x 250 ml (9 fl oz) glasses.

NUTRITION PER SERVE
Fat 6 g; Protein 16 g; Carbohydrate 54 g; Dietary Fibre 7 g; Cholesterol 11 mg; 1370 kJ (325 Cal)

Cook the tomato sauce over medium heat until thickened.

Break one egg carefully into each greased ramekin dish.

EGGS EN COCOTTE

Preparation time: 15 minutes
Total cooking time: 30 minutes
Serves 4

Tomato sauce
1 tablespoon olive oil
1 clove garlic, crushed
3 vine-ripened tomatoes (about 300 g or 10½ oz), peeled, seeded and chopped

½ teaspoon olive oil
4 eggs
Tabasco sauce, to taste
2 tablespoons chives, snipped with scissors
4 slices thick multigrain bread
1 tablespoon margarine

1 Preheat the oven to 180°C (350°F/Gas 4). To make the sauce, heat the oil in a heavy-based frying pan. Add the garlic and cook for 1 minute, or until it starts to turn golden. Add the tomato and season to taste with salt and freshly ground pepper. Cook over medium heat for 15 minutes, or until thickened.

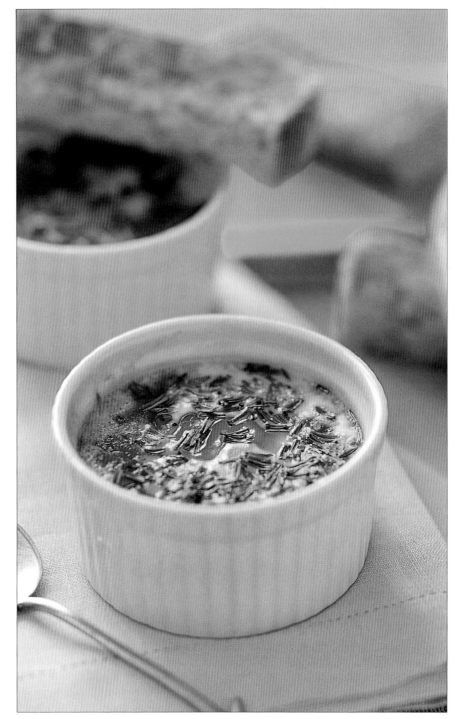

2 Grease four 125 ml (½ cup) ramekins with the olive oil, then carefully break 1 egg into each, trying not to break the yolk. Pour the tomato sauce evenly around the outside of each egg so the yolk is still visible. Add a little Tabasco sauce then sprinkle with chives and season lightly with salt and freshly ground black pepper.
3 Place the ramekins in a deep baking tray and pour in enough hot water to come halfway up the side of the ramekins. Bake for 10–12 minutes, or until the egg white is set. Toast and lightly spread the slices of bread with the margarine, then cut into thick fingers. Serve immediately with the egg.

NUTRITION PER SERVE
Fat 15 g; Protein 11 g; Carbohydrate 20 g; Dietary Fibre 3 g; Cholesterol 187.5 mg; 1075 kJ (255 Cal)

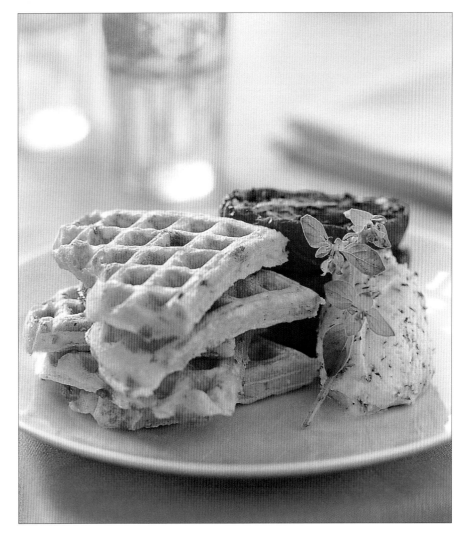

Bake the prepared tomato halves in a warm oven until very soft.

Use two tablespoons to shape the ricotta mixture into quenelle shapes.

Gently fold the beaten egg whites into the cheese mixture.

CHEESE AND ONION WAFFLES WITH HERBED RICOTTA AND ROAST TOMATO

Preparation time: 20 minutes
Total cooking time: 1 hour 15 minutes
Serves 4

4 Roma (plum) tomatoes, cut in half
1 tablespoon olive oil
1 tablespoon balsamic vinegar
1 teaspoon sugar
1 tablespoon chopped oregano
310 g (1 1/4 cups) low-fat ricotta
 cheese
4 tablespoons chopped herbs
 (oregano, sage, rosemary, parsley)
185 g (1 1/2 cups) self-raising flour
3 tablespoons freshly grated
 Parmesan cheese
3 tablespoons grated low-fat Cheddar
 cheese
3 large spring onions (scallions), finely
 chopped
1 egg
250 ml (1 cup) low-fat milk
2 egg whites
fresh oregano sprigs, to garnish

1 Preheat the oven to 160°C (315°F/Gas 2–3). Lightly grease an oven tray. Place the tomato halves on the tray and drizzle the cut surface with olive oil and balsamic vinegar. Sprinkle with the sugar, oregano and salt. Bake for 1 hour, or until very soft.
2 Place the ricotta in a bowl and fold in the chopped herbs. Season to taste. Using two tablespoons, shape the herbed ricotta into quenelle shapes. Refrigerate until needed.
3 Meanwhile, place the flour, Parmesan, Cheddar, spring onion, whole egg and milk in a bowl. Season with salt and black pepper, then mix well. Whisk the egg whites until soft peaks form and gently fold into the cheese and egg mixture.
4 Preheat a waffle iron and brush lightly with olive oil. Pour in 80 ml (1/3 cup) waffle batter and cook until golden on both sides. Keep warm in the oven while you cook the remaining waffles.
5 To serve, arrange two waffle halves on each serving plate with two tomato halves and two ricotta quenelles on the side. Garnish with a sprig of fresh oregano.

NUTRITION PER SERVE
Fat 14 g; Protein 24 g; Carbohydrate 41 g; Dietary Fibre 3.5 g; Cholesterol 84.5 mg; 1620 kJ (385 Cal)

Stir the passionfruit pulp into the strained ginger and lemon grass syrup.

Peel the pawpaw, then remove the seeds with a spoon.

Peel the lychees, make a slit in the flesh and remove the seed.

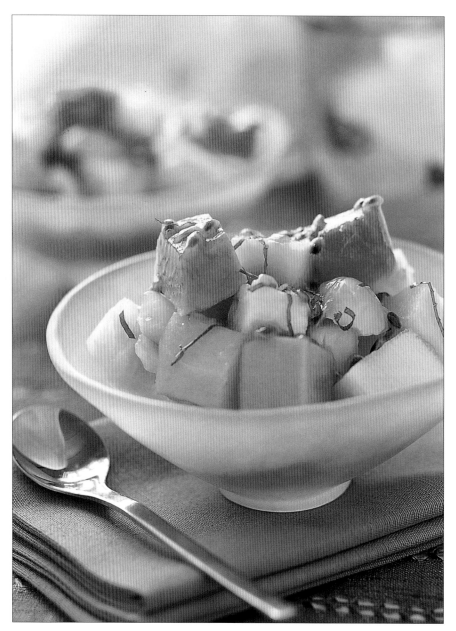

LEMON GRASS AND GINGER INFUSED FRUIT SALAD

Preparation time: 20 minutes
Total cooking time: 10 minutes
Serves 4

60 g (¼ cup) caster (superfine) sugar
2 cm x 2 cm (¾ inch x ¾ inch) piece fresh ginger, thinly sliced
1 stem lemon grass, bruised and halved
1 large passionfruit
1 Fiji red pawpaw (560 g or 1 lb 4 oz)
½ honeydew melon (800 g or 1 lb 12 oz)
1 large mango (535 g or 1lb 4 oz)
1 small pineapple (1 kg or 2 lb 4 oz)
12 fresh lychees
15 g (¼ cup) mint, shredded

1 Place the sugar, ginger and lemon grass in a small saucepan, add 125 ml (½ cup) water and stir over low heat to dissolve the sugar. Boil for 5 minutes, or until reduced to 80 ml (⅓ cup); cool. Strain the syrup and add the passionfruit pulp.
2 Peel and seed the pawpaw and melon. Cut into 4 cm (1½ inch) cubes. Peel the mango and cut the flesh into cubes, discarding the stone. Peel, halve and core the pineapple and cut into cubes. Peel the lychees, then make a slit in the flesh and remove the seed.
3 Place all the fruit in a large serving bowl. Pour on the syrup, or serve separately if preferred. Garnish with the shredded mint.

NUTRITION PER SERVE
Fat 2 g; Protein 7 g; Carbohydrate 80 g; Dietary Fibre 13.5 g; Cholesterol 0 mg; 1485 kJ (355 Cal)

COOK'S FILE
Note: If fresh lychees are not available, canned ones are fine.

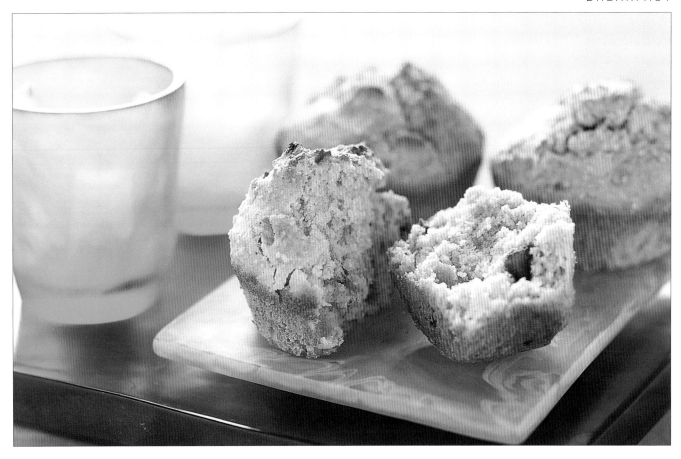

HEALTHY FRUIT MUFFINS

Preparation time: 15 minutes +
 5 minutes soaking
Total cooking time: 20 minutes
Makes 12

180 g (1 cup) chopped mixed dried
 fruits (apricots, dates, peaches or
 fruit medley with peel)
225 g (1 ½ cups) wholemeal
 (whole-wheat) self-raising flour
1 teaspoon baking powder
150 g (1 cup) oat bran, unprocessed
60 g (⅓ cup) soft brown sugar

300 ml (1 ¼ cups) skim milk
1 egg
1 tablespoon oil

1 Preheat the oven to 180°C
(350°F/Gas 4). Grease twelve 125 ml
(½ cup) muffin holes. Soak the dried
fruit in a bowl with 60 ml (¼ cup)
boiling water for 5 minutes.
2 Sift the flour and baking powder
into a large bowl, returning the husks
to the bowl. Stir in the oat bran and
sugar and make a well in the centre.
3 Combine the milk, egg and oil in
a jug. Add the soaked fruit and milk
mixture all at once to the dry

ingredients. Fold in gently using a
metal spoon, until just combined—
do not overmix.
4 Divide evenly among the muffin
holes. Bake for 20 minutes, or until
risen and golden, and a skewer
inserted into the centre comes out
clean. Cool for a few minutes in the
tin then turn out onto a wire rack.
Serve warm or at room temperature.

NUTRITION PER MUFFIN
Fat 3.5 g; Protein 6 g; Carbohydrate 33 g;
Dietary Fibre 4.5 g; Cholesterol 16.5 mg;
755 kJ (180 Cal)

*Soak the mixed dried fruit in boiling water
until plump and softened.*

*Add the soaked fruit and the milk mixture
all at once to the dry ingredients.*

*Divide the mixture evenly among the
greased muffin holes.*

BAKED RICOTTA AND RED CAPSICUM WITH PESTO

Preparation time: 10 minutes
Total cooking time: 45 minutes
Serves 6

1 large red capsicum (pepper), cut
 into quarters and seeded
750 g (3 cups) low-fat ricotta cheese
1 egg
6 slices wholegrain bread

Pesto
2 tablespoons pine nuts
100 g (2 cups) basil
2 cloves garlic
2 tablespoons good-quality olive oil
2 tablespoons finely grated fresh
 Parmesan cheese

1 Grill the capsicum, skin-side up, under a hot grill for 5–6 minutes, or until the skin blackens and blisters. Place in a bowl and cover with plastic wrap until cool enough to handle. Peel off the skin and slice the flesh into 2 cm (³/4 inch) wide strips.
2 To make the pesto, place the pine nuts, basil and garlic in a food processor and process for 15 seconds, or until finely chopped. While the processor is running add the oil in a continuous thin stream, then season with salt and freshly ground black pepper. Stir in the Parmesan.
3 Preheat the oven to 180°C (350°F/Gas 4). Grease six large muffin holes.
4 Mix the ricotta and egg until well combined. Season with salt and freshly ground black pepper. Divide the capsicum strips among the muffin holes, top with 2 teaspoons pesto and spoon in the ricotta mixture.
5 Bake for 35–40 minutes, or until the ricotta is firm and golden. Cool, then unmould. Toast the bread slices and cut into fingers. Serve with the baked ricotta and the remaining pesto on the side.

NUTRITION PER SERVE
Fat 21 g; Protein 20 g; Carbohydrate 22 g; Dietary Fibre 2.5 g; Cholesterol 72 mg; 1530 kJ (365 Cal)

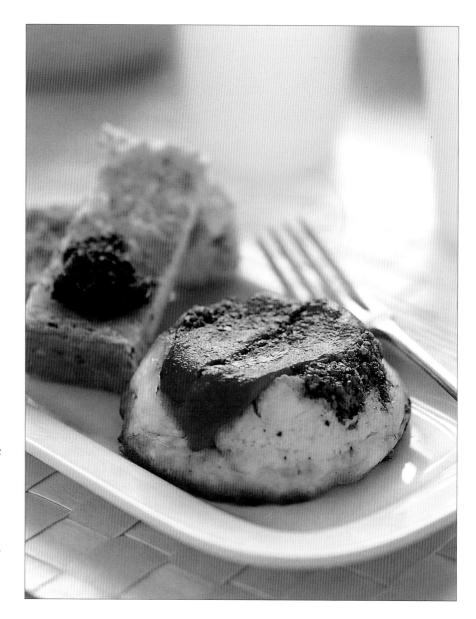

Grill the capsicum until blackened and blistered, then peel off the skin.

Top the capsicum strips with 2 teaspoons of the pesto mixture.

Bake the ricotta cakes until they are firm and golden.

OMELETTE WITH ASPARAGUS, SMOKED SALMON AND DILL

Preparation time: 10 minutes
Total cooking time: 10 minutes
Serves 2

6 egg whites
6 eggs
2 tablespoons low-fat ricotta cheese
2 tablespoons chopped dill
420 g (15 oz) fresh asparagus, cut into 5 cm (2 inch) lengths
100 g (3½ oz) smoked salmon, thinly sliced
lemon wedges, to garnish
sprigs of dill, to garnish

1 Whisk the egg whites until foaming. In a separate bowl, whisk the whole eggs and ricotta until combined. Add the whites. Season and stir in the dill.
2 Bring a saucepan of lightly salted water to the boil. Add the asparagus and cook for 1–2 minutes, or until tender but still firm to the bite. Drain and refresh in iced water.
3 Heat a non-stick 24 cm (9½ inch) frying pan over low heat. Spray lightly with oil spray. Pour in half egg mixture. Arrange half the asparagus on top. Cook over medium heat until the egg is just setting. Flip one side onto the other. Transfer to a serving plate. Repeat with remaining mixture.
4 To serve, top with smoked salmon and add lemon and a sprig of dill.

NUTRITION PER SERVE
Fat 19 g; Protein 49 g; Carbohydrate 4 g; Dietary Fibre 3 g; Cholesterol 595 mg; 1620 kJ (390 Cal)

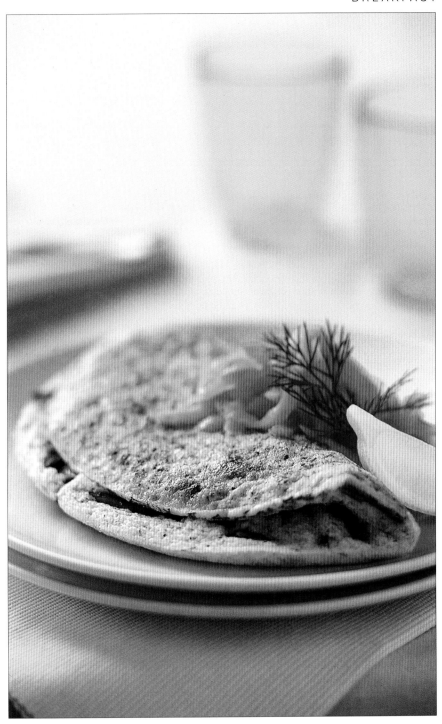

Whisk the egg whites in a clean dry bowl until foaming.

Place the asparagus pieces in iced water to stop them cooking.

Arrange half the asparagus pieces evenly over the egg mixture.

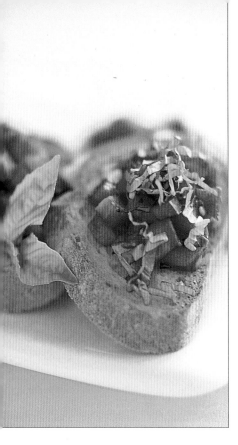
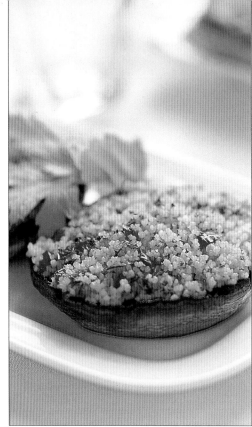

SNACKS

These tasty snacks are a mix of Mediterranean and eastern flavours, suitable for any social gathering. From a dinner party to a cocktail party, a table laden with these offerings will satisfy the fussiest of eaters.

BRUSCHETTA

Combine 4 chopped Roma (plum) tomatoes, 2 tablespoons olive oil, 1 tablespoon balsamic vinegar and 2 tablespoons chopped basil. Season well. Toast 8 slices of crusty Italian bread (day old is ideal) on one side. Rub toasted side lightly with a peeled clove of garlic. Top with the tomato and garnish with extra chopped basil. Serve immediately. Makes 8.

NUTRITION PER BRUSCHETTA
Fat 9 g; Protein 3.5 g; Carbohydrate 17 g; Dietary Fibre 2 g; Cholesterol 0 mg; 710 kJ (170 Cal)

STUFFED MUSHROOMS WITH SPICED COUSCOUS

Peel and remove the stalks from 8 field mushrooms, then grill top-side up. Place 95 g (½ cup) instant couscous, 1 tablespoon extra virgin olive oil, 1 teaspoon ground cumin, ¼ teaspoon cayenne pepper and 2 teaspoons finely grated lemon zest in a bowl. Season. Stir the flavourings through the couscous. Stir in 125 ml (½ cup) boiling chicken stock and cover. Leave for 5 minutes, then fluff the grains with a fork. Stir in 1 finely chopped tomato, 1 tablespoon lemon juice, 2 tablespoons chopped fresh parsley and 2 tablespoons chopped mint. Fill each of mushroom with the couscous mixture and pack down firmly. Grill until the couscous is golden. Serve hot or cold. Makes 8.

NUTRITION PER MUSHROOM
Fat 2 g; Protein 3 g; Carbohydrate 11 g; Dietary Fibre 1 g; Cholesterol 0 mg; 317 kJ (75 Cal)

PIZZETTE

Sift 125 g (1 cup) plain (all-purpose) flour into a bowl, then add 150 g (1 cup) wholemeal (whole-wheat) plain flour, 2 teaspoons dry yeast, ½ teaspoon sugar and ½ teaspoon salt. Make a well in the centre, add 125 ml (½ cup) water and 2 tablespoons natural yoghurt and mix to a dough. Knead on a lightly floured surface for 5 minutes, or until smooth and elastic. Cover with a tea towel and rest in a warm place for 20–30 minutes, or until doubled in size. Preheat the oven to 200°C (400°F/Gas 6). Punch the dough down and knead for 30 seconds, then divide into four portions. Roll each portion into a 15 cm (6 inch) round and place on a baking tray. Combine 2 tablespoons tomato paste (purée), 1 crushed clove garlic, 1 teaspoon dried oregano and 1 tablespoon water. Spread the paste over each base then top each with 20 g (½ oz) lean shaved ham and 2 teaspoons grated light mozzarella. Bake for 12–15 minutes, or until crisp and golden on the edges. Just before serving, top with chopped rocket (arugula) and drizzle with extra virgin olive oil. Makes 4.

NUTRITION PER PIZZETTE
Fat 5 g; Protein 17 g; Carbohydrate 45 g; Dietary Fibre 6 g; Cholesterol 23 mg; 1235 kJ (295 Cal)

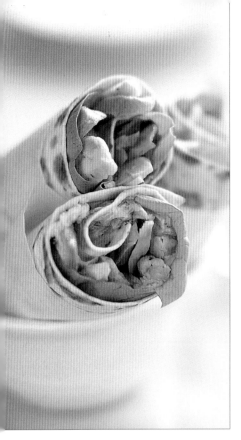
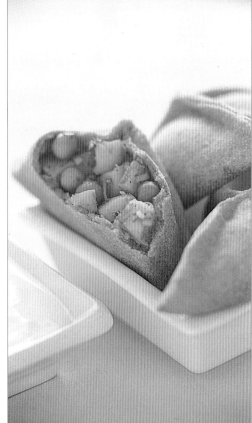
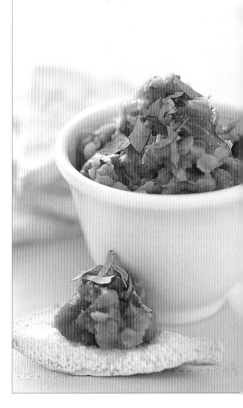

CHICKEN AND TZATZIKI WRAP

To make the tzatziki, seed and grate
¹/₂ telegraph (long) cucumber into a
bowl, then sprinkle with ¹/₂ teaspoon
salt. Leave for 10 minutes. Drain,
then mix with 100 g (3¹/₂ oz) low-fat
natural yoghurt, ¹/₄ teaspoon lemon
juice and 1 tablespoon chopped mint.
Season. Flatten 4 skinless and
trimmed chicken thigh fillets, season
and sprinkle with spicy paprika. Grill
for 5–7 minutes on each side. On
4 sheets of Lavash or other flat bread,
place a large butter lettuce leaf and
spread with ¹/₄ of the tzatziki. Top
with a sliced chicken fillet. Roll up,
folding one end closed. Repeat. Wrap
in baking paper to serve. Makes 4.

NUTRITION PER WRAP
Fat 13 g; Protein 40 g; Carbohydrate 38 g;
Dietary Fibre 3 g; Cholesterol 149 mg;
1830 kJ (435 Cal)

OVEN-BAKED SAMOSAS

Place in a bowl 300 g (2 cups)
wholemeal (whole-wheat) plain (all-
purpose) flour, 1 tablespoon canola oil,
60 g (¹/₄ cup) low-fat natural yoghurt
and ¹/₂ teaspoon salt. Rub the mixture
with your fingertips until it resembles
breadcrumbs. Add 2 tablespoons cold
water and mix to bring together,
adding a little more water if needed.
Turn out dough onto a lightly floured
surface. Knead for 1 minute, or until
smooth. Wrap and set aside to rest.
Dice 400 g (14 oz) new potatoes into
5 mm (¹/₄ inch) cubes; rinse. Steam
until tender. Transfer to a large bowl.
Add ¹/₂ teaspoon ground cumin,
¹/₂ teaspoon ground coriander,
¹/₂ teaspoon garam masala and a
pinch of chilli powder. Add 2 finely
sliced spring onions (scallions),
75 g (2¹/₂ oz) fresh peas, 2 teaspoons
lemon juice and 1 tablespoon
chopped coriander (cilantro) leaves
and mix. Season. Preheat oven to
180°C (350°F/Gas 4). Divide dough
into 8 portions. Roll out on a lightly
floured surface into a rough triangle
about 2 mm (¹/₈ inch) thick. Place
1 tablespoon of filling in the centre.
Bring each of the 3 points to the
centre. Press edges together to seal.
Remove any excess pastry. Place on a
baking tray lined with baking paper.
Lightly spray with canola oil spray.
Bake for 10 minutes or until golden
and crispy. Serve hot with low-fat
natural yoghurt. Makes 8.

NUTRITION PER SAMOSA
Fat 1.5 g; Protein 3 g; Carbohydrate 11 g;
Dietary Fibre 2 g; Cholesterol 0.5 mg;
280 kJ (65 Cal)

DHAL WITH PITTA CHIPS

Heat 2 teaspoons vegetable oil in a
saucepan over medium heat, add
¹/₂ finely chopped onion and 1 clove
crushed garlic and cook until
softened. Add ¹/₂ teaspoon each
cumin seeds, ground coriander,
paprika and garam masala and cook
for a further 10 seconds, or until
fragrant. Stir in 125 g (¹/₂ cup) red
lentils, then add 375 ml (1¹/₂ cups)
water and 125 g (¹/₂ cup) canned
chopped tomato. Bring to the boil,
reduce the heat and simmer for
12–15 minutes, or until the lentils are
very tender and most of the liquid
has been absorbed. Season. Garnish
with 2 tablespoons roughly chopped
coriander (cilantro) leaves.
Serves 4–6.
To make the pitta chips, preheat
the oven to 200°C (400°F/Gas 6).
Cut 2 wholemeal pitta pockets open,
to make 4 circles. Cut each circle into
8 wedges and lay out on a baking
tray—they should not overlap. Bake
for 5–8 minutes, or until crisp and
golden. Cool and serve with the dhal.
Makes 32.

NUTRITION PER SERVE (6)
Fat 3 g; Protein 8 g; Carbohydrate 22 g;
Dietary Fibre 5 g; Cholesterol 0 mg;
580 kJ (140 Cal)

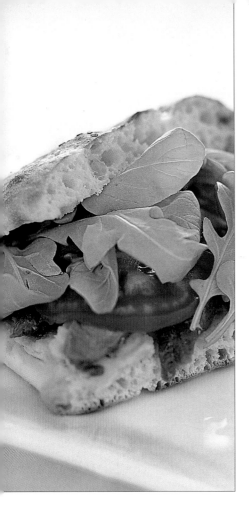
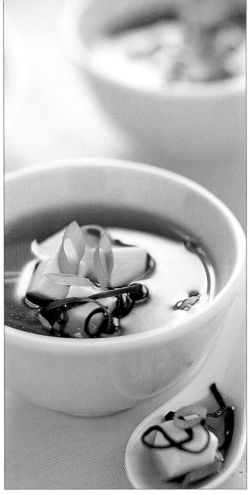
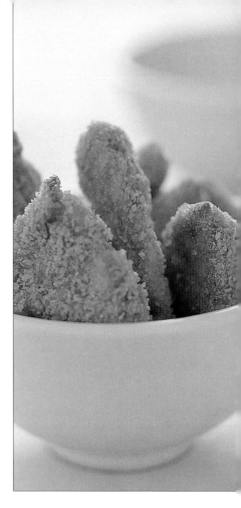

SNACKS

More healthy 'tiny meals'—roll ups, soups, nibblies and dips—your guests will thank you for these extra innovative healthy ideas.

LAMB PIDE WITH GARLIC AND CHICKPEA PUREE

Marinate 4 trimmed lamb fillets in 1 tablespoon lemon juice, 1 teaspoon ground cumin, 1 tablespoon olive oil and salt and pepper. Preheat the oven to 210°C (415°F/Gas 6–7). Wrap a bulb of garlic in foil, then roast for 20 minutes, or until soft. Cool, then squeeze out the pulp from each clove. Purée the pulp, 100 g (1/2 cup) drained canned chickpeas, 2 teaspoons lemon juice and 1 tablespoon low-fat plain yoghurt in a food processor—add a little water for a spreading consistency. Season. Grill (broil) or barbecue the lamb for 3 minutes on each side, or until done to your liking. Toast four 100 g (3 1/2 oz) pieces Turkish bread. Slice through the middle and spread with the chickpea spread. Top with thin slices of lamb, tomato and rocket leaves. Serves 4.

NUTRITION PER SERVE
Fat 11 g; Protein 33 g; Carbohydrate 49 g; Dietary Fibre 4.5 g; Cholesterol 66.5 mg; 1815 kJ (435 Cal)

MISO SOUP

Bring 1 teaspoon dashi granules and 800 ml (3 1/4 cups) water to the boil. Dissolve 2 1/2 tablespoons white or red miso in a little boiling water. Add to the stock. Place 50 g (1 3/4 oz) diced silken firm tofu and some shredded wakame seaweed in each bowl. Pour on stock. Garnish with finely sliced spring onion (scallion). Serves 4.

NUTRITION PER SERVE
Fat 2 g; Protein 3.5 g; Carbohydrate 3.5 g; Dietary Fibre 1 g; Cholesterol 0 mg; 185 kJ (45 Cal)

OVEN-BAKED CHICKEN NUGGETS WITH HONEY MUSTARD SAUCE

Preheat the oven to 200°C (400°F/Gas 6). Process 45 g (1 1/2 cups) cornflakes in a food processor to make fine crumbs. Cut 400 g (14 oz) chicken breast fillets into bite-sized pieces. Toss in seasoned flour then in lightly beaten egg white. Roll each piece in crumbs until well coated, Lightly spray a baking tray with canola spray and place the nuggets on it. Bake for 10–12 minutes. Combine 1 1/2 tablespoons honey and 2 tablespoons Dijon mustard and serve with the nuggets. Serves 4.

NUTRITION PER SERVE
Fat 4 g; Protein 24.5 g; Carbohydrate 17.5 g; Dietary Fibre 0.5 g; Cholesterol 50 mg; 850 kJ (205 Cal)

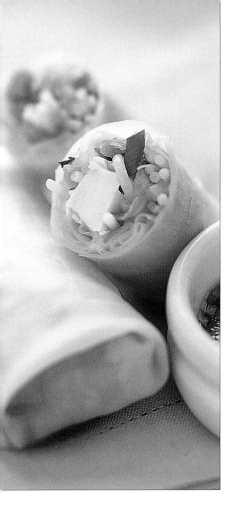

FRESH RICE PAPER ROLLS

Combine 100 g (3½ oz) firm tofu cut into batons, 50 g (⅓ cup) grated carrot, 50 g (⅓ cup) grated cucumber, 50 g (⅓ cup) grated white radish, 50 g (½ cup) bean sprouts, 50 g (⅓ cup) snow pea (mangetout) sprouts and 1 tablespoon each of chopped fresh garlic chives and mint. Soften 60 g (2¼ oz) thin rice stick noodles in boiling water. Drain. Snip into 5 cm (2 inch) lengths. Add to the vegetables. Combine 1 tablespoon sweet chilli sauce, 2 teaspoons lime juice and 2 teaspoons soy sauce and gently toss through the vegetables. Dip 8 round rice paper wrappers (one at a time) into warm water until soft. Drain. Place on a dry surface or tea towel. Place 2 tablespoons of filling on the front edge of the wrapper, spreading out evenly toward the middle. Fold the front edge over the filling and roll up, folding in sides. Repeat. Serve with dipping sauce, made of 1 tablespoon fish sauce, 2 teaspoons palm sugar, 1 tablespoon lime juice, 1 finely chopped red chilli and 2 teaspoons finely chopped lemon grass (white part only). Serves 4.

NUTRITION PER SERVE
Fat 2 g; Protein 7 g; Carbohydrate 23 g; Dietary Fibre 3 g; Cholesterol 0 mg; 590 kJ (140 Cal)

EGGPLANT DIP

Grill 2 whole eggplants (aubergines), turning occasionally, until the flesh is soft and the skin black and charred. Alternatively, roast in an oven heated to 200°C (400°F/Gas 6) for 50 minutes. Cool and peel off the skin. Drain the flesh in a colander for 20 minutes. Transfer to a food processor with 1 crushed garlic clove, ½ teaspoon Indian curry powder and ½ teaspoon ground cumin. Slowly add enough olive oil to blend until smooth. Season with salt and freshly ground pepper. Add lemon juice and chopped coriander (cilantro) to taste. Serve with fresh vegetable sticks. Serves 4–6.

NUTRITION PER SERVE (6)
Fat 2 g; Protein 1.5 g; Carbohydrate 3.5 g; Dietary Fibre 3 g; Cholesterol 1 mg; 155 kJ (35 Cal)

SUSHI HAND ROLLS

Rinse 200 g (1 cup) sushi rice until it runs clear. Put in a pan with 310 ml (1¼ cups) water and bring to the boil. Simmer, covered, over very low heat for 12 minutes, or until the water is absorbed. Remove from the heat. Leave for 15 minutes. Mix 2 tablespoons white rice vinegar, 1 tablespoon sugar and a pinch of salt until dissolved, then stir through the rice. Put in a bowl and cool. Cover with a damp cloth. Cut nori sheets into quarters. Put a square of nori in the palm of your hand and place 1½ tablespoons rice in the centre. Lightly spread wasabi over the rice and top with 2–3 fillings from a selection of thinly sliced sashimi tuna, cooked and peeled prawns (shrimp), fresh or smoked salmon, sliced cucumber, pickled daikon, sliced avocado and blanched English spinach. Roll into a cone shape and serve with Japanese soy sauce for dipping. Serves 4–6.

NUTRITION PER SERVE (6)
Fat 2 g; Protein 7 g; Carbohydrate 22 g; Dietary Fibre 2.5 g; Cholesterol 37.5 mg; 575 kJ (135 Cal)

MAIN MEALS

ROASTED VEGETABLE AND FETA SALAD

Preparation time: 20 minutes
Total cooking time: 50 minutes
Serves 4

150 g (5½ oz) reduced-fat feta
 cheese, grated
80 ml (⅓ cup) skim milk
3 tablespoons olive oil
6 Roma (plum) tomatoes, cut in half
 lengthways
400 g (14 oz) pumpkin, peeled,
 seeded and cut into large chunks
1 red onion, cut into eight wedges
4 small zucchini (courgettes), cut in half
8 cloves garlic, unpeeled
1 teaspoon thyme
50 g (1¾ oz) rocket (arugula) leaves
1 tablespoon pine nuts, toasted

1 To make the dressing, blend the feta and milk in a food processor for 20–30 seconds to combine well. Gradually pour in 1 tablespoon of the oil and process until combined. Season lightly with salt. Store in a sealed container in the refrigerator until ready to use.

2 Preheat the oven to 200°C (400°F/Gas 6). Place the tomatoes, pumpkin, onion, zucchini, garlic and thyme in a large bowl with the remaining olive oil and season with salt and freshly ground black pepper, then toss to coat. Arrange the vegetables on a greased baking tray and roast for 45–50 minutes, or until the pumpkin is cooked through. Remove all the vegetables and cool slightly.

3 Place the rocket leaves on a large serving platter and arrange the roasted vegetables on top. Spoon the feta dressing over the vegetables and sprinkle with pine nuts.

NUTRITION PER SERVE
Fat 22 g; Protein 16 g; Carbohydrate 12 g; Dietary Fibre 4.5 g; Cholesterol 23 mg; 1285 kJ (305 Cal)

Blend the grated feta and milk together in a food processor, then add the oil.

Toss the vegetables and thyme in the remaining oil and seasonings.

Roll the dough into long even-sized ropes, then cut it into pieces.

Place a piece of dough in your palm and press gently with the tines of a fork.

RICOTTA AND HERB GNOCCHI WITH FRESH TOMATO SAUCE

Preparation time: 40 minutes +
 1 hour chilling
Total cooking time: 30 minutes
Serves 4

Gnocchi
450 g (1 lb) reduced-fat ricotta cheese
35 g (1/3 cup) grated fresh Parmesan
 cheese
20 g (1/2 cup) chopped mixed fresh
 herbs (parsley, basil, chives,
 thyme, oregano)
pinch of nutmeg
120 g (11/2 cups) fresh white
 breadcrumbs
2 small eggs, beaten
plain (all-purpose) flour, for rolling

Tomato sauce
1 tablespoon olive oil
1 onion, finely chopped
2 cloves garlic, crushed
125 ml (1/2 cup) dry white wine
800 g (1lb 12 oz) ripe tomatoes,
 peeled, seeded and diced
1 tablespoon shredded basil

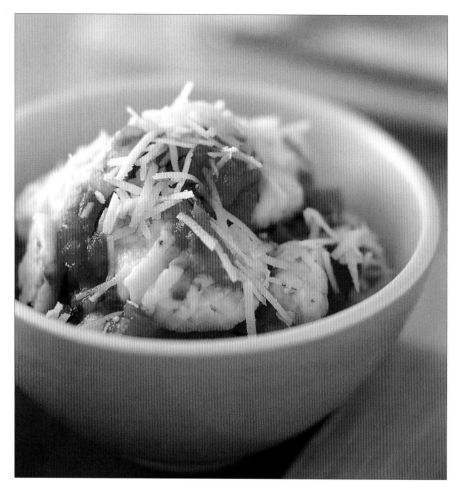

1 To make the gnocchi, combine the ricotta, Parmesan, herbs, nutmeg, breadcrumbs and egg in a bowl. Season well. Cover and chill for at least 1 hour.

2 To make the tomato sauce, heat the oil in a large frying pan. Add the onion and garlic and gently cook over low heat without browning for 6–7 minutes, or until softened. Add the wine, increase the heat and cook until it has almost evaporated. Add the tomato, reduce the heat to medium and simmer for 5–8 minutes, or until the sauce has reduced and thickened a little. Season well with salt and pepper, then stir in the basil. Keep warm.

3 Remove the gnocchi mixture from the refrigerator and transfer to a lightly floured work surface. Knead gently, working in a little flour if you find it is sticking to your hands—the dough should be light and soft, a little damp to touch, but not sticky. Take about one-fifth of the dough and roll it with your hands on the

lightly floured work surface to form a long, even rope the thickness of your ring finger. Cut into 2 cm (3/4 inch) pieces. Place a piece in the palm of your hand and, using the tines of a fork, press gently with your fingers, flipping the gnocchi as you do so—it will be rounded into a concave shell shape, ridged on the outer surface. Place on a tray lined with baking paper and continue with the remaining dough.

4 Cook the gnocchi in a large saucepan of boiling salted water in batches. The gnocchi are cooked when they all rise to the surface after 2–3 minutes. Remove with a slotted spoon and drain well. Keep warm while cooking the remainder.

5 Place the gnocchi in a serving bowl, spoon on the sauce. Garnish with extra grated Parmesan, if desired.

NUTRITION PER SERVE
Fat 20 g; Protein 23 g; Carbohydrate 24 g; Dietary Fibre 4 g; Cholesterol 133 mg; 1635 kJ (390 Cal)

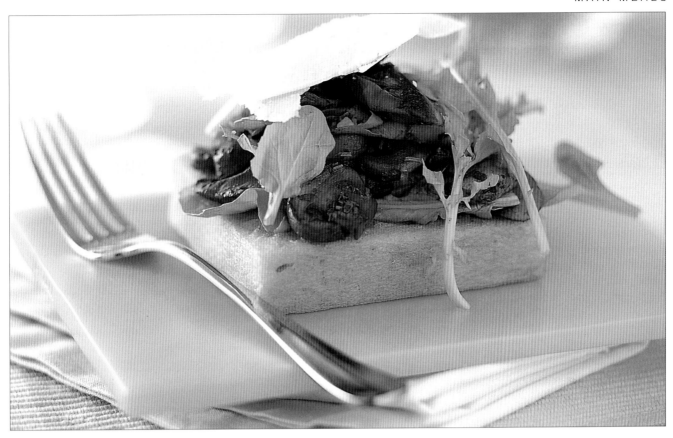

CRISP POLENTA WITH MUSHROOMS

Preparation time: 20 minutes +
 10 minutes soaking +
 30 minutes refrigeration
Total cooking time: 40 minutes
Serves 4

1 litre (4 cups) vegetable stock
150 g (1 cup) polenta
2 tablespoons low-fat margarine
1 tablespoon grated fresh Parmesan
 cheese
rocket (arugula), to serve
fresh Parmesan cheese, shaved,
 to serve

Mushroom sauce
10 g (1/4 oz) dried porcini mushrooms
1 tablespoon olive oil
800 g (1 lb 12 oz) mixed mushrooms
 (field, Swiss browns), thickly sliced
4 cloves garlic, finely chopped
2 teaspoons chopped thyme
185 ml (3/4 cup) dry white wine
125 ml (1/2 cup) vegetable stock
30 g (1/2 cup) chopped parsley

1 Bring the stock to the boil in a large saucepan. Add the polenta in a thin stream, stirring constantly. Simmer for 20 minutes over very low heat, stirring frequently, or until the mixture starts to leave the sides of the pan. Add the margarine and Parmesan. Season. Grease a shallow 20 cm (8 inch) square cake tin. Pour in the polenta, smooth the surface and refrigerate for 30 minutes, or until set.
2 For the mushroom sauce, soak the porcini mushrooms in 125 ml (1/2 cup) boiling water for 10 minutes, until soft. Drain, reserving 80 ml (1/3 cup) liquid.
3 Heat the oil in a large frying pan. Add mixed mushrooms. Cook over high heat for 4–5 minutes, or until soft. Add the porcini, garlic and thyme. Season and cook for 2–3 minutes. Add the wine. Cook until it has evaporated. Add the stock, then reduce the heat. Cook for a further 3–4 minutes, or until the stock has reduced and thickened. Add the parsley.
4 Cut the polenta into 4 squares and grill (broil) until golden on both sides. Place one on each serving plate and top with the mushrooms. Garnish with rocket and Parmesan shavings.

NUTRITION PER SERVE
Fat 11 g; Protein 15 g; Carbohydrate 35 g;
Dietary Fibre 7 g; Cholesterol 1.5 mg;
1390 kJ (330 Cal)

Cook the porcini and mixed mushrooms over high heat until softened.

Cook squares of polenta until golden on both sides.

BEEF TERIYAKI WITH CUCUMBER SALAD

Preparation time: 20 minutes +
 30 minutes refrigeration +
 10 minutes resting
Total cooking time: 20 minutes
Serves 4

4 scotch fillet steaks
80 ml (1/3 cup) soy sauce
2 tablespoons mirin
1 tablespoon sake (optional)
1 clove garlic, crushed
1 teaspoon grated fresh ginger
1 teaspoon sugar
1 teaspoon toasted sesame seeds

Cucumber salad

1 large Lebanese (short) cucumber,
 peeled, seeded and diced
1/2 red capsicum (pepper), diced
2 spring onions (scallions), sliced
 thinly on the diagonal
2 teaspoons sugar
1 tablespoon rice vinegar

1 Place the steaks in a non-metallic dish. Combine the soy, mirin, sake, garlic and ginger and pour over the steaks. Cover with plastic wrap and refrigerate for at least 30 minutes.
2 To make the cucumber salad, place the cucumber, capsicum and spring onion in a small bowl. Place the sugar, rice vinegar and 60 ml (1/4 cup) water in a small saucepan and stir over medium heat until the sugar dissolves. Increase the heat and simmer rapidly for 3–4 minutes, or until slightly thickened. Pour over the cucumber salad, stir to combine and leave to cool completely.
3 Spray a chargrill (griddle) or hot plate with oil spray and heat until very hot. Drain the steaks and reserve the marinade. Cook for 3–4 minutes on each side, or until cooked to your liking. Remove and rest the meat for 5–10 minutes before slicing.
4 Meanwhile, place the sugar and the reserved marinade in a small saucepan and heat, stirring, until the sugar has dissolved. Bring to the boil, then simmer for 2–3 minutes, remove from the heat and keep warm.

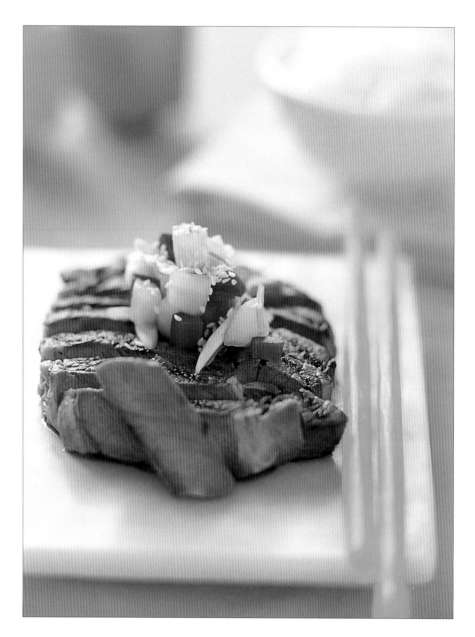

5 Slice each steak into 1 cm (1/2 inch) strips, being careful to keep the steak in its shape. Arrange the steak on each plate. Spoon on some of the marinade, a spoonful of cucumber salad and garnish with sesame seeds.

Serve with steamed rice and the remaining cucumber salad.

NUTRITION PER SERVE
Fat 5 g; Protein 23 g; Carbohydrate 6 g;
Dietary Fibre 1 g; Cholesterol 67 mg;
720 kJ (170 Cal)

Combine the cucumber, capsicum and spring onion with the dressing.

Cook the steaks for 3–4 minutes on each side, or until cooked to your liking.

Tear some of the cos lettuce leaves into small bite-sized pieces.

Bake the cubes of bread in a moderate oven until golden brown.

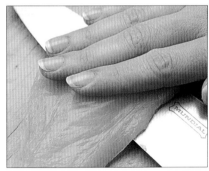

Cut the chicken breast in half, lengthways, with a sharp knife.

Whisk all the dressing ingredients together until well combined.

LOW-FAT CHICKEN CAESAR SALAD

Preparation time: 25 minutes
Total cooking time: 35 minutes
Serves 4

100 g (3½ oz) thickly sliced white bread, crusts removed
8 rashers lean bacon, rind removed (about 90 g or 3¼ oz)
500 g (1lb 2 oz) chicken breast fillet
¾ teaspoon garlic salt
1 cos (romaine) lettuce (reserve some leaves for serving and tear the remaining leaves into small pieces)
2 tablespoons grated fresh Parmesan cheese
4 anchovies, drained and chopped

Dressing
2 cloves garlic, crushed
2 teaspoons Worcestershire sauce
1 tablespoon Dijon mustard
1½ tablespoons lemon juice
2 anchovies, drained and finely chopped
2 tablespoons olive oil
½ teaspoon caster (superfine) sugar
Tabasco sauce, to taste

1 Preheat the oven to 180°C (350°F/Gas 4). Cut the bread slices into 1.5 cm (⅝ inch) cubes, then spread evenly on a baking tray. Bake for 12–15 minutes, or until golden brown. Allow to cool.
2 Cut the bacon into 5 mm (¼ inch) strips and place on a foil-lined baking tray. Cook for 10–12 minutes, or until lightly browned. Drain on paper towels and allow to cool.
3 Cut the chicken breast in half lengthways to form two thin schnitzels. Coat the chicken in the garlic salt, pressing firmly into the flesh. Cook under a hot grill for 3–4 minutes each side, or until just cooked. Remove and cool slightly.
4 To make the dressing, whisk all the ingredients until combined.
5 Arrange the reserved lettuce leaves in individual serving bowls, then divide the torn leaves among them. Slice the chicken breast on the diagonal and arrange on top of the lettuce. Pour the dressing over the chicken, then scatter the croutons and bacon on top. Sprinkle with the Parmesan and garnish each bowl with the chopped anchovies.

NUTRITION PER SERVE
Fat 20 g; Protein 37 g; Carbohydrate 14 g; Dietary Fibre 2 g; Cholesterol 102 mg; 1590 kJ (380 Cal)

Cut each baby bok choy into eighths with a sharp knife.

Cook the noodles until tender, drain and rinse, then drain again.

Stir-fry the chicken in the ginger and chilli mixture until browned and almost cooked.

SESAME CHICKEN AND SHANGHAI NOODLE STIR-FRY

Preparation time: 20 minutes
Total cooking time: 15 minutes
Serves 4

600 g (1 lb 5 oz) Shanghai noodles
1 tablespoon olive oil
1 tablespoon julienned fresh ginger
1 long red chilli, seeded and finely chopped
500 g (1lb 2 oz) chicken breast fillets, cut crossways into 1 cm (½ inch) slices
2 cloves garlic, crushed

60 ml (¼ cup) salt-reduced soy sauce
3 teaspoons sesame oil
700 g (1 lb 9 oz) baby bok choy (pak choi), sliced lengthways into eighths
2 tablespoons sesame seeds, toasted

1 Cook the noodles in a saucepan of boiling water for 4–5 minutes, or until tender. Drain and rinse under cold water. Drain again.
2 Heat the oil in a wok and swirl to coat. Add the ginger and chilli and stir-fry for 1 minute. Add the chicken

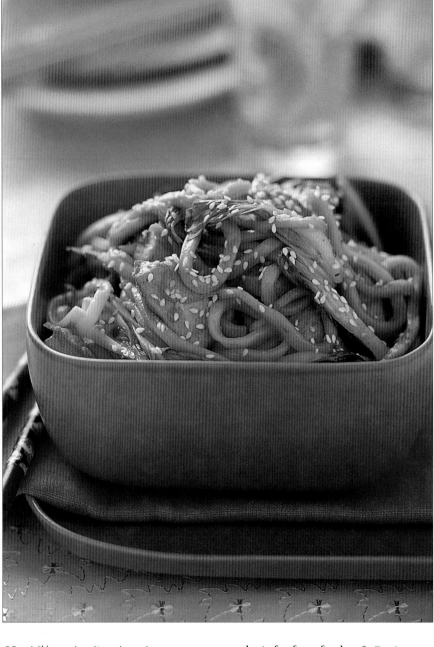

and stir-fry for a further 3–5 minutes, or until browned and almost cooked.
3 Add the garlic and cook for a further 1 minute. Pour in the soy sauce and sesame oil and toss to coat. Add the bok choy and noodles and stir-fry until the bok choy is tender and the noodles are warmed through. Place in individual serving bowls, sprinkle with sesame seeds and serve.

NUTRITION PER SERVE
Fat 19 g; Protein 45 g; Carbohydrate 80 g; Dietary Fibre 6 g; Cholesterol 102 mg; 2850 kJ (680 Cal)

LEAN PORK STEW WITH ASIAN FLAVOURS

Preparation time: 20 minutes
Total cooking time: 50 minutes
Serves 4

2 teaspoons oil
2 cloves garlic, crushed
1 tablespoon julienned fresh ginger
1 teaspoon Sichuan pepper, crushed
1 star anise
800 g (1 lb 12 oz) pork fillet, cut into
 3 cm (1¼ inch) cubes
250 ml (1 cup) chicken stock
1 tablespoon light soy sauce
1 tablespoon cornflour (cornstarch)
2 teaspoons chilli bean paste
250 g (9 oz) Chinese broccoli (gai lan),
 cut into 4 cm (1½ inch) lengths

1 Heat the oil in a heavy-based saucepan over high heat. Add the garlic, ginger, Sichuan pepper and star anise and cook for 30 seconds, or until fragrant. Stir in the pork to coat.
2 Add the stock, soy sauce and 250 ml (1 cup) water and bring to the boil. Reduce the heat and simmer for 40 minutes, or until the pork is tender. Combine the cornflour with 2 tablespoons of cooking liquid. Stir until smooth. Add to the pan and stir over medium heat for 3–4 minutes, or until the mixture thickens slightly.
3 Stir in the bean paste and Chinese broccoli and cook for a further 2 minutes, or until the broccoli is just tender. Serve with steamed rice.

NUTRITION PER SERVE
Fat 7 g; Protein 47 g; Carbohydrate 4 g;
Dietary Fibre 3 g; Cholesterol 190 mg;
1135 kJ (270 Cal)

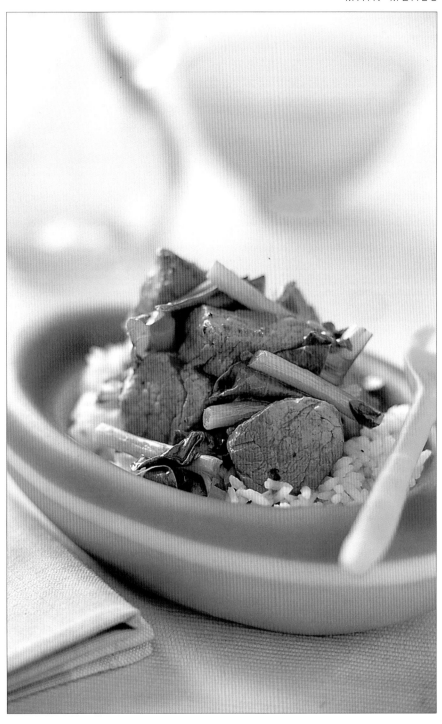

Crush the Sichuan pepper in a mortar and pestle.

Cut the Chinese broccoli into short lengths, using a sharp knife.

Stir the cornflour mixture into the stew until the mixture thickens slightly.

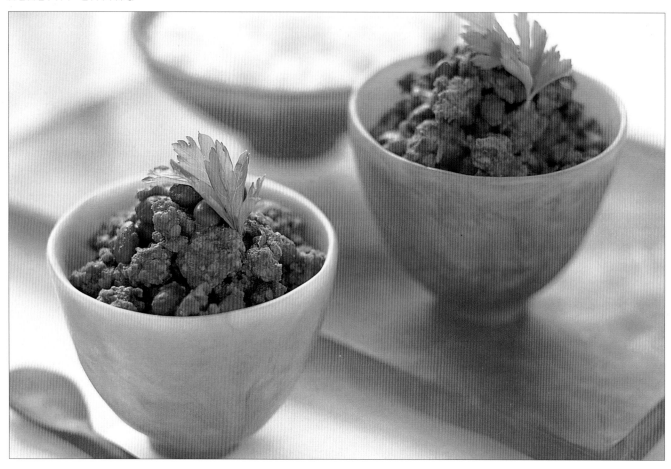

CHILLI CON CARNE

Preparation time: 15 minutes
Total cooking time: 1 hour 10 minutes
Serves 6

2 teaspoons olive oil
1 large onion, chopped
1 clove garlic, crushed
1 teaspoon cayenne pepper
2 teaspoons paprika
1 teaspoon dried oregano
2 teaspoons ground
 cumin

750 g (1 lb 10 oz) extra lean minced
 (ground) beef
375 ml (1½ cups) beef stock
400 g (14 oz) can diced tomatoes
125 g (½ cup) tomato paste (purée)
300 g (10½ oz) can kidney beans,
 drained and rinsed
sprigs of parsley, to garnish

1 Heat the oil in a saucepan over low heat. Add the onion and cook for 4–5 minutes, or until soft. Stir in the garlic, cayenne pepper, paprika, oregano, cumin and ½ teaspoon salt. Increase the heat to medium, add the minced beef and cook for 5–8 minutes, or until just browned.

2 Reduce the heat to low, add the stock, canned tomato and its juice and the tomato paste to the pan and cook for 35–45 minutes, stirring frequently.

3 Stir in the kidney beans and simmer for 10 minutes. Serve on its own in small bowls or over rice. Garnish with a sprig of parsley.

NUTRITION PER SERVE
Fat 11 g; Protein 30 g; Carbohydrate 12 g; Dietary Fibre 4.5 g; Cholesterol 63.5 mg; 1125 kJ (270 Cal)

Cook the chopped onion over low heat until it is transparent.

Add the beef to the onion mixture and cook until the meat is just browned.

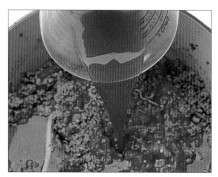

Add the canned tomato and its juice, tomato paste and the beef stock.

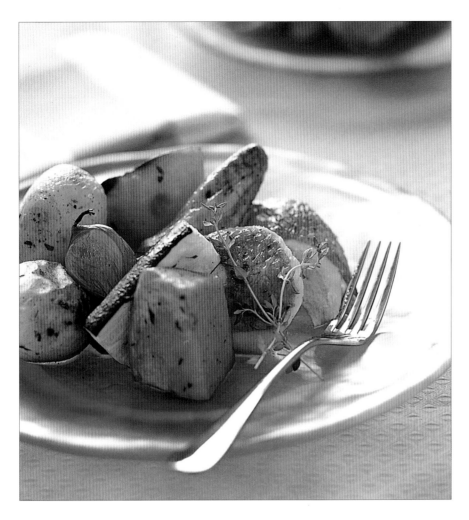

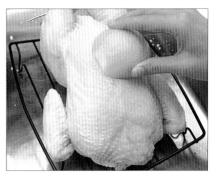

Cut the remaining lemon in half, then rub all over the chicken.

Test if the chicken is cooked by piercing between the body and the leg with a skewer.

Add all the vegetables, including the garlic, to the marinade and toss until coated.

LOW-FAT LEMON ROAST CHICKEN WITH ROASTED VEGETABLES

Preparation time: 20 minutes +
 10 minutes standing
Total cooking time: 1 hour 10 minutes
Serves 4

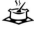

1.4 kg (3 lb 3 oz) whole chicken
2 bay leaves
2 lemons
2 sprigs lemon thyme
2 sprigs marjoram
1 tablespoon chopped lemon thyme
1 tablespoon chopped marjoram
3 tablespoons olive oil
12 new potatoes
300 g (10 1/2 oz) orange sweet potato, peeled and cut into 8 pieces
8 French shallots (eschalots), unpeeled
2 large zucchini (courgettes), halved lengthways and halved again widthways
8 whole cloves garlic, unpeeled

1 Preheat the oven to 200°C (400°F/ Gas 6). Pat the chicken dry with paper towels and place on a rack in a deep roasting tin. Season the cavity and place the bay leaves, 1 whole lemon, and the thyme and marjoram sprigs inside. Cut the remaining lemon in half and rub all over the chicken—cut the lemon into quarters and reserve. Season lightly and roast, basting every 20 minutes with the pan juices, for 1 hour 10 minutes, or until browned and the juices run clear when pierced between the thigh and the body. Cover lightly with foil. Stand for 5–10 minutes before carving.
2 Meanwhile, combine the chopped thyme and marjoram with the oil, salt, pepper and the reserved lemon in a large bowl. Add all the vegetables and the garlic and toss until well coated. Lift out the zucchini and the garlic and set aside.
3 Put the new potatoes, orange sweet potato and French shallots in a single layer on a large baking tray.

Place in the oven, 15 minutes after the chicken. Roast for 25 minutes, then add the zucchini (cut-side down) and garlic. Cook for a further 25 minutes, or until golden and tender, turning occasionally to ensure they don't burn. Discard the lemon wedges. Carve the chicken and serve with roast vegetables.

NUTRITION PER SERVE
Fat 23 g; Protein 46 g; Carbohydrate 37 g; Dietary Fibre 7.5 g; Cholesterol 180 mg; 2280 kJ (545 Cal)

COOK'S FILE
Note: Keeping the skins on the garlic and French shallots prevents them from burning during cooking.

53

Gradually add the oil in a steady stream to the herb mixture until well combined.

VEGETABLE SKEWERS WITH SALSA VERDE

Preparation time: 20 minutes +
 30 minutes soaking
Total cooking time: 40 minutes
Serves 8

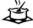

Salsa verde
1 clove garlic
1 tablespoon drained capers
20 g (1 cup) flat-leaf
 (Italian) parsley
15 g (1/2 cup) basil
10 g (1/2 cup) mint
80 ml (1/3 cup) olive oil
1 teaspoon Dijon mustard
1 tablespoon red wine vinegar

16 small yellow squash
16 baby carrots, peeled
16 French shallots (eschalots), peeled
1 large red capsicum (pepper), halved
 and cut into 2 cm (3/4 inch) thick slices
16 baby zucchini (courgettes)
2 cloves garlic, crushed
1 teaspoon chopped thyme
1 tablespoon olive oil
16 bay or sage leaves

1 Soak 16 wooden skewers in cold water for 30 minutes to prevent them from burning during cooking.
2 To make the salsa verde, combine the garlic, capers and herbs in a food processor until the herbs are roughly chopped. With the motor running, pour the olive oil in a slow stream until incorporated. Combine the mustard with the red wine vinegar and stir through the salsa verde. Season. Cover with plastic wrap and refrigerate.
3 Blanch the vegetables separately in a large pot of boiling, salted water until just tender. Drain in a colander, then toss with the garlic, thyme and oil. Season well.
4 Thread the vegetables onto the skewers starting with a squash, then a French shallot, a bay leaf then the zucchini, carrot and capsicum. Repeat to make 16 skewers in total.
5 Place the skewers on a hot grill and cook for 3 minutes on each side, or until cooked and browned. Arrange on couscous or rice and serve with the salsa verde.

NUTRITION PER SERVE
Fat 11 g; Protein 3 g; Carbohydrate 5 g; Dietary Fibre 3.5 g; Cholesterol 0 mg; 525 kJ (125 Cal)

GRILLED LAMB PITTAS WITH FRESH MINT SALAD

Preparation time: 20 minutes +
 30 minutes refrigeration
Total cooking time: 15 minutes
Serves 4

1 kg (2 lb 4 oz) lean minced (ground) lamb
60 g (1 cup) finely chopped parsley
25 g (1/2 cup) finely chopped mint
1 onion, finely chopped
1 clove garlic, crushed
1 egg
1 teaspoon chilli sauce
4 small wholemeal pitta pockets

Mint salad
3 small vine-ripened tomatoes
1 small red onion, finely sliced
20 g (1 cup) mint
1 tablespoon olive oil
2 tablespoons lemon juice

1 Place the lamb, parsley, mint, onion, garlic, egg and chilli sauce in a large bowl and mix together. Shape into eight small patties. Chill for 30 minutes. Preheat the oven to 160°C (315°F/Gas 2–3).

2 To make the mint salad, slice the tomatoes into thin rings and place in a bowl with the onion, mint, olive oil and lemon juice. Season well with salt and pepper. Gently toss to coat.

3 Wrap the pitta breads in foil and warm in the oven for 5–10 minutes.

4 Heat a chargrill (griddle) or hot plate and brush with a little oil. When very hot, cook the patties for 3 minutes on each side. Do not turn until a nice crust has formed on the base or they will fall apart.

5 Remove the pitta breads from the oven. Cut the pockets in half, fill each half with some mint salad and a lamb patty. Serve with some low-fat yoghurt, if desired.

NUTRITION PER SERVE
Fat 24 g; Protein 59 g; Carbohydrate 29 g; Dietary Fibre 8 g; Cholesterol 211 mg; 2390 kJ (570 Cal)

Mix the lamb, herbs, onion, garlic, egg and chilli sauce together with your hands.

Toss together the tomato and onion slices, mint, oil and lemon juice.

Chargrill the patties on a lightly oiled surface until a crust has formed.

SWORDFISH SKEWERS WITH WHITE BEAN PUREE

Preparation time: 25 minutes +
 30 minutes soaking +
 30 minutes marinating
Total cooking time: 20 minutes
Serves 4

1 kg (2 lb 4 oz) swordfish steaks, cut
 into 3 cm (1¼ inch) cubes
1 tablespoon olive oil
2 tablespoons lemon juice
1 clove garlic, crushed
1 tablespoon chopped rosemary
1 tablespoon chopped thyme
2 tablespoons chopped
 flat-leaf (Italian) parsley

White bean purée
2 x 400 g (14 oz) cans cannellini
 beans
375 ml (1½ cups) chicken stock
2 bay leaves
2 cloves garlic, crushed
1 teaspoon chopped thyme
½ teaspoon finely grated lemon zest
60 ml (¼ cup) extra virgin olive oil

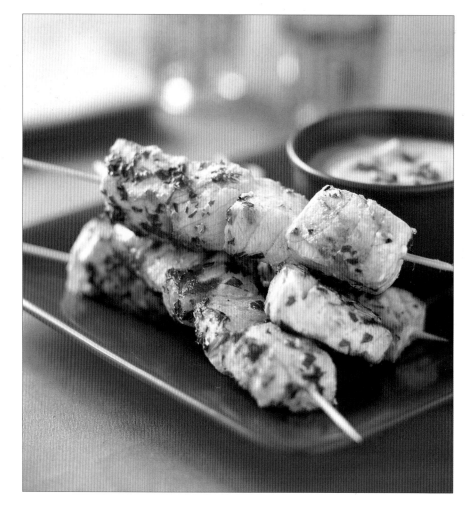

1 Soak eight wooden skewers in water for at least 30 minutes. Thread the swordfish cubes onto the skewers. Place in a large non-metallic dish and pour on the combined olive oil, lemon juice, garlic, rosemary and thyme. Season well. Cover with plastic wrap and refrigerate for at least 30 minutes.
2 Meanwhile, to make the white bean purée, wash the beans in a colander and place in a large saucepan. Add the chicken stock, bay leaves and 125 ml (½ cup) water. Bring to the boil, then reduce the heat and simmer for 10 minutes. Remove from the heat and drain well, reserving 2 tablespoons of the liquid.
3 Place the beans and the reserved liquid in a food processor or blender with the garlic, thyme and lemon zest. Season with salt and pepper and process until smooth. With the motor running, gradually pour in the olive oil in a thin stream. Continue processing until well combined, then keep warm.

4 Heat a chargrill (griddle) or hot plate until very hot. Cook the skewers, turning regularly and basting with any leftover marinade, for 3–4 minutes, or until cooked through and golden.
5 Serve the skewers warm, sprinkled with parsley and a spoonful of white bean purée on the side.

NUTRITION PER SERVE
Fat 21 g; Protein 62 g; Carbohydrate 18 g; Dietary Fibre 9 g; Cholesterol 147 mg; 2115 kJ (505 Cal)

Drain the beans over a heatproof bowl and reserve some of the liquid.

Process the beans, garlic, thyme and lemon zest, then the oil, in a food processor.

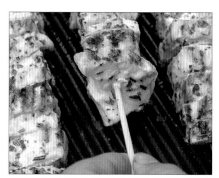

Chargrill the swordfish skewers until cooked through and golden.

Stir the garlic, peas and mint into the stock and leek mixture.

Stir in the cream, nutmeg and grated Parmesan.

TAGLIATELLE WITH ASPARAGUS, PEAS AND HERB SAUCE

Preparation time: 20 minutes
Total cooking time: 25 minutes
Serves 4

375 g (13 oz) dried or 500 g (1 lb 2 oz) fresh tagliatelle
250 ml (1 cup) chicken or vegetable stock
2 leeks (white part only), thinly sliced
3 cloves garlic, crushed
235 g (1½ cups) shelled fresh peas
1 tablespoon finely chopped mint
400 g (14 oz) asparagus spears, trimmed and cut into 5 cm (2 inch) lengths
15 g (¼ cup) finely chopped parsley
30 g (½ cup) shredded basil
80 ml (⅓ cup) light cream
pinch nutmeg
1 tablespoon grated fresh Parmesan cheese
2 tablespoons extra virgin olive oil

1 Bring a large saucepan of salted water to the boil and cook the tagliatelle until *al dente*. Drain well.

2 Place 125 ml (½ cup) of the stock and the leek in a large, deep, frying pan. Cook over low heat, stirring often, for 4–5 minutes. Stir in the garlic, peas and mint and cook for 1 minute. Add the remaining stock and 125 ml (½ cup) water and bring to the boil. Simmer for 5 minutes. Add the asparagus, parsley and basil and season well with salt and freshly ground black pepper. Simmer for a further 3–4 minutes, or until the asparagus is just tender. Gradually increase the heat to reduce the sauce to a light coating consistency, if necessary. Stir in the cream, nutmeg and Parmesan and adjust the seasonings to taste.

3 Add the tagliatelle to the sauce and toss lightly to coat. Divide among individual serving bowls. Drizzle with the extra virgin olive oil. Garnish with extra grated Parmesan, if desired.

NUTRITION PER SERVE
Fat 11 g; Protein 21 g; Carbohydrate 76 g; Dietary Fibre 9 g; Cholesterol 32 mg; 2080 kJ (495 Cal)

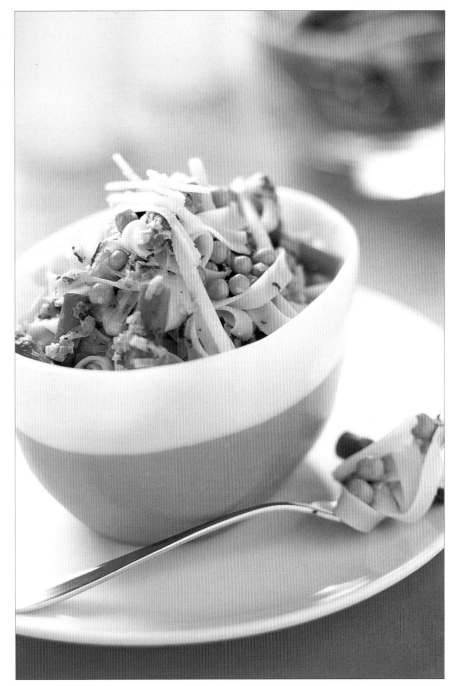

JACKET POTATOES

There's nothing quite as satisfying as a baked potato with toppings. Full of carbohydrates and fibre, the potato itself has many good nutritional qualities. Remember, it's the lashings of full-fat cheese and sour cream that will send the fat meter soaring, so try these low-fat ideas instead.

BAKING YOUR POTATO

Preheat the oven to 210°C (415°F/Gas 6–7). Scrub 4 large potatoes clean, dry and pierce all over with a fork. Bake directly on the oven rack for 1 hour, or until tender when tested with a skewer. Leave to stand for about 2 minutes. Cut a cross in the top of each cooked potato and squeeze gently from the base to open (if the potato is still too hot, hold the potato in a clean tea towel). The following toppings all serve 4.

AVOCADO TOMATO AND CORN SALSA

Remove the seeds from 2 vine-ripened tomatoes and chop. Place the tomato in a bowl with 125 g (4½ oz) can corn kernels, 2 chopped spring onions (scallions), 1 tablespoon lime juice and ½ teaspoon sugar and mix well. Add 1 diced avocado and 15 g (¼ cup) chopped coriander (cilantro) leaves. Season. Spoon mixture onto each potato and, if desired, dollop with 1 tablespoon low-fat sour cream.

NUTRITION PER SERVE
Fat 15 g; Protein 7 g; Carbohydrate 33 g; Dietary Fibre 7.5 g; Cholesterol 0 mg; 1245 kJ (300 Cal)

MUSHROOM AND BACON

Fry 3 trimmed and finely sliced bacon rashers in a non-stick frying pan until lightly golden. Add 1 clove crushed garlic, 2 chopped spring onions (scallions), 1 teaspoon chopped thyme and 180 g (2 cups) sliced button mushrooms. Cook over high heat for 3–4 minutes, or until the liquid has evaporated. Add 185 g (¾ cup) low-fat sour cream and season well. Reduce the heat to low. Cook for one further minute. Stir in 2 tablespoons chopped parsley. Spoon the mixture onto each potato. Sprinkle with extra chopped parsley and grated low-fat cheese.

NUTRITION PER SERVE
Fat 13 g; Protein 14 g; Carbohydrate 29 g; Dietary Fibre 6 g; Cholesterol 45 mg; 1195 kJ (285 Cal)

COTTAGE PIE POTATOES

Spray a deep frying pan lightly with oil spray. Place over medium heat. Add 1 finely chopped onion, 1 clove crushed garlic, 1 chopped carrot and 1 chopped celery stick. Cook until just soft. Add 250 g (9 oz) lean minced (ground) lamb. Cook for 2–3 minutes,

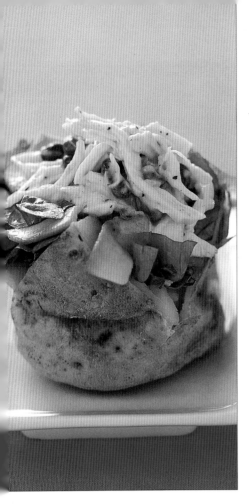
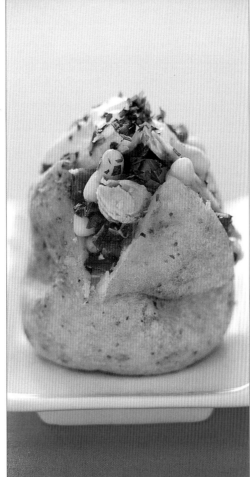
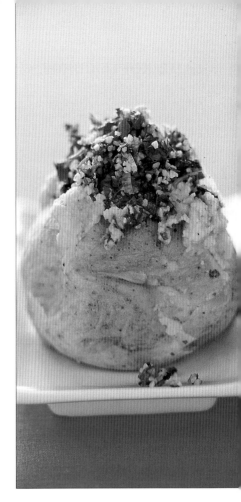

or until it changes colour. Add 400 g (14 oz) canned tomatoes, 1 tablespoon Worcestershire sauce, 1 tablespoon tomato paste (purée) and 125 ml (1/2 cup) water. Cook for 20–25 minutes, or until thickened and reduced. Add 80 g (1/2 cup) frozen peas and 2 tablespoons chopped parsley. Simmer for another 5 minutes. Season. Spoon the mixture onto each potato and serve.

NUTRITION PER SERVE
Fat 5 g; Protein 20 g; Carbohydrate 34 g; Dietary Fibre 8 g; Cholesterol 43 mg; 1115 kJ (265 Cal)

CHICKEN, ROCKET AND BABY CAPER SALAD

Bring 500 ml (2 cups) chicken stock to the boil in a small saucepan. Add 2 chicken breasts, reduce the heat and simmer, covered, for 5 minutes. Remove the pan from the heat and cool the chicken breasts in the liquid. Shred the meat into a bowl. Add 2 tablespoons low-fat mayonnaise, 1 teaspoon grated lemon zest and 1 tablespoon baby capers. Season. Toss 135 g (3 cups) roughly shredded

rocket (arugula) with 1 tablespoon extra virgin olive oil, 1 tablespoon balsamic vinegar and 1 thinly sliced avocado. Stuff into each potato. Top with the chicken mixture. Season.

NUTRITION PER SERVE
Fat 21 g; Protein 36 g; Carbohydrate 28 g; Dietary Fibre 5.5 g; Cholesterol 96.5 mg; 1880 kJ (450 Cal)

SMOKED TUNA AND WHITE BEAN SALSA

Drain 100 g (3 1/2 oz) can smoked tuna, reserving 1 tablespoon of its oil. Heat the oil in a frying pan and cook 3 finely chopped spring onions (scallions) and 2 crushed garlic cloves over low heat for 1 minute, or until softened. Add 400 g (14 oz) can cannellini beans (rinsed and drained) and cook for a further 3–4 minutes, or until the beans are warmed through. Remove from the heat and add 2 tablespoons chopped basil, 2 tablespoons chopped mint, 1 tablespoon lemon juice and 1 seeded and chopped vine-ripened tomato and combine well. Add the tuna and season with salt and freshly

ground black pepper. Spoon the mixture onto each potato. Garnish with low-fat sour cream and chopped fresh flat-leaf (Italian) parsley.

NUTRITION PER SERVE
Fat 5 g; Protein 15 g; Carbohydrate 34 g; Dietary Fibre 9 g; Cholesterol 10 mg; 980 kJ (235 Cal)

TABBOULEH AND HUMMUS POTATOES

Soak 45 g (1/4 cup) burghul (bulgar) in 60 ml (1/4 cup) water for 15 minutes, or until all the water has been absorbed. Place in a bowl with 30 g (1/2 cup) chopped parsley, 25 g (1/2 cup) chopped mint, 2 finely sliced spring onions (scallions), 1 finely chopped tomato, 2 tablespoons olive oil and 2 tablespoons lemon juice. Season well with salt and freshly ground black pepper. Dollop 1–2 tablespoons low-fat hummus onto each potato and top with the tabbouleh.

NUTRITION PER SERVE
Fat 13 g; Protein 8 g; Carbohydrate 33 g; Dietary Fibre 8 g; Cholesterol 0 mg; 1175 kJ (280 Cal)

LAMB KOFTA CURRY

Preparation time: 25 minutes
Total cooking time: 35 minutes
Serves 4

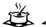

500 g (1 lb 2 oz) lean minced
 (ground) lamb
1 onion, finely chopped
1 clove garlic, finely chopped
1 teaspoon grated fresh ginger
1 small chilli, finely chopped
1 teaspoon garam masala
1 teaspoon ground coriander
45 g (¼ cup) ground almonds
2 tablespoons chopped coriander
 (cilantro) leaves

Sauce
½ tablespoon oil
1 onion, finely chopped
3 tablespoons Korma curry paste
400 g (14 oz) can chopped tomatoes
125 g (½ cup) low-fat plain yoghurt
1 teaspoon lemon juice

1 Combine the lamb, onion, garlic, ginger, chilli, garam masala, ground coriander, ground almonds and 1 teaspoon salt in a bowl. Shape into walnut-sized balls with your hands.
2 Heat a large non-stick frying pan and cook the koftas in batches until brown on both sides—they don't have to be cooked all the way through.
3 Meanwhile, to make the sauce, heat the oil in a saucepan over low heat. Add the onion and cook for 6–8 minutes, or until soft and golden. Add the curry paste and cook until fragrant. Add the chopped tomatoes and simmer for 5 minutes. Stir in the yoghurt (1 tablespoon at a time) and the lemon juice until combined.
4 Place koftas in the tomato sauce. Cook, covered, over low heat for 20 minutes. Serve over steamed rice and garnish with chopped coriander.

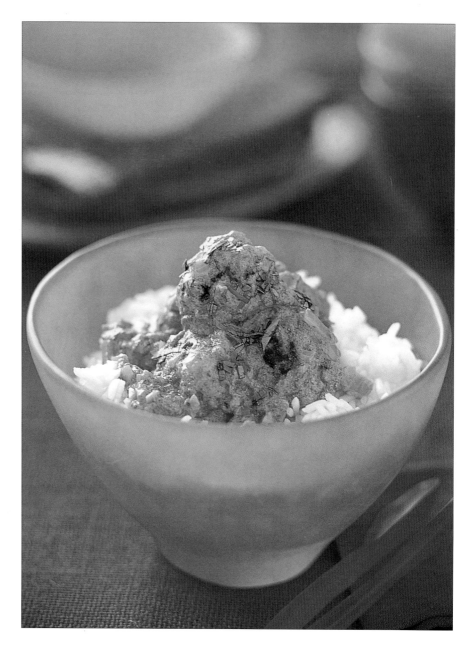

NUTRITION PER SERVE
Fat 23 g; Protein 32 g; Carbohydrate 10 g; Dietary Fibre 5 g; Cholesterol 88 mg; 1575 kJ (375 Cal)

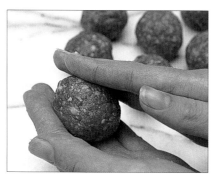

Roll the lamb mixture into walnut-sized balls with your hands.

Add the chopped tomatoes and simmer for 5 minutes.

Add the koftas to the tomato sauce and cook over low heat for 20 minutes.

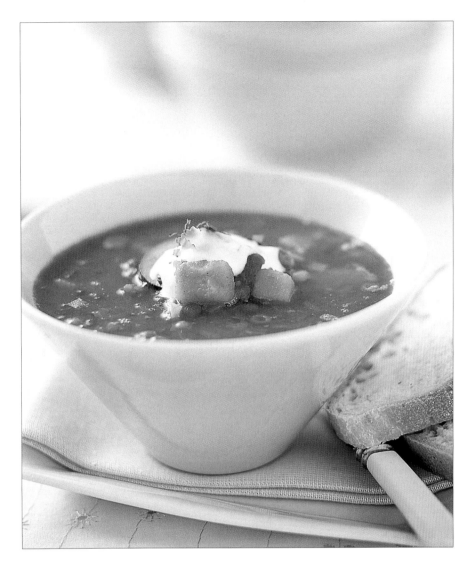

Stir in the curry powder, cumin and garam masala and cook until fragrant.

Simmer the lentils and vegetables over low heat until the lentils are tender.

Combine the yoghurt, coriander, garlic and Tabasco sauce.

LENTIL AND VEGETABLE SOUP WITH SPICED YOGHURT

Preparation time: 30 minutes
Total cooking time: 40 minutes
Serves 6

2 tablespoons olive oil
1 small leek (white part only), chopped
2 cloves garlic, crushed
2 teaspoons curry powder
1 teaspoon ground cumin
1 teaspoon garam masala
1 litre (4 cups) vegetable stock
1 bay leaf
185 g (1 cup) brown lentils
450 g (1 lb) butternut pumpkin (squash), peeled and cut into 1 cm (1/2 inch) cubes
2 zucchini (courgettes), cut in half lengthways and sliced
400 g (14 oz) can chopped tomatoes
200 g (7 oz) broccoli, cut into small florets
1 small carrot, diced
80 g (1/2 cup) peas
1 tablespoon chopped mint

Spiced yoghurt
250 g (1 cup) thick plain yoghurt
1 tablespoon chopped coriander (cilantro) leaves
1 clove garlic, crushed
3 dashes Tabasco sauce

1 Heat the oil in a saucepan over medium heat. Add the leek and garlic and cook for 4–5 minutes, or until soft and lightly golden. Add the curry powder, cumin and garam masala and cook for 1 minute, or until fragrant.
2 Add the stock, bay leaf, lentils and pumpkin. Bring to the boil, then reduce the heat to low and simmer for 10–15 minutes, or until the lentils are tender. Season well.
3 Add the zucchini, tomatoes, broccoli, carrot and 500 ml (2 cups) water and simmer for 10 minutes, or until the vegetables are tender. Add the peas and simmer for 2–3 minutes.
4 To make the spiced yoghurt, place the yoghurt, coriander, garlic and Tabasco in a small bowl and stir until combined. Dollop a spoonful of the yoghurt on each serving of soup and garnish with the chopped mint.

NUTRITION PER SERVE
Fat 10 g; Protein 17 g; Carbohydrate 26 g; Dietary Fibre 10 g; Cholesterol 6.5 mg; 1100 kJ (260 Cal)

SHREDDED SICHUAN CHICKEN AND NOODLE SALAD

Preparation time: 20 minutes
Total cooking time: 40 minutes
Serves 4

4 cm x 4 cm (1¹/2 inch x 1¹/2 inch)
 piece fresh ginger, thinly sliced
5 spring onions (scallions)
2 chicken breasts on the bone
 (skin on)
1 teaspoon Sichuan peppercorns
 (or whole black peppercorns)
250 g (9 oz) Shanghai noodles
1 teaspoon sesame oil
1 tablespoon light soy sauce
2 Lebanese (short) cucumbers, cut in
 half lengthways and thinly sliced
1¹/2 tablespoons lime juice
15 g (¹/2 cup) coriander (cilantro)
 leaves
lime wedges, to serve

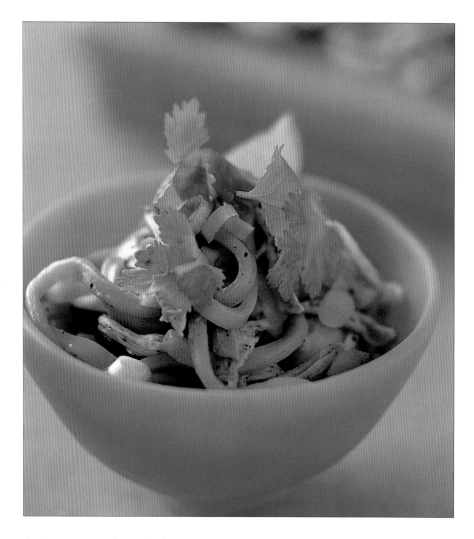

1 Bring a large saucepan of water to the boil. Add the ginger, 2 spring onions, thinly sliced, and 2 teaspoons salt and simmer for 10 minutes. Add the chicken and simmer gently for 15–20 minutes. Remove the chicken from the pan. When cool enough to handle, remove the skin and bones, then finely shred the flesh—there should be about 300 g (10¹/2 oz) of shredded chicken. Place in a bowl and cover with plastic wrap. Refrigerate until ready to use.
2 Heat the peppercorns and 1 teaspoon salt in a small non-stick frying pan over medium–high heat. Dry roast, stirring constantly, for 5 minutes, or until the salt begins to

darken. Remove from the heat and cool. When cool, grind the salt and pepper mixture in a spice grinder or mortar and pestle, until very fine.
3 Cook the noodles in a saucepan of boiling water for 4–5 minutes, or until tender. Drain well and rinse under cold water. Place the noodles in a large bowl and toss with the sesame oil and soy sauce.
4 Sprinkle the spice mixture on the chicken and toss well. Cover as much

of the chicken as possible with the spice mixture. Thinly slice the remaining spring onions, then add to the chicken mixture with the cucumber and toss well. Add the chicken mixture and lime juice to the noodles and toss. Top with coriander and serve with lime wedges.

NUTRITION PER SERVE
Fat 5 g; Protein 28 g; Carbohydrate 34 g;
Dietary Fibre 2 g; Cholesterol 77 mg;
1255 kJ (300 Cal)

Remove the skin and bones from the chicken breasts and shred the flesh.

Toss the Shanghai noodles, sesame oil and soy sauce in a large bowl.

Add the cucumber and spring onion to the seasoned chicken and toss well.

STUFFED SQUID WITH TOMATO SAUCE

Preparation time: 30 minutes
Total cooking time: 1 hour 30 minutes
Serves 4

100 g (½ cup) long-grain rice
1 teaspoon olive oil
4 spring onions (scallions), chopped
2 cloves garlic, crushed
40 g (¼ cup) pine nuts
50 g (⅓ cup) currants
2 tablespoons chopped flat-leaf
 (Italian) parsley
2 teaspoons finely grated lemon zest
2 teaspoons lemon juice
8 small–medium (450 g or 1 lb)
 cleaned squid tubes

Tomato sauce
3 teaspoons olive oil
1 onion, sliced
2 cloves garlic, crushed
1 bird's-eye chilli, chopped
2 teaspoons paprika
125 ml (½ cup) white wine
2 x 420 g (15 oz) cans crushed
 tomatoes
1 fresh bay leaf
10 g (¼ cup) chopped flat-leaf
 (Italian) parsley

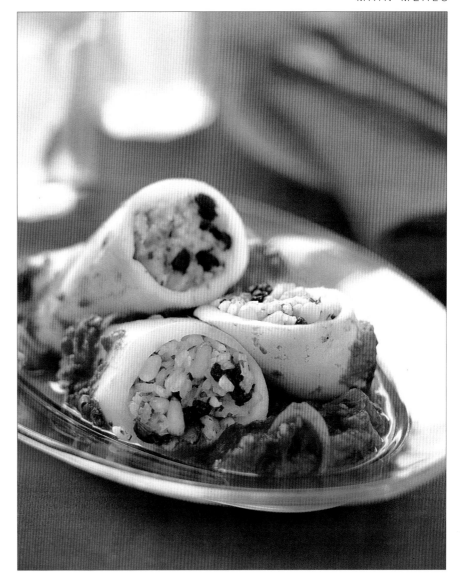

1 Cook the rice in a large saucepan of boiling water for 12 minutes, stirring occasionally. Drain and cool.
2 Heat the oil in a saucepan. Add the spring onion and garlic and cook over low heat for 1–2 minutes, or until softened. Add the cooked rice, pine nuts, currants, parsley, lemon zest and lemon juice. Season, then remove from the pan and cool.
3 To make the tomato sauce, heat the oil in a heavy-based saucepan. Add the onion and cook over low heat for 6–8 minutes, or until soft and lightly golden. Add the garlic and chilli and cook for another 1 minute. Add the paprika and cook for a further 1 minute. Add the wine, and cook for 2 minutes, or until reduced by half. Add the tomato and bay leaf, bring to the boil, then reduce the heat and simmer for 30 minutes, stirring occasionally. Stir in the parsley and

season. Discard the bay leaf.
4 Preheat the oven to 180°C (350°F/Gas 4). Spoon the cooled rice mixture evenly into the squid tubes and secure the ends with a toothpick.
5 Place the squid in an ovenproof ceramic dish and pour the tomato sauce on top. Bake for 30 minutes,

or until the squid is tender. Cut the squid on the diagonal, remove the toothpicks and serve with the sauce.

NUTRITION PER SERVE
Fat 10 g; Protein 25 g; Carbohydrate 37 g; Dietary Fibre 6 g; Cholesterol 224 mg; 1510 kJ (360 Cal)

Stir in the cooked rice, pine nuts, currants, parsley, lemon zest and lemon juice.

Thread a toothpick through the end of each squid tube.

PEARL BARLEY AND ASIAN MUSHROOM PILAF

Preparation time: 20 minutes +
 overnight soaking
Total cooking time: 45 minutes
Serves 4

330 g (1 1/2 cups) pearl barley
3 dried shiitake mushrooms
625 ml (2 1/2 cups) vegetable or
 chicken stock
125 ml (1/2 cup) dry sherry
2 tablespoons olive oil
1 large onion, finely chopped
3 cloves garlic, crushed
2 tablespoons grated fresh ginger
1 teaspoon Sichuan peppercorns,
 crushed
500 g (1 lb 2 oz) mixed fresh Asian
 mushrooms (oyster, Swiss brown,
 enoki)
500 g (1 lb 2 oz) choy sum, cut into
 short lengths
3 teaspoons kecap manis
1 teaspoon sesame oil

1 Soak the barley in enough cold water to cover for at least 6 hours, or preferably overnight. Drain.
2 Soak the shiitake mushrooms in enough boiling water to cover for 15 minutes. Strain, reserving 125 ml (1/2 cup) of the liquid. Discard the stalks and finely slice the caps.
3 Heat the stock and sherry in a small saucepan. Cover and keep at a low simmer.
4 Heat the oil in a large saucepan over medium heat. Add the onion and cook for 4–5 minutes, or until softened. Add the garlic, ginger and peppercorns and cook for 1 minute. Slice the Asian

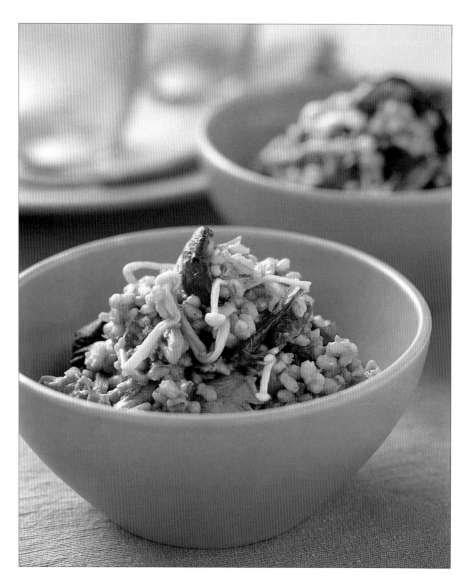

mushrooms, reserving the enoki for later. Increase the heat and add the mushrooms. Cook for 5 minutes, or until the mushrooms have softened. Add the barley, shiitake mushrooms, reserved soaking liquid and hot stock. Stir well to combine. Bring to the boil, then reduce the heat to low and simmer, covered, for 35 minutes,

or until the liquid evaporates.
5 Steam the choy sum until just wilted. Add to the barley mixture with the enoki mushrooms. Stir in the kecap manis and sesame oil.

NUTRITION PER SERVE
Fat 13 g; Protein 15 g; Carbohydrate 52 g; Dietary Fibre 14.5 g; Cholesterol 0 mg; 1725 kJ (410 Cal)

Once the shiitake mushrooms have been soaked, finely slice the caps.

Stir the barley, shiitake mushrooms, soaking liquid and stock until combined.

Steam the lengths of choy sum until the leaves have just wilted.

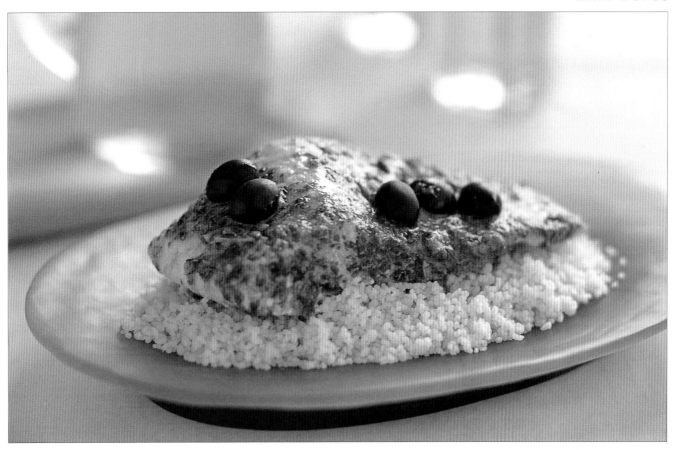

MOROCCAN SALMON WITH COUSCOUS

Preparation time: 15 minutes +
 2 hours marinating
Total cooking time: 20 minutes
Serves 4

4 salmon fillets (about 170–200 g or
 6–7 oz each), skinned and pin boned
2 cloves garlic, crushed
4 tablespoons chopped coriander
 (cilantro) leaves
2 tablespoons chopped flat-leaf
 (Italian) parsley

¼ preserved lemon, pith discarded
½ teaspoon paprika
2 tablespoons chopped mint
2 teaspoons ground cumin
2 teaspoons ground turmeric
2 tablespoons lemon juice
¼ teaspoon crushed dried chillies
2 tablespoons olive oil
2 tablespoons niçoise olives
400 g (14 oz) instant couscous

1 Pat the salmon dry with paper towels, then place in a non-metallic dish. Place the garlic, coriander leaves, parsley, preserved lemon, paprika, mint, ground cumin, ground turmeric, lemon juice, chilli, 2 tablespoons of the olive oil and 2 tablespoons water in a food processor and pulse to blend. Do not over-process; it should remain chunky. Spread on the fish and marinate for at least 2 hours.

2 Preheat the oven to 190°C (375°F/ Gas 5). Cut out four squares of foil large enough to enclose each fillet of fish. Place a fillet (flat-side down), some of the marinade and olives on each piece of foil, then season well. Bring up the sides of the foil and fold in the ends to form a neat parcel. Place on a baking tray and bake for 20 minutes.

3 Place the couscous in a large heatproof bowl. Add the remaining oil and 500 ml (2 cups) boiling water, then cover and leave for 5 minutes. Fluff up with a fork. Divide the couscous among the serving plates. Remove the salmon from the foil and place on top of the couscous. Spoon on the cooking juices and olives.

NUTRITION PER SERVE
Fat 21 g; Protein 44 g; Carbohydrate 79 g; Dietary Fibre 2 g; Cholesterol 82 mg; 2885 kJ (690 Cal)

To pin bone, remove the bones from the salmon fillets with a pair of tweezers.

Evenly spread the chunky sauce on the salmon and leave to marinate.

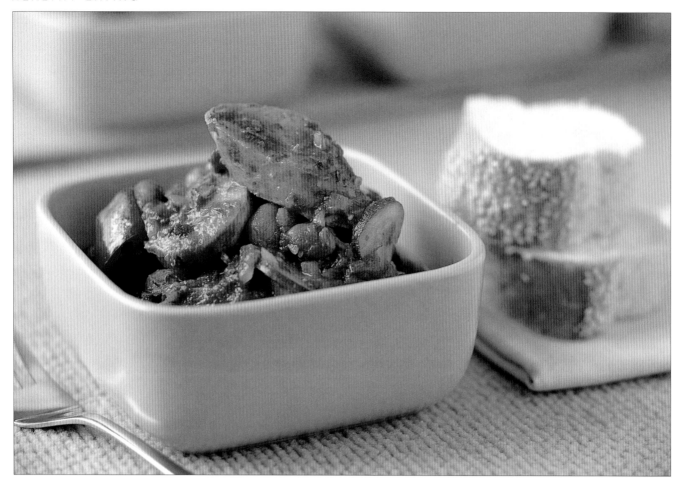

CHICKEN SAUSAGES AND BEAN RAGOUT

Preparation time: 20 minutes
Total cooking time: 1 hour
Serves 6

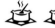 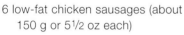

6 low-fat chicken sausages (about
 150 g or 5½ oz each)
1 onion, chopped
4 cloves garlic, crushed
1 red capsicum (pepper), cut into
 2 cm (¾ inch) pieces

½ bird's-eye chilli, finely sliced
2 celery stalks, sliced
2 x 400 g (14 oz) cans chopped tomatoes
1 bay leaf
400 g (14 oz) can borlotti beans, drained
2 small zucchini (courgettes), sliced
pinch chilli powder
1 tablespoon chopped oregano
15 g (¼ cup) chopped basil
30 g (½ cup) chopped parsley
1 tablespoon tomato paste (purée)
250 ml (1 cup) chicken stock
1 tablespoon balsamic vinegar
1 tablespoon lemon juice

1 Heat a large non-stick frying pan over medium heat. Add the sausages and cook until brown all over. Remove from the pan. Add the onion, garlic, capsicum, chilli and celery to the frying pan and cook for 5 minutes, or until soft. Add the tomato and bay leaf, then reduce the heat and simmer for 5 minutes.

2 Cut the sausages on the diagonal into 3 cm (1¼ inch) slices, then add to the tomato mixture. Cook, covered, for 5 minutes. Add the beans, zucchini, chilli powder, oregano, basil, half the parsley, the tomato paste and stock. Season. Cook over low heat for another 25 minutes. Add the balsamic vinegar and simmer for 5 minutes, or until the liquid is reduced and the mixture is thick.

3 Stir in the lemon juice and the remaining parsley just before serving. Serve with crusty bread.

NUTRITION PER SERVE
Fat 7 g; Protein 42 g; Carbohydrate 19 g; Dietary Fibre 5 g; Cholesterol 115 mg; 1275 kJ (305 Cal)

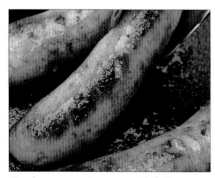

Fry the sausages in a non-stick frying pan until brown all over.

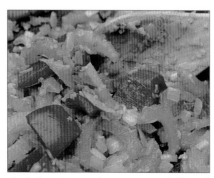

Cook the onion, garlic, capsicum, chilli and celery until soft.

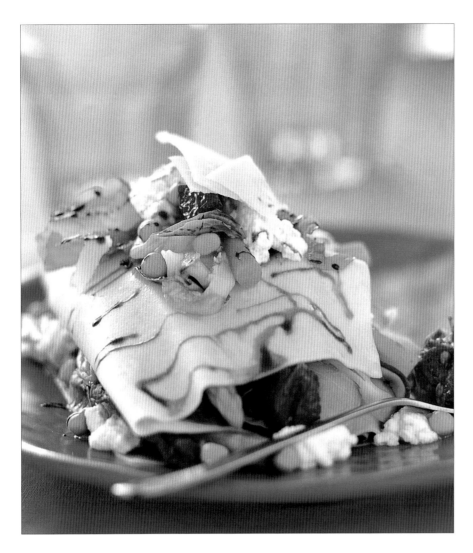

Simmer the balsamic vinegar and brown sugar until it becomes syrupy.

Toss the peas, asparagus, zucchini, rocket, basil and olive oil together.

Fold one third of the lasagne sheet over the salad mix, ricotta and tomato.

FRESH VEGETABLE LASAGNE WITH ROCKET

Preparation time: 20 minutes
Total cooking time: 20 minutes
Serves 4

Balsamic syrup
80 ml (1/3 cup) balsamic vinegar
1 1/2 tablespoons soft brown sugar

150 g (1 cup) fresh or frozen peas
16 asparagus spears, trimmed and cut into 5 cm (2 inch) lengths
2 large zucchini (courgettes), cut into thin ribbons
2 lasagne sheets (200 g/7 oz), each sheet 24 cm x 35 cm (9 1/2 inch x 14 inch)
100 g (3 1/2 oz) rocket (arugula) leaves
30 g (1 cup) basil, torn
2 tablespoons extra virgin olive oil
150 g (1 cup) semi-dried (sun-blushed) tomatoes

250 g (1 cup) low-fat ricotta cheese
Parmesan cheese shavings, to garnish

1 To make the syrup, put the vinegar and sugar in a small saucepan. Stir over medium heat until the sugar dissolves. Reduce the heat and simmer for 3–4 minutes, or until the sauce becomes syrupy. Take off the heat.
2 Bring a large saucepan of salted water to the boil. Blanch the peas, asparagus and zucchini in separate batches until just tender, removing each batch with a slotted spoon and refreshing in cold water. Reserve the cooking liquid and return to the boil.
3 Cook the lasagne sheets in boiling water for 1–2 minutes, until *al dente*. Refresh in cold water and drain well. Cut each sheet in half lengthways.
4 Toss the vegetables and the rocket with the basil and olive oil. Season.
5 To assemble, place one strip of pasta on a serving plate—one third on the centre and two thirds overhanging. Place a small amount of the salad on the centre third, topped with some tomato and ricotta. Season lightly and fold over one third of the lasagne sheet. Top with another layer of salad, tomato and ricotta. Fold back the final layer of pasta. Garnish with a little salad and tomato. Repeat with the remaining pasta strips, salad, ricotta and tomato to make four individual servings. Just before serving, drizzle with the balsamic syrup and garnish with Parmesan.

NUTRITION PER SERVE
Fat 16 g; Protein 18 g; Carbohydrate 36 g; Dietary Fibre 6 g; Cholesterol 63 mg; 1515 kJ (360 Cal)

HOT AND SOUR LIME SOUP WITH BEEF

Preparation time: 20 minutes
Total cooking time: 30 minutes
Serves 4

1 litre (4 cups) beef stock
2 stems lemon grass, (white part
 only), halved
3 cloves garlic, halved
2.5 cm x 2.5 cm (1 inch x 1 inch)
 piece fresh ginger, sliced
95 g (3 cups) coriander (cilantro), leaves
 and stalks separated
4 spring onions (scallions), thinly
 sliced on the diagonal
2 strips (1.5 cm x 4 cm or
 5/8 inch x 5/8 inch) lime zest
2 star anise
3 small red chillies, seeded and finely
 chopped
500 g (1 lb 2 oz) fillet steak, trimmed
2 tablespoons fish sauce
1 tablespoon grated palm sugar
2 tablespoons lime juice
coriander (cilantro) leaves, extra,
 to garnish

1 Place the stock, lemon grass, garlic, ginger, coriander stalks, 2 spring onions, lime zest, star anise, 1 teaspoon chopped chilli and 1 litre (4 cups) water in a saucepan. Bring to the boil and simmer, covered, for 25 minutes. Strain and return the liquid to the pan.
2 Heat a ridged chargrill pan until very hot. Brush lightly with olive oil. Sear the steak on both sides until browned on the outside, but very rare in the centre.
3 Reheat the soup, adding the fish

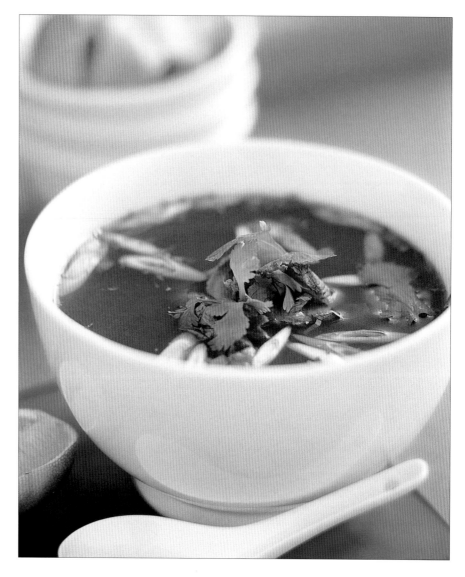

sauce and palm sugar. Season with salt and black pepper. Add the lime juice to taste (you may want more than 2 tablespoons)—you should achieve a hot and sour flavour.
4 Add the remaining spring onion and the chopped coriander leaves to the soup. Slice the beef across the grain into thin strips. Curl the strips into a decorative pattern, then place in the centre of four deep wide serving bowls. Pour the soup over the beef and garnish with the remaining chilli and a few extra coriander leaves.

NUTRITION PER SERVE
Fat 7 g; Protein 31 g; Carbohydrate 7 g; Dietary Fibre 0.5 g; Cholesterol 84 mg; 900 kJ (215 Cal)

Bring the soup to the boil, then reduce the heat and simmer for 25 minutes.

Brown the fillet steak on a hot, lightly oiled chargrill pan.

Gently curl the thin strips of beef into a decorative pattern.

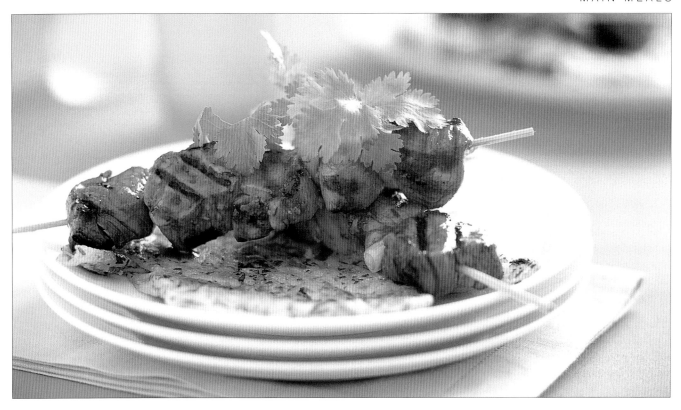

PORK SKEWERS ON RICE NOODLE CAKES

Preparation time: 20 minutes +
 30 minutes soaking +
 overnight marinating
Total cooking time: 30 minutes
Serves 4

1 kg (2 lb 4 oz) pork fillet, cut into
 2 cm (³/4 inch) cubes
8 spring onions (scallions), cut into
 3 cm (1¼ inch) lengths
2 tablespoons rice vinegar
2 teaspoons chilli bean paste
3 tablespoons char siu sauce
400 g (14 oz) fresh flat rice noodles
3 spring onions (scallions), extra, sliced
30 g (1 cup) coriander (cilantro)
 leaves, chopped
1 tablespoon vegetable oil
coriander (cilantro) sprigs, to garnish

1 Soak eight bamboo skewers in water for 30 minutes. Thread the pork and spring onion alternately on the skewers. Combine the vinegar, bean paste and char siu sauce in a shallow non-metallic dish. Add the skewers and turn to coat. Cover with plastic wrap and refrigerate overnight.
2 Drain the skewers, reserving the marinade. Cook them on a very hot grill plate (griddle) for 1–2 minutes each side, until brown and cooked through. Remove and keep warm. Pour the reserved marinade into a saucepan and bring to the boil.
3 Gently separate the noodles, add the extra spring onion and the coriander; toss well. Divide into 4 portions. Heat the oil in a non-stick frying pan over medium heat. Put a portion in the pan and press down with a spatula to form a pancake. Cook each side for 4 minutes, or until golden. Remove and keep warm. Repeat with the remaining noodles.
4 To serve, put each noodle cake on a plate and top with two skewers. Drizzle with the marinade and garnish with the coriander.

NUTRITION PER SERVE
Fat 11.5 g; Protein 59.5 g; Carbohydrate 46.5 g; Dietary Fibre 3 g; Cholesterol 237.5 mg; 2240 kJ (535 Cal)

Thread the pork cubes and pieces of spring onion alternately onto each skewer.

Toss the coriander and spring onion through the flat rice noodles.

Press the noodles firmly with a spatula to form a pancake, then cook until golden.

BEAN ENCHILADAS

Preparation time: 20 minutes
Total cooking time: 25 minutes
Serves 4

1 tablespoon light olive oil
1 onion, finely sliced
3 cloves garlic, crushed
1 bird's-eye chilli, finely chopped
2 teaspoons ground cumin
125 ml (1/2 cup) vegetable stock
3 tomatoes, peeled, seeded and
 chopped
1 tablespoon tomato paste (purée)
2 x 430 g (15 oz) cans three-bean mix
2 tablespoons chopped coriander
 (cilantro) leaves
8 flour tortillas
1 small avocado, peeled and chopped
125 g (1/2 cup) light sour cream
10 g (1/3 cup) coriander (cilantro)
 sprigs
115 g (2 cups) shredded lettuce

1 Heat the oil in a deep frying pan over medium heat. Add the onion and cook for 3–4 minutes, or until just soft. Add the garlic and chilli and cook for a further 30 seconds. Add the cumin, vegetable stock, tomato and tomato paste and cook for 6–8 minutes, or until the mixture is quite thick and pulpy. Season with salt and freshly ground black pepper.
2 Preheat the oven to 170°C (325°F/Gas 3). Drain and rinse the beans. Add the beans to the sauce and cook for 5 minutes to heat through, then add the chopped coriander.
3 Meanwhile, wrap the tortillas in foil and warm in the oven for 3–4 minutes.
4 Place a tortilla on a plate and spread with 60 ml (1/4 cup) of the bean mixture. Top with some avocado, sour cream, coriander sprigs and lettuce. Roll the enchiladas up, tucking in the ends. Cut each one in half to serve.

NUTRITION PER SERVE
Fat 23 g; Protein 17 g; Carbohydrate 47 g; Dietary Fibre 13.5 g; Cholesterol 20 mg; 1910 kJ (455 Cal)

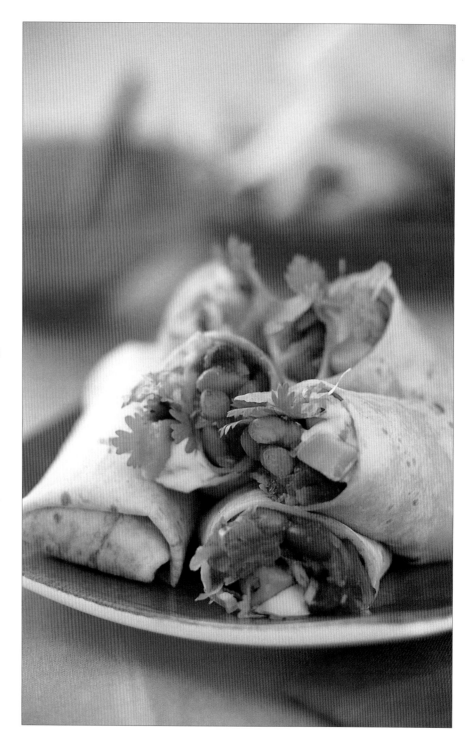

Cook the tomato sauce until the mixture is thick and pulpy.

Place the filling in the centre of the tortilla and roll up, tucking in the ends.

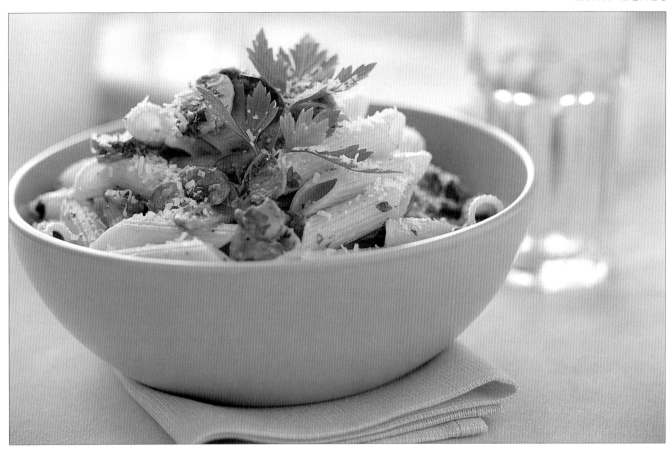

PENNE WITH MUSHROOM AND HERB SAUCE

Preparation time: 15 minutes
Total cooking time: 25 minutes
Serves 4

2 tablespoons olive oil
500 g (1 lb 2 oz) button mushrooms, sliced
2 cloves garlic, crushed
2 teaspoons chopped marjoram
125 ml (1/2 cup) dry white wine
80 ml (1/3 cup) light cream
375 g (13 oz) penne

1 tablespoon lemon juice
1 teaspoon finely grated lemon zest
2 tablespoons chopped parsley
50 g (1/2 cup) freshly grated Parmesan cheese

1 Heat the oil in a large heavy-based frying pan over high heat. Add the mushrooms and cook for 3 minutes, stirring constantly. Add the garlic and marjoram and cook for 2 minutes.
2 Add the wine to the pan, reduce the heat and simmer for 5 minutes, or until nearly all the liquid has evaporated. Stir in the cream and continue to cook over low heat for 5 minutes, or until the sauce has thickened.
3 Meanwhile, cook the penne in a large saucepan of boiling water until *al dente*. Drain.
4 Add the lemon juice, zest, parsley and half the Parmesan to the sauce. Season to taste with salt and freshly ground black pepper. Toss the penne through the sauce and sprinkle with the remaining Parmesan.

NUTRITION PER SERVE
Fat 18 g; Protein 20 g; Carbohydrate 67 g; Dietary Fibre 6.5 g; Cholesterol 25 mg; 2275 kJ (545 Cal)

Add the garlic and marjoram to the softened mushrooms.

Cook the pasta in a large saucepan of boiling water until al dente.

Stir the lemon juice, zest, parsley and half the Parmesan into the sauce.

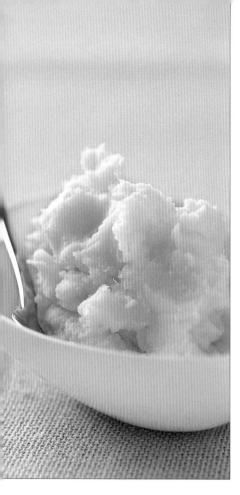

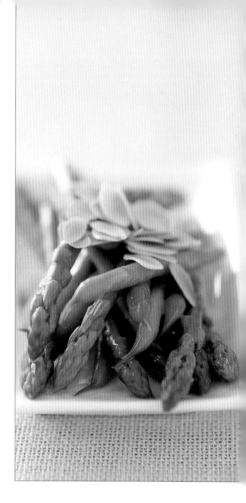

VEGETABLE SIDES

Are you tired of serving the usual boring carrots, peas and potatoes with steak? These ideas add a little something extra—luckily, that's taste and not calories!

LOW-FAT POTATO MASH

Place 750 g (1 lb 10 oz) peeled chopped desiree potatoes in a large saucepan with 500 ml (2 cups) chicken stock and enough water to cover. Bring to the boil and cook for 15 minutes, or until tender. Remove from the heat and drain, reserving 80 ml (⅓ cup) of the liquid. Mash the potatoes with a potato masher, then add 1 clove crushed garlic, the reserved cooking liquid and 2 tablespoons low-fat sour cream. Season well with salt and white pepper and serve with chicken, steak or fish.
Serves 4.

NUTRITION PER SERVE
Fat 2.5 g; Protein 5 g; Carbohydrate 24.5 g; Dietary Fibre 3 g; Cholesterol 6.5 mg; 595 kJ (140 Cal)

SAUTEED MUSHROOMS

Heat 15 g (½ oz) butter in a large saucepan. Add 3 chopped spring onions (scallions), 2 teaspoons thyme and 2 cloves crushed garlic and cook for 2 minutes. Add 270 g (3 cups) sliced Swiss brown mushrooms. Cook, stirring frequently, until the mushrooms are very soft and most of the liquid has evaporated. Add 1 tablespoon red wine vinegar. Season well with salt and freshly ground black pepper. Cook for another 2 minutes, then serve. Delicious with chargrilled meats.
Serves 4.

NUTRITION PER SERVE
Fat 3.5 g; Protein 2.5 g; Carbohydrate 1.5 g; Dietary Fibre 2 g; Cholesterol 9.5 mg; 190 kJ (45 Cal)

ASPARAGUS AND GREEN BEANS WITH ALMONDS

Add 150 g (5½ oz) trimmed young asparagus and 100 g (3½ oz) baby green beans to a large saucepan of rapidly boiling water. Cook for 1 minute, or until just tender. Drain and toss with 2 teaspoons butter and 30 g (⅓ cup) toasted flaked almonds. Season well with freshly ground black pepper and serve immediately. Good with a roast.
Serves 4.

NUTRITION PER SERVE
Fat 4 g; Protein 2.5 g; Carbohydrate 1.5 g; Dietary Fibre 1.5 g; Cholesterol 6 mg; 210 kJ (50 Cal)

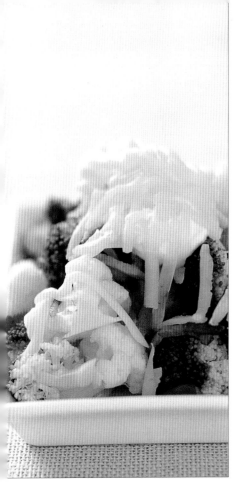
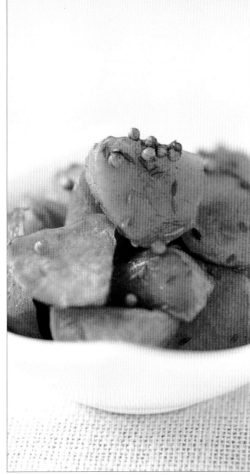
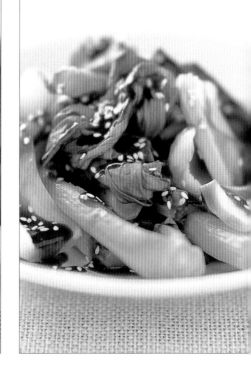

BROCCOLI AND CAULIFLOWER WITH BACON AND CHEESE

Trim 400 g (14 oz) broccoli and 400 g (14 oz) cauliflower into florets. Place the vegetables in a metal or bamboo steamer over boiling water and steam, covered, for 4–5 minutes, or until tender. Meanwhile, chop 2 bacon rashers into thin strips and fry until golden and crisp. Drain on paper towels. Combine the broccoli, cauliflower and bacon in a large serving dish. Top with 1 tablespoon low-fat sour cream and 2 tablespoons grated low-fat cheese. Serve with grilled (broiled) meats or chicken. Serves 4.

NUTRITION PER SERVE
Fat 3.5 g; Protein 13.5 g; Carbohydrate 3 g; Dietary Fibre 6 g; Cholesterol 15 mg; 410 kJ (95 Cal)

SPICY BAKED ORANGE SWEET POTATO

Preheat the oven to 190°C (375°F/ Gas 5). Peel 800 g (1 lb 12 oz) orange sweet potato. Cut into small wedges or rounds, then place in a bowl and toss with 2 teaspoons olive oil, 2 tablespoons warmed honey, 2 teaspoons cumin seeds, 2 teaspoons coriander seeds crushed in a mortar and pestle, 2 tablespoons coriander (cilantro) sprigs and 1/2 teaspoon ground cinnamon. Transfer the sweet potato to a lightly greased baking tray and bake for 45 minutes. Serve immediately. If desired, top with a dollop of low-fat yoghurt. Great accompaniment to roasts. Serves 4.

NUTRITION PER SERVE
Fat 2 g; Protein 4 g; Carbohydrate 39.5 g; Dietary Fibre 4 g; Cholesterol 0 mg; 795 kJ (190 Cal)

STEAMED MIXED ASIAN GREENS

Bring 750 ml (3 cups) water to the boil in a wok or large saucepan, add 1 lime cut into thin slices and a 3 cm x 3 cm (1 1/2 inch x 1 1/2 inch) piece chopped fresh ginger. Place a bamboo steamer lined with baking paper over the wok or pan, and add 400 g (14 oz) trimmed mixed Asian greens (bok choy or pak choi, choy sum, Chinese broccoli or gai lan). Steam, covered, for 2–3 minutes, or until tender. Mix 2 tablespoons oyster sauce with 1 tablespoon Chinese rice wine, 1 teaspoon sesame oil and 1 clove crushed garlic in a small saucepan. Bring to the boil then simmer for 1–2 minutes. Place the steamed greens on a large plate, drizzle the sauce over the top and sprinkle with 1 teaspoon toasted sesame seeds. Serve immediately with poached or steamed chicken, or fish. Serves 4.

NUTRITION PER SERVE
Fat 2.5 g; Protein 2 g; Carbohydrate 3.5 g; Dietary Fibre 1.5 g; Cholesterol 0 mg; 220 kJ (55 Cal)

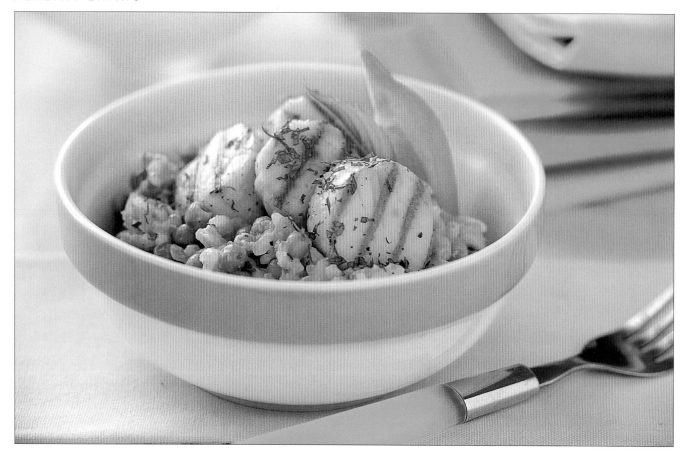

RISOTTO WITH SCALLOPS AND MINTED PEAS

Preparation time: 15 minutes
Total cooking time: 35 minutes
Serves 4–6

1 litre (4 cups) chicken, fish or
 vegetable stock
360 g (2¾ cups) fresh or frozen
 baby peas
2 tablespoons light sour cream
2 tablespoons finely shredded mint
1 tablespoon olive oil
1 small onion, finely chopped
2 cloves garlic, finely chopped
150 g (5½ oz) arborio rice
16 large scallops (without roe)
1 tablespoon grated fresh Parmesan
 cheese
4 mint leaves, to garnish
lemon wedges, to serve

1 Put the stock in a saucepan, bring to the boil, then add the peas. Simmer for 1–2 minutes, or until the peas are tender, then remove them with a slotted spoon and keep the stock at a low simmer. Blend 230 g (1¾ cups) of the peas with the sour cream in a food processor until smooth. Season, then stir in 1 tablespoon of the mint.
2 Place the oil in a large shallow saucepan and cook the onion over low heat for 4–5 minutes, or until just soft. Add the garlic and cook for 30 seconds. Stir in the rice to coat. Increase the heat to medium.
3 Add 250 ml (1 cup) stock to the rice mixture and cook, stirring constantly, until all the liquid has evaporated. Add the stock, 125 ml (½ cup) at a time, until the rice is cooked and the mixture is creamy.

This will take about 20 minutes.
4 Lightly season the scallops. Heat a chargrill (griddle) or hotplate, add the scallops and sear on both sides until cooked to your liking.
5 Fold the pea purée through the risotto with reserved whole peas and Parmesan. Divide the risotto among serving bowls and place the scallops on top. Sprinkle with the remaining mint, garnish with a mint leaf and serve with a wedge of lemon.

NUTRITION PER SERVE (6)
Fat 6 g; Protein 12.5 g; Carbohydrate 27.5 g; Dietary Fibre 4.5 g; Cholesterol 17 mg; 895 kJ (215 Cal)

Process the peas and sour cream in a food processor until smooth.

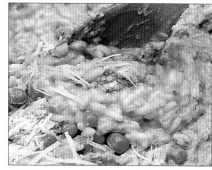

Fold the pea purée, reserved whole peas and Parmesan through the risotto.

FLATHEAD BAKED IN BAKING PAPER

Preparation time: 15 minutes
Total cooking time: 30 minutes
Serves 4

2 baby fennel bulbs (about 300 g or 10½ oz), trimmed and finely sliced
1 clove garlic, thinly sliced
1 tablespoon chopped dill
60 ml (¼ cup) olive oil
2 tablespoons lemon juice
1 large flathead (about 1.25 kg or 2lb 12 oz), gutted and head removed
small dill sprigs, to garnish
small parsley sprigs, to garnish
lemon wedges, to serve

1 Place the fennel in a bowl with the garlic, dill, oil and lemon juice. Season well with salt and freshly ground black pepper.
2 Preheat the oven to 180°C (350°F/Gas 4). Cut a piece of baking paper 5 cm (2 inch) longer than the fish. Cut a large strip of baking paper wide enough to support the main body of the fish and long enough to wrap around. Lay the strip lengthways, then place the other piece widthways over the top, forming a cross. Place the fish in the centre of the baking paper and spoon some of the fennel mixture into its cavity and the remaining fennel mixture over the top. Fold the top and bottom ends of paper over the fish, then fold the sides in about 2 cm (³/₄ inch), securing with staples. Fold the side ends over the top of the fish and secure with staples. Lift onto a large baking tray. Bake for

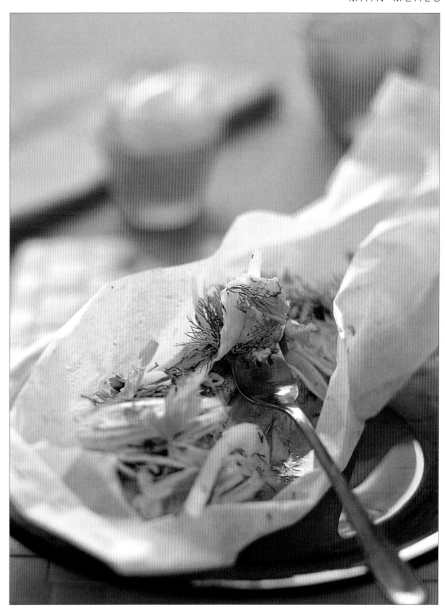

30 minutes, or until the flesh flakes easily when tested with a fork.
3 Place the parcel on a warm serving platter and cut a hole in the top with kitchen scissors. Fold the edges back neatly to expose the top of the fish.

Sprinkle with the sprigs of dill and parsley and serve with lemon wedges.

NUTRITION PER SERVE
Fat 12 g; Protein 32.5 g; Carbohydrate 3 g; Dietary Fibre 2.5 g; Cholesterol 85.5 mg; 1040 kJ (250 Cal)

Spoon some of the fennel mixture into the fish cavity and the rest on top.

Fold the strip of baking paper over the fish and secure with staples.

Flake the fish with a fork to test that it is cooked.

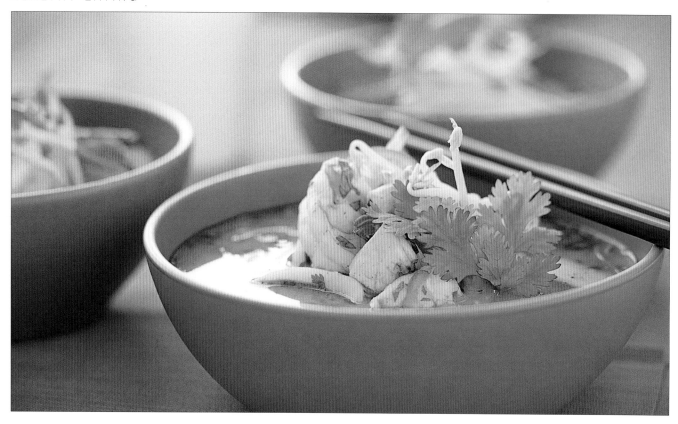

LOW-FAT SEAFOOD LAKSA

Preparation time: 15 minutes +
 10 minutes soaking
Total cooking time: 10 minutes
Serves 4

150 g (5½ oz) dried rice vermicelli
80 g (¼ cup) good-quality laksa paste
250 ml (1 cup) low-fat coconut milk
1 litre (4 cups) fish or vegetable stock
12 large raw prawns (shrimp), peeled
 and deveined, with tails intact
250 g (9 oz) firm white fish fillets
 (ling or blue eye), cut into
 3 cm (1¼ inch) cubes

200 g (7 oz) squid rings
1½ tablespoons lime juice
1½ tablespoons fish sauce
15 g (¼ cup) chopped coriander
 (cilantro) leaves
100 g (3½ oz) bean sprouts
1 lime, cut into quarters
coriander (cilantro) leaves, extra,
 to garnish

1 Soak the noodles in hot water for 10 minutes. Drain and set aside.
2 Heat a large wok and when very hot, add the laksa paste. Stir-fry for 1 minute, then add the coconut milk. Bring to the boil, then reduce the heat. Add the stock and simmer for another minute before adding the prawns and fish. Cook for 4 minutes, or until the prawns and fish have turned opaque, then stir in the squid rings, lime juice, fish sauce and the chopped coriander. Cook for a further 1–2 minutes.
3 To serve, run the noodles under hot water to separate, then divide among four serving bowls. Top the noodles with the bean sprouts and pour on the soup—each bowl should get three prawns. Garnish with a wedge of lime and extra coriander leaves.

NUTRITION PER SERVE
Fat 9 g; Protein 41.5 g; Carbohydrate 30.5 g; Dietary Fibre 4 g; Cholesterol 213.5 mg; 1570 kJ (375 Cal)

Peel the prawns and pull out the dark vein from the back, leaving the tail intact.

Stir-fry the laksa paste for 1 minute in a very hot wok.

Cook the prawns and fish in the coconut milk and stock until they turn opaque.

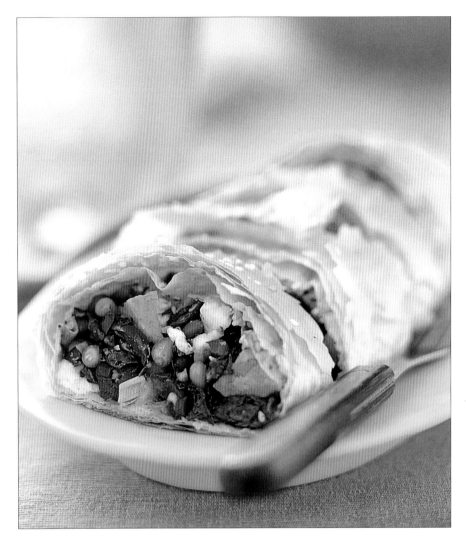

Roast the sweet potato and garlic cloves until the sweet potato is soft and coloured.

Remove the skin, then roughly chop the roasted garlic flesh.

Spoon the filling into the centre of the prepared pastry.

ORANGE SWEET POTATO, PINE NUT AND FETA STRUDEL

Preparation time: 25 minutes
Total cooking time: 1 hour 5 minutes
Serves 6

250 g (9 oz) orange sweet potato, peeled and cut into 2 cm (3/4 inch) cubes
2 tablespoons olive oil
3 cloves garlic, unpeeled
250 g (9 oz) English spinach, blanched, excess moisture squeezed out
40 g (1/4 cup) pine nuts, toasted
125 g (4 1/2 oz) low-fat feta cheese, crumbled
3 spring onions (scallions), including green part, chopped
50 g (1/2 cup) black olives, pitted and sliced
15 g (1/4 cup) chopped basil
1 tablespoon chopped rosemary
8 sheets filo pastry
2 tablespoons sesame seeds

1 Preheat the oven to 180°C (350°F/Gas 4). Place the sweet potato on a roasting tray and brush lightly with 1 tablespoon of the oil, then add the garlic cloves. Roast for 30 minutes, or until the sweet potato has softened and is slightly coloured. Remove and cool slightly.
2 Place the sweet potato, roughly chopped spinach, pine nuts, feta, spring onion, olives, basil and rosemary in a bowl. Cut off the end of each garlic clove and peel off the skin. Roughly chop the flesh, then add to the sweet potato mixture. Season with salt and freshly ground black pepper. Combine well.
3 Cover the pastry sheets with a slightly damp tea towel to prevent the pastry from drying and cracking. Lay the pastry sheets out in front of you, stacked on top of each other, and brush every second layer with the remaining oil. Spread the filling in the centre of the pastry, covering an area of about 10 cm x 30 cm (4 inch x 12 inch). Fold in the shorter ends of the pastry. Fold the long side closest to you over the filling, then carefully roll up. Place the strudel on a greased baking tray, seam-side down. Brush with any remaining oil and sprinkle with the sesame seeds. Bake for 35 minutes, or until the pastry is crisp and golden. Serve warm.

NUTRITION PER SERVE
Fat 15.5 g; Protein 11 g; Carbohydrate 19 g; Dietary Fibre 3.5 g; Cholesterol 12.5 mg; 1080 kJ (260 Cal)

STEAMED CHICKEN BREAST WITH ASIAN GREENS AND SOY MUSHROOM SAUCE

Preparation time: 10 minutes +
 20 minutes soaking +
 1 hour marinating
Total cooking time: 20 minutes
Serves 4

8–10 g (about ¼ oz) dried Chinese
 mushrooms
2 tablespoons light soy sauce
2 tablespoons rice wine
½ teaspoon sesame oil
1 tablespoon finely sliced fresh ginger
4 chicken breast fillets (about 200 g
 or 7 oz each), trimmed
450 g (1 lb) bok choy (pak choi), ends
 removed and cut lengthways into
 quarters
125 ml (½ cup) chicken stock
1 tablespoon cornflour (cornstarch)

1 Soak the mushrooms in 60 ml
(¼ cup) boiling water for 20 minutes.
Drain and reserve the liquid. Discard
the stalks and slice the caps thinly.
2 Combine the soy sauce, rice
wine, sesame oil and ginger in a
non-metallic dish. Add the chicken to
the marinade and turn to coat. Cover
and marinate for 1 hour.
3 Line a bamboo steamer with
baking paper. Place the chicken on
top, reserving the marinade. Bring
water to the boil in a wok. Place the
steamer in the wok. Cover and steam
for 6 minutes. Turn the chicken over
and steam for a further 6 minutes.
Put the bok choy on top of the
chicken and steam for 2–3 minutes.

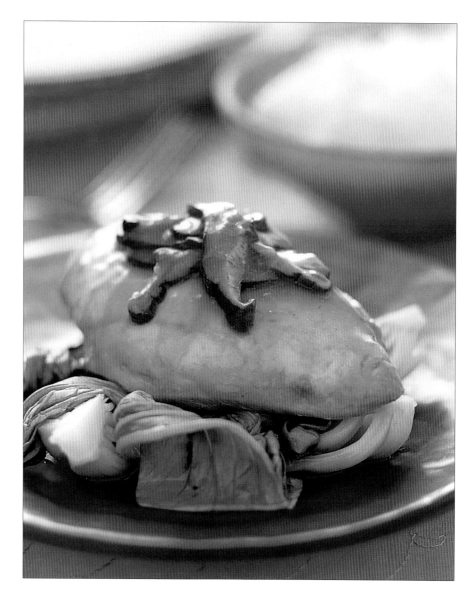

4 Meanwhile, place the reserved
marinade, mushrooms and their
soaking liquid in a small saucepan
and bring to the boil. Add enough
stock to the cornflour in a small bowl
to make a smooth paste. Add the
cornflour paste and remaining stock
and stir for 2 minutes over medium

heat, or until the sauce thickens.
5 Place some bok choy and a chicken
fillet on each serving plate, then pour
on a little sauce. Serve with rice.

NUTRITION PER SERVE
Fat 5.5 g; Protein 45.5 g; Carbohydrate
4.5 g; Dietary Fibre 2 g; Cholesterol
95 mg; 1085 kJ (260 Cal)

*Turn the chicken fillets until well coated in
the marinade.*

*Place the lengths of bok choy in the bamboo
steamer, on top of the chicken.*

*Stir the marinating liquid and chicken
stock mixture until the sauce thickens.*

Bake the dressed and seasoned tomato quarters until golden.

Cook the tuna steaks on a chargrill plate until cooked to your liking.

TUNA WITH CHICKPEAS AND ROAST TOMATO SALAD

Preparation time: 10 minutes +
 overnight soaking +
 30 minutes marinating
Total cooking time: 1 hour 25 minutes
Serves 4

220 g (1 cup) dried chickpeas
6 Roma (plum) tomatoes, cut into
 quarters lengthways
2 tablespoons olive oil
4 tuna steaks (about 150 g or
 5½ oz each)
2 tablespoons lemon juice
1 red onion, chopped
1 clove garlic, crushed
1 teaspoon ground cumin
30 g (1 cup) roughly chopped flat-leaf
 (Italian) parsley with a little extra,
 to garnish

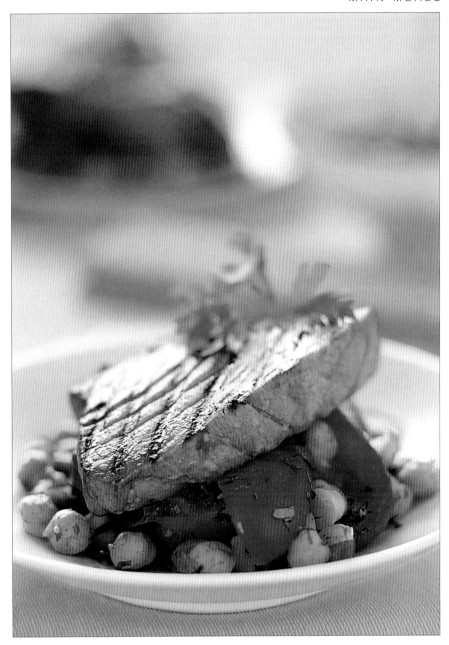

1 Soak the chickpeas in enough water to cover for 8 hours or overnight. Drain and discard the liquid. Place the chickpeas in a saucepan with enough water to cover them and bring to the boil. Cook for 25–30 minutes, or until tender. Drain, then rinse well under cold water.

2 Preheat the oven to 180°C (350°F/Gas 4). Combine the tomatoes, 2 teaspoons of the olive oil, salt and black pepper. Place evenly on a baking tray, then bake for 35–40 minutes, or until golden.

3 Brush the tuna with 2 teaspoons of the olive oil and 1 tablespoon of the lemon juice. Season to taste and marinate for 30 minutes.

4 Heat the remaining olive oil in a frying pan over medium heat. Add the onion and garlic and cook, stirring, for 4–5 minutes, or until softened. Add the ground cumin and cook for a further minute, then add the chickpeas. Cook for 5 minutes, stirring occasionally. Add the tomatoes, parsley and remaining lemon juice. Season to taste with salt and freshly ground black pepper.

5 Heat a non-stick chargrill plate (griddle) to high. Add the tuna steaks. Cook on each side for 1–2 minutes, or until cooked to your liking. Serve tuna steaks on top of the warm chickpea salad and garnish with parsley leaves.

NUTRITION PER SERVE
Fat 20 g; Protein 47.5 g; Carbohydrate 21 g; Dietary Fibre 8 g; Cholesterol 54 mg; 1930 kJ (460 Cal)

VEGETABLE TAGINE WITH COUSCOUS

Preparation time: 25 minutes
Total cooking time: 45 minutes
Serves 6

1/4 teaspoon saffron threads
2 tablespoons olive oil
2 onions, thinly sliced
3 cloves garlic, crushed
2 thin carrots, cut into 5 mm (1/4 inch) slices
1 cinnamon stick
2 teaspoons ground cumin
1 teaspoon ground ginger
1/2 teaspoon ground turmeric
1/2 teaspoon cayenne pepper
300 g (10 1/2 oz) pumpkin, cut into 2 cm (3/4 inch) cubes
4 ripe tomatoes, peeled, seeded and quartered
400 g (14 oz) can chickpeas, drained and rinsed
500 ml (2 cups) vegetable stock
1 zucchini (courgette), halved lengthways then cut into 1 cm (1/2 inch) slices
4 tablespoons raisins
50 g (1 cup) roughly chopped coriander (cilantro) leaves
2 tablespoons flaked almonds, toasted

Couscous
500 ml (2 cups) vegetable stock
500 g (1 lb 2 oz) instant couscous
1 tablespoon olive oil
2 teaspoons low-fat margarine

1 Dry-fry the saffron threads in a small frying pan over low heat for 1 minute, or until darkened. Remove from the heat and cool.
2 Heat the oil in a large flameproof

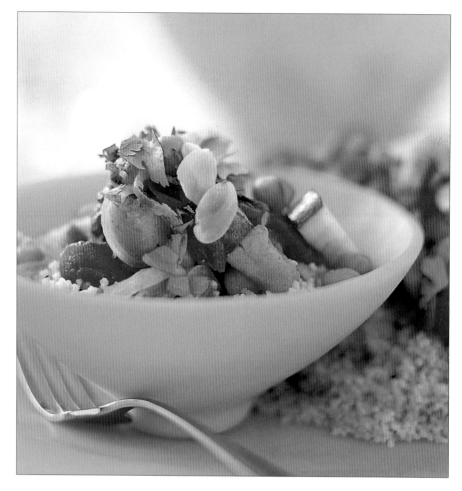

casserole dish. Add the onion, garlic, carrot, cinnamon stick, ground cumin, ground ginger, ground turmeric, cayenne and saffron. Cook over medium–low heat, stirring often, for 10 minutes. Add the pumpkin, tomato and chickpeas. Stir to coat. Add the stock, then bring to the boil. Cover and simmer for 10 minutes. Stir in the zucchini, raisins and half the coriander. Cover and simmer for a further 20 minutes.
3 To make the couscous, bring the stock to the boil in a large saucepan.

Place the couscous in a large heatproof bowl and add the oil and the hot stock. Cover and leave for 5 minutes, then fluff the grains with a fork. Stir in the margarine and season.
4 Spoon the couscous onto a large serving platter. Spoon the vegetables and sauce on top and sprinkle with the almonds and the remaining coriander. Serve at once.

NUTRITION PER SERVE
Fat 13 g; Protein 19 g; Carbohydrate 86 g; Dietary Fibre 7 g; Cholesterol 0 mg; 2295 kJ (550 Cal)

Fry the saffron threads in a dry frying pan until darkened.

Stir in the pumpkin cubes, tomato and chickpeas until they are well coated.

Stir the margarine into the couscous with a fork.

THAI-STYLE WHOLE STEAMED FISH WITH SPICY TOMATO SAUCE

Preparation time: 25 minutes +
 30 minutes standing
Total cooking time: 40 minutes
Serves 4

6 cloves garlic
3 red Asian shallots
3 vine-ripened tomatoes
2 long red chillies
1 1/2 tablespoons lime juice
3 1/2 tablespoons fish sauce
2 cloves garlic, extra
4 coriander (cilantro) roots
6 whole black peppercorns
4 snapper or firm white fish (about
 300 g or 10 1/2 oz each), fins
 trimmed, cleaned and gutted
25 g (3/4 cup) coriander (cilantro) leaves

1 Chargrill the skins of the garlic, shallots, tomatoes and chillies over an open gas flame, using a pair of metal tongs, or roast in a preheated (230°C/450°F/Gas 8) oven for 15–20 minutes. When cool enough to handle, peel and discard the skins of all vegetables. Roughly chop the vegetables and combine with lime juice and 2 tablespoons of the fish sauce. Leave for 30 minutes.

2 Place the extra garlic, coriander roots and peppercorns in a mortar and pestle and grind to a smooth paste. Add the remaining fish sauce and stir to combine. Score each fish on both sides in a criss-cross pattern. Rub the paste on both sides.

3 Line the bottom of a large bamboo steamer with baking paper. Put the fish on the paper. Place the steamer over a wok of boiling water. Cover and steam for 15–20 minutes, or until the flesh flakes easily when tested with a fork. Remove the steamer from the wok and slide the fish onto a serving plate. Spoon the tomato sauce over the fish and sprinkle with coriander leaves.

NUTRITION PER SERVE
Fat 3 g; Protein 33.5 g; Carbohydrate 4 g;
Dietary Fibre 3 g; Cholesterol 91.5 mg;
750 kJ (180 Cal)

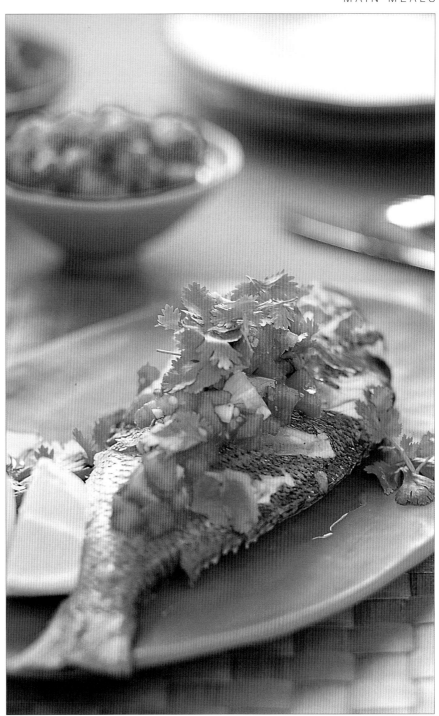

Once the vegetables have been chargrilled, peel off and discard the skins.

Grind the garlic, coriander roots and peppercorns until smooth.

CHICKEN WRAPPED IN VINE LEAVES WITH AVGOLEMONO SAUCE

Preparation time: 15 minutes
Total cooking time: 25 minutes
Serves 4

4 single chicken breast fillets
 (about 180 g or 6 oz each)
8–12 vine leaves packed in brine,
 rinsed
2 eggs
3 tablespoons lemon juice
250 ml (1 cup) chicken stock
1 tablespoon chopped dill

1 Preheat the oven to 200°C (400°F/Gas 6). Season each chicken breast with salt and freshly ground black pepper. Wrap each breast in 2–3 vine leaves (depending on the size of the leaves), then in baking paper and then in foil. Bake for 20 minutes.

2 Meanwhile, whisk the eggs until frothy and slowly add the lemon juice. Heat the stock in a small saucepan. Gradually whisk the hot stock into the eggs. When incorporated, return the mixture to the pan and whisk over medium–low heat until the mixture has thickened, being careful not to allow the mixture to boil or the eggs will scramble. Stir in the dill and remove from the heat.

3 Remove the foil and baking paper, transfer the chicken to serving plates and drizzle with the avgolemono.

NUTRITION PER SERVE
Fat 7 g; Protein 45.5 g; Carbohydrate 1 g; Dietary Fibre 1 g; Cholesterol 180 mg; 1050 kJ (250 Cal)

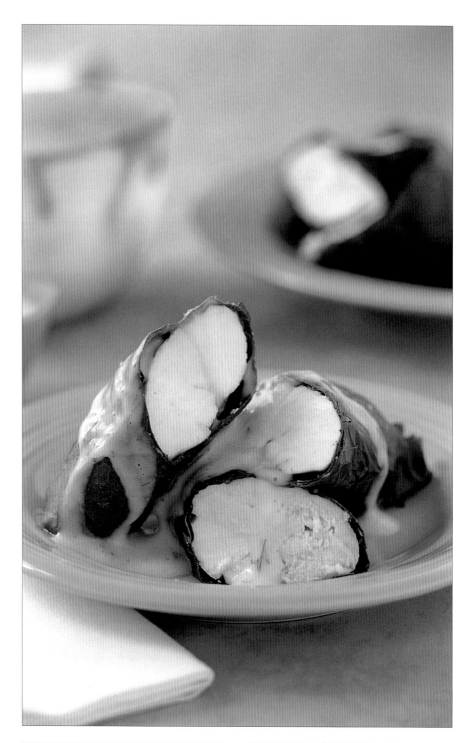

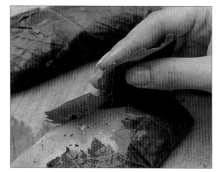

Wrap each seasoned chicken breast in two or three vine leaves.

Whisk the hot stock gradually into the egg and lemon juice mixture.

Remove from the heat and stir in the chopped dill.

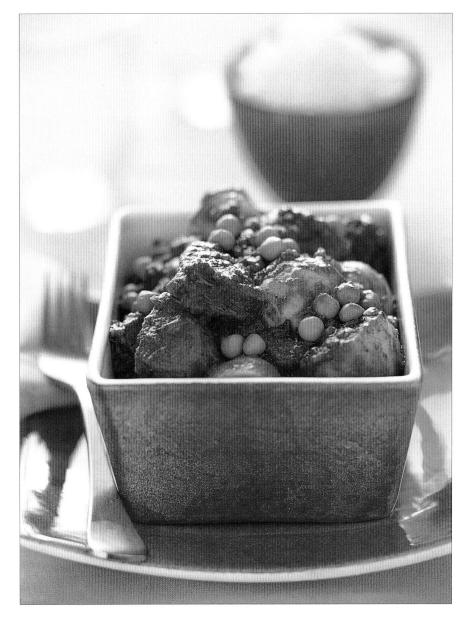

Fry the onion, garlic and ginger until the onion is lightly golden.

Stir the cubes of steak into the curry paste until well coated.

Stir in the potato halves and cook for 30 minutes.

MADRAS BEEF CURRY

Preparation time: 20 minutes
Total cooking time: 1 hour 45 minutes
Serves 6

1 tablespoon vegetable oil
2 onions, finely chopped
3 cloves garlic, finely chopped
1 tablespoon grated fresh ginger
4 tablespoons madras curry
 paste
1 kg (2 lb 4 oz) chuck steak, trimmed
 and cut into 3 cm (1¼ inch) cubes
60 g (¼ cup) tomato paste (purée)
250 ml (1 cup) beef stock
6 new potatoes, halved
155 g (1 cup) frozen peas

1 Preheat the oven to 180°C (350°F/Gas 4). Heat the oil in a large heavy-based 3 litre (12 cup) flameproof casserole dish. Cook the onion over medium heat for 4–5 minutes. Add the garlic and ginger and cook, stirring for a further 5 minutes, or until the onion is lightly golden, taking care not to burn it.
2 Add the curry paste and cook, stirring, for 2 minutes, or until fragrant. Increase the heat to high, add the meat and stir constantly for 2–3 minutes, or until the meat is well coated. Add the tomato paste and stock and stir well.
3 Bake, covered, for 50 minutes, stirring 2–3 times during cooking,

and add a little water if necessary. Reduce the oven to 160°C (315°F/Gas 2–3). Add the potato and cook for 30 minutes, then add the peas and cook for another 10 minutes, or until the potato is tender. Serve hot with steamed jasmine rice.

NUTRITION PER SERVE
Fat 13 g; Protein 39.5 g; Carbohydrate 15 g; Dietary Fibre 5.5 g; Cholesterol 112 mg; 1410 kJ (335 Cal)

SLOW-COOKED LAMB SHANKS WITH SOFT POLENTA

Preparation time: 20 minutes
Total cooking time: 2 hours 20 minutes
Serves 4

60 ml (¼ cup) olive oil
8 French trimmed lamb shanks
30 g (¼ cup) seasoned flour
2 onions, sliced
3 cloves garlic, crushed
1 celery stick, cut into 2.5 cm (1 inch)
 lengths
2 long thin carrots, cut into
 3 cm (1¼ inch) chunks
2 parsnips, peeled and cut into
 3 cm (1¼ inch) chunks
250 ml (1 cup) red wine
750 ml (3 cups) chicken stock
250 ml (1 cup) Italian tomato passata
1 bay leaf
1 sprig thyme
zest of half an orange (without pith),
 cut into thick strips
1 sprig parsley
sprigs of thyme, to garnish

Polenta
500 ml (2 cups) chicken stock
150 g (1 cup) fine instant polenta
50 g (1¾ oz) butter
pinch paprika, for sprinkling

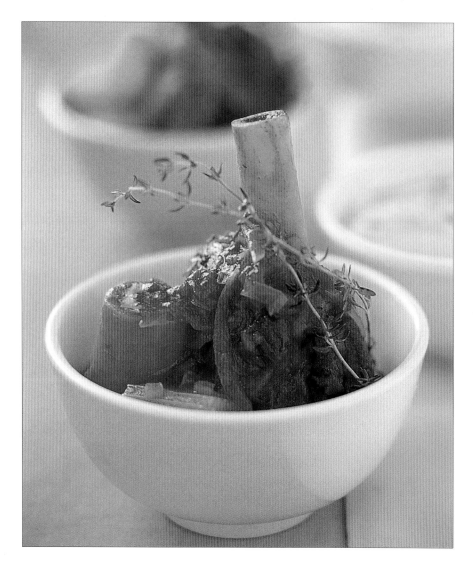

1 Preheat the oven to 160°C (315°F/Gas 2–3). Heat the oil in a large heavy-based flameproof casserole dish, big enough to fit the shanks in a single layer. Lightly dust the shanks with seasoned flour then brown them in batches on the stovetop. Remove from the casserole dish.

2 Add the onion, reduce the heat and cook gently for 3 minutes. Stir in the garlic, celery, carrot and parsnip. Pour in the wine and simmer for 1 minute, then return the shanks to the casserole dish. Add the stock, tomato passata, bay leaf, thyme, orange zest and parsley. Cover and bake for 2 hours, or until the meat is very tender.

3 To make the polenta, place the stock and 500 ml (2 cups) water in a large saucepan and bring to the boil.

Gradually stir in the polenta using a wooden spoon. Reduce the heat and simmer over low heat, stirring often, for 5–6 minutes, or until the mixture thickens and starts to leave the side of the pan. Remove from the heat, add the butter and season with salt and pepper. Stir until the butter melts. Spoon into a warm dish and sprinkle with paprika.

4 Gently remove the shanks from the pan. Arrange on a warm serving platter. Discard the herbs and zest, then spoon vegetables and gravy over the shanks. Garnish with the thyme sprigs. Serve with the soft polenta.

NUTRITION PER SERVE
Fat 31 g; Protein 70 g; Carbohydrate 44 g; Dietary Fibre 5 g; Cholesterol 235 mg; 3275 kJ (785 Cal)

Cook the seasoned lamb shanks in batches until brown all over.

Bake the lamb shanks and vegetables until the meat is very tender.

VEGETARIAN PAELLA

Preparation time: 20 minutes +
 overnight soaking
Total cooking time: 40 minutes
Serves 6

200 g (1 cup) dried haricot beans
1/4 teaspoon saffron threads
2 tablespoons olive oil
1 onion, diced
1 red capsicum (pepper), cut into
 1 cm x 4 cm (1/2 inch x 1 1/2 inch)
 strips
5 cloves garlic, crushed
275 g (1 1/4 cups) paella rice or
 arborio rice
1 tablespoon sweet paprika
1/2 teaspoon mixed spice
750 ml (3 cups) vegetable stock
400 g (14 oz) can diced tomatoes
1 1/2 tablespoons tomato paste (purée)
150 g (1 cup) fresh or frozen soya
 beans
100 g (3 1/2 oz) silverbeet (Swiss
 chard) leaves (no stems), shredded
400 g (14 oz) can artichoke hearts,
 drained and quartered
4 tablespoons chopped coriander
 (cilantro) leaves

1 Cover the haricot beans in cold water and soak overnight. Drain and rinse well.
2 Place the saffron threads in a small frying pan over medium–low heat. Dry-fry, shaking for 1 minute, or until darkened. Remove from the heat and when cool, crumble into a small bowl. Pour in 125 ml (1/2 cup) warm water and allow to steep.
3 Heat the oil in a large paella pan or frying pan. Add the onion and capsicum and cook over medium–high heat for 4–5 minutes, or until the onion softens. Stir in the garlic and cook for 1 minute. Reduce the heat and add the drained beans, rice, paprika, mixed spice and 1/2 teaspoon salt. Stir to coat. Add the saffron water, stock, tomatoes and tomato paste and bring to the boil. Cover, reduce the heat and simmer for 20 minutes.
4 Stir in the soy beans, silverbeet and artichoke hearts and cook, covered, for 8 minutes, or until all

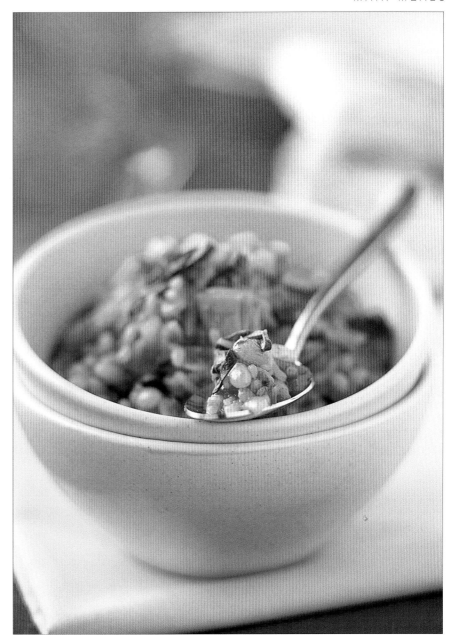

the liquid is absorbed and the rice and beans are tender. Turn off the heat and leave for 5 minutes. Stir in the coriander just before serving.

NUTRITION PER SERVE
Fat 8 g; Protein 16 g; Carbohydrate 55 g; Dietary Fibre 12 g; Cholesterol 0 mg; 1510 kJ (360 Cal)

Allow the crumbled saffron threads to steep in warm water.

Add the haricot beans, rice, paprika, mixed spice and salt and stir to coat.

Peel the blackened and blistered skin from the capsicum.

Using your hands, form the lamb mixture into even-sized patties.

LAMB BURGER WITH WEDGES

Preparation time: 30 minutes
Total cooking time: 1 hour
Serves 4

1 red capsicum (pepper)
1 yellow capsicum (pepper)
1 green capsicum (pepper)
400 g (14 oz) baking potatoes
 (Pontiac or desiree)
garlic oil spray
300 g (10½ oz) lean minced (ground)
 lamb
2 teaspoons chopped thyme
2 tablespoons chopped parsley
2 tomatoes (140 g or 5 oz), seeded
 and finely chopped
1 large onion, finely chopped
25 g (⅓ cup) fresh breadcrumbs
1 egg white, lightly beaten
4 slices low-fat cheese
1 large red onion, thinly sliced
2 teaspoons olive oil
4 hamburger buns
40 g (1 cup) rocket (arugula)

1 Cut the capsicums into quarters and remove the membranes and seeds.

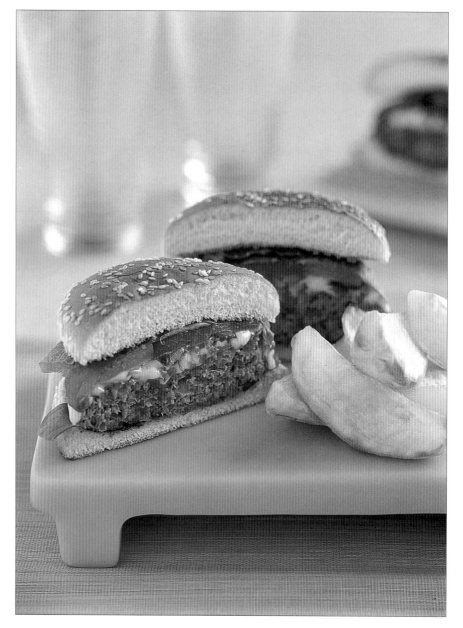

Grill (broil), skin-side up, until the skin blackens and blisters. Put in a bowl and cover with plastic wrap. When cool enough to handle, peel off the skin and cut the flesh into strips.
2 Preheat the oven to 200°C (400°F/Gas 6). Line a baking tray with foil. Cut the potatoes into medium wedges. Spray well with the oil spray, then season and toss. Lay out evenly on the baking tray. Bake for 40 minutes, or until crisp and golden, turning once.
3 Meanwhile, combine the lamb, thyme, parsley, tomato, onion, breadcrumbs, egg white and 1 teaspoon pepper. Form into 4 even-sized patties. Heat a non-stick frying pan over medium heat and cook the patties on each side for 5 minutes, or until cooked. Put a slice of cheese on top to melt slightly. Remove from the pan. Cook the onion in the olive oil for 4–5 minutes over medium heat until softened a little. Cut the buns in half and toast each side until crisp.
4 To assemble, layer the bun with a little rocket, the patty with cheese, onion, one strip each of red, yellow and green capsicum, and top with more rocket and the top of the bun. Cut in half and serve with wedges.

NUTRITION PER SERVE
Fat 14 g; Protein 34.5 g; Carbohydrate 52 g; Dietary Fibre 5.5 g; Cholesterol 65.5 mg; 1995 kJ (475 Cal)

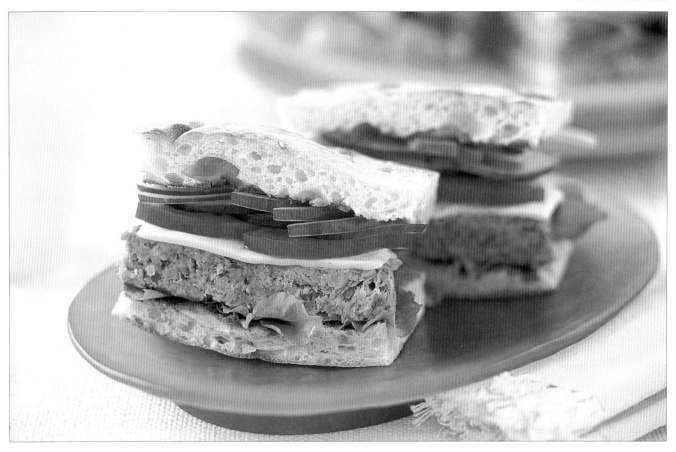

LEMON PEPPER TUNA BURGER

Preparation time: 20 minutes
Total cooking time: 15 minutes
Serves 4

2 x 185 g (7 1/2 oz) cans lemon pepper
 tuna, drained
1 large onion, chopped
65 g (2/3 cup) dry breadcrumbs
1 egg, lightly beaten
2 tablespoons chopped lemon thyme
1 tablespoon chopped parsley
2 teaspoons grated lemon zest

1 tablespoon oil
1 loaf Turkish bread
80 g (1/3 cup) 97% fat-free mayonnaise
150 g (5 1/2 oz) rocket (arugula)
4 slices low-fat cheese
2 tomatoes, sliced
1 cucumber, sliced
1/2 red onion, sliced

1 Combine the tuna, onion, breadcrumbs, egg, thyme, parsley and lemon zest in a bowl and mix well. Form into four even-sized patties and flatten slightly. Heat a non-stick frying pan with the oil. Cook the patties over medium heat on both sides for 5 minutes, or until browned.
2 Cut the bread into 4 portions. Cut each portion in half horizontally and place under a grill to lightly brown.
3 Spread both cut sides of the bread with mayonnaise. Top with some rocket and layer with a patty, a slice of cheese and slices of tomato, cucumber and onion. Place the other half of the Turkish bread on top, cut in half and serve.

NUTRITION PER SERVE
Fat 13.5 g; Protein 38.5 g; Carbohydrate 50.5 g; Dietary Fibre 5.5 g; Cholesterol 89 mg; 2025 kJ (485 Cal)

Combine the tuna, onion, breadcrumbs, egg, lemon thyme, parsley and lemon zest.

Fry the patties on both sides for 5 minutes, or until brown.

Cut each portion of Turkish bread in half horizontally with a serrated knife.

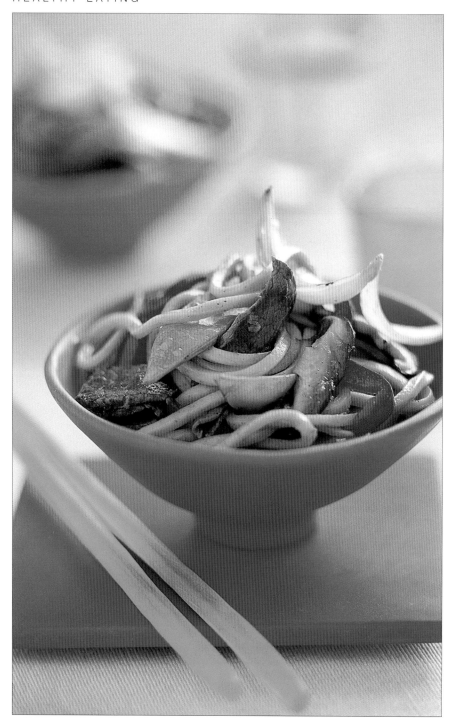

BEEF AND HOKKIEN NOODLE STIR-FRY

Preparation time: 15 minutes +
 10 minutes soaking
Total cooking time: 15 minutes
Serves 4

350 g (12 oz) beef fillet, partially
 frozen
100 g (3½ oz) snow peas (mangetout)
600 g (1 lb 5 oz) fresh Hokkien (egg)
 noodles
1 tablespoon peanut oil
1 large onion, cut into thin wedges
1 large carrot, sliced thinly on the
 diagonal
1 medium red capsicum (pepper),
 cut into thin strips
2 cloves garlic, crushed
1 teaspoon grated fresh ginger
200 g (7 oz) shiitake mushrooms,
 sliced
60 ml (¼ cup) oyster sauce
2 tablespoons light soy sauce
1 tablespoon soft brown sugar
½ teaspoon five-spice powder

1 Cut the steak into thin slices. Top
and tail the snow peas and slice in
half diagonally. Soak the noodles in a
large bowl with enough boiling water
to cover for 10 minutes.
2 Spray a large wok with oil spray
and when very hot, cook the steak
in batches until brown. Remove and
keep warm.
3 Heat the peanut oil in the wok,
and when very hot, stir-fry the onion,
carrot and capsicum for 2–3 minutes,
or until tender. Add the garlic, ginger,
snow peas and shiitake mushrooms,
and cook for another minute before
returning the steak to the wok.
4 Separate the noodles with a fork,
then drain. Add to the wok, tossing
well. Combine the oyster sauce with
the soy sauce, brown sugar, five-spice
powder and 1 tablespoon water and
pour over the noodles. Toss until
warmed through, then serve
immediately.

NUTRITION PER SERVE
Fat 10 g; Protein 37.5 g; Carbohydrate
91.5 g; Dietary Fibre 6.5 g; Cholesterol
78 mg; 2555 kJ (610 Cal)

*Cut the partially frozen beef fillet into thin
slices with a sharp knife.*

*Stir in the garlic, ginger, snow peas and
shiitake mushrooms.*

STUFFED CABBAGE ROLLS

Preparation time: 35 minutes
Total cooking time: 1 hour 35 minutes
Makes 12

1 tablespoon olive oil
1 onion, finely chopped
large pinch of allspice
1 teaspoon ground cumin
large pinch of ground nutmeg
2 bay leaves
1 large head cabbage (3 kg or
 6 lb 12 oz)
750 g (1 lb 10 oz) minced (ground)
 lamb
200 g (1 cup) long-grain white rice,
 partially cooked (see Note)
4 cloves garlic, crushed
50 g (1/3 cup) pine nuts, toasted
2 tablespoons finely chopped mint
2 tablespoons finely chopped flat-leaf
 (Italian) parsley
1 tablespoon finely chopped raisins
 or currants
2 tablespoons olive oil, extra
80 ml (1/3 cup) lemon juice
lemon wedges, to serve

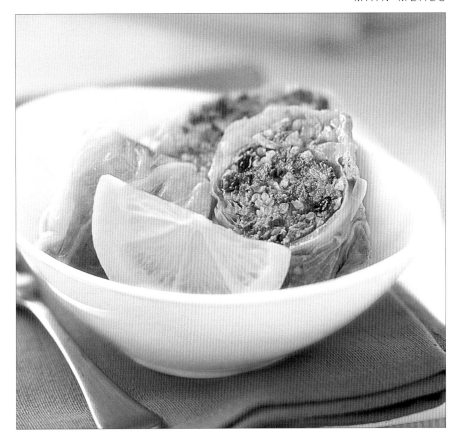

1 Heat the oil in a saucepan, add the onion and cook over medium heat for 10 minutes, or until golden. Add the allspice, cumin and nutmeg and cook for 2 minutes, or until fragrant. Remove from the heat.
2 Bring a very large saucepan of water to the boil and add the bay leaves. Remove the tough outer leaves and about 5 cm (2 inch) of the core from the cabbage with a sharp knife, then place the cabbage into the boiling water. Cook for 5 minutes, then carefully loosen a whole leaf with tongs and remove. Continue to cook and remove the leaves until you reach the core. Drain and reserve the liquid. Allow to cool.
3 Take 12 leaves of equal size. Cut a small "V" from the core end of each leaf to remove the thickest part. Trim the firm central veins so the leaf is as flat as possible. Line the base of the large saucepan with three-quarters of the leftover leaves to prevent the rolls catching on the bottom.

4 Combine the onion mixture, rice, mince, garlic, pine nuts, mint, parsley and raisins in a bowl and season. With the core end of the leaf closest to you, form 2 well-rounded tablespoons of mixture into an oval and place in the centre of the leaf. Roll up, tucking in the sides to enclose the filling. Repeat with the remaining 11 leaves and filling. Place the rolls tightly in the lined saucepan, seam-side down.
5 Combine 3½ cups (875 ml) of the cooking liquid with the extra olive oil, lemon juice and 1 teaspoon salt and pour over the rolls (the liquid should just come to the top of the rolls). Lay the remaining cabbage leaves over the top. Cover and bring to the boil over high heat, then reduce the heat and simmer very gently for 1 hour 15 minutes, or until the mince and rice are cooked through. Carefully remove from the pan and drizzle with extra virgin olive oil, if desired. Serve with lemon wedges.

NUTRITION PER ROLL
Fat 11.5 g; Protein 15 g; Carbohydrate 9 g; Dietary Fibre 3 g; Cholesterol 43 mg; 840 kJ (200 Cal)

COOK'S FILE
Note: Partially cook the rice in a saucepan of boiling water for 8 minutes.

Gently loosen a whole leaf using tongs and remove from the pan.

Roll up the leaf, starting at the core end, tucking in the sides to enclose the filling.

MOUSSAKA

Preparation time: 30 minutes
Total cooking time: 1 hour 30 minutes
Serves 4–6

2 large eggplants (aubergines) (about
 800 g or 1 lb 12 oz)
1 tablespoon olive oil
1 large onion, chopped
1 clove garlic, crushed
500 g (1 lb 2 oz) extra lean minced
 (ground) beef
125 ml (1/2 cup) red wine
125 g (1/2 cup) tomato paste (purée)
pinch of ground cinnamon
2 teaspoons chopped oregano
15 g (1/2 cup) flat-leaf (Italian) parsley,
 chopped
35 g (1/3 cup) dry wholemeal or
 multigrain breadcrumbs
2 tablespoons grated Parmesan cheese

Sauce
20 g (1/2 oz) butter
40 g (1/3 cup) plain (all-purpose) flour
250 ml (1 cup) skim milk
250 ml (1 cup) milk
pinch of ground nutmeg
1 tablespoon grated Parmesan cheese

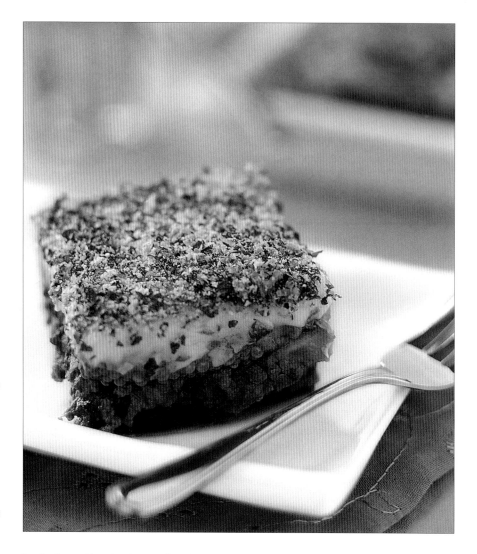

1 Preheat the oven to moderately hot 200°C (400°F/Gas 6). Slice the eggplants lengthways into 1.5 cm (5/8 inch) pieces, then lay the slices on two foil-lined baking sheets. Using 2 teaspoons oil, brush each slice on one side then turn over. Bake for 10 minutes, then turn and bake for 10 minutes, or until just golden. Cool.
2 Heat the remaining oil in a large saucepan. Add the onion and garlic. Cook over medium heat for 5 minutes, or until the onion becomes transparent. Increase the heat to high, add the beef and brown for 5 minutes. Stir in the wine, tomato paste, cinnamon, oregano and 5 g (1/4 cup) of parsley. Season with salt and pepper, reduce the heat and simmer, stirring occasionally, for 15–20 minutes. Remove from the heat.
3 To make the sauce, melt the butter in a small saucepan. Stir in the flour and cook over low heat for 2–3 minutes. Gradually whisk in

both the milks. Cook over low heat for 6–8 minutes, or until it is smooth and thick. Remove the mixture from heat. Add the nutmeg, Parmesan and 1/2 teaspoon salt.
4 To assemble, grease an 18 x 28 cm (7 inch x 11 inch) rectangular or 22 cm (9 inch) round casserole dish. Sprinkle the base with half the breadcrumbs. Add a layer of eggplant slices. Spread the beef on top. Place

the remaining eggplant slices over the mince. Pour the sauce over top. Combine the Parmesan, remaining parsley and breadcrumbs, and pepper. Sprinkle on top. Bake for 30 minutes, or until bubbling and golden. Leave for 5 minutes before serving.

NUTRITION PER SERVE (6)
Fat 15 g; Protein 25 g; Carbohydrate 19 g; Dietary Fibre 4 g; Cholesterol 61 mg; 1350 kJ (325 Cal)

Bake the slices of eggplant on a foil-lined baking tray until just golden brown.

Whisk the sauce until the mixture is smooth and thickens.

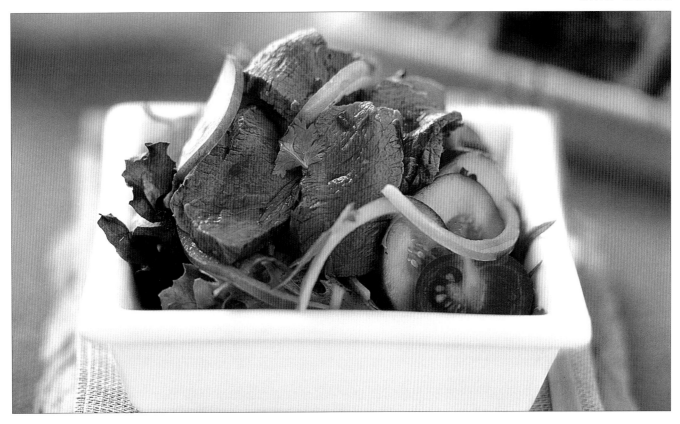

WARM THAI BEEF SALAD

Preparation time: 15 minutes
Total cooking time: 10 minutes
Serves 4

400 g (14 oz) beef fillet steaks
75 g (2½ oz) mixed salad leaves
½ small red onion, thinly sliced
100 g (3½ oz) cherry tomatoes,
 halved
1 small Lebanese (short) cucumber,
 thinly sliced
20 g (⅓ cup) chopped coriander
 (cilantro) leaves
20 g (⅓ cup) chopped mint

Dressing

1½ tablespoons fish sauce
2 tablespoons lime juice
1 tablespoon soft brown sugar
1 small red chilli, seeded and finely
 chopped

1 Season the beef well on both sides with freshly ground black pepper. Spray a chargrill (griddle) or hotplate with oil spray and when very hot, sear the beef fillets on each side for 3–4 minutes. Season with salt. Remove and leave to rest for 10 minutes. Slice the beef thinly—the meat should still be quite pink in the middle.

2 While the meat is resting, make the dressing. Combine the fish sauce, lime juice, brown sugar, chilli and 2 tablespoons water in a small saucepan and stir over low heat until the sugar has dissolved. Remove from the heat and keep warm.

3 Place the mixed salad leaves, onion, tomato, cucumber, coriander leaves and mint in a large bowl and toss together. Arrange the salad on a large platter, top with the beef slices and pour the warm dressing on top. Serve immediately.

NUTRITION PER SERVE
Fat 4.5 g; Protein 23 g; Carbohydrate 5.5 g; Dietary Fibre 2 g; Cholesterol 67 mg; 655 kJ (155 Cal)

Press freshly ground black pepper onto the fillets with your fingertips.

Allow the steaks to rest, then slice thinly using a sharp knife.

Toss together the mixed salad leaves, onion, tomato, cucumber, coriander and mint.

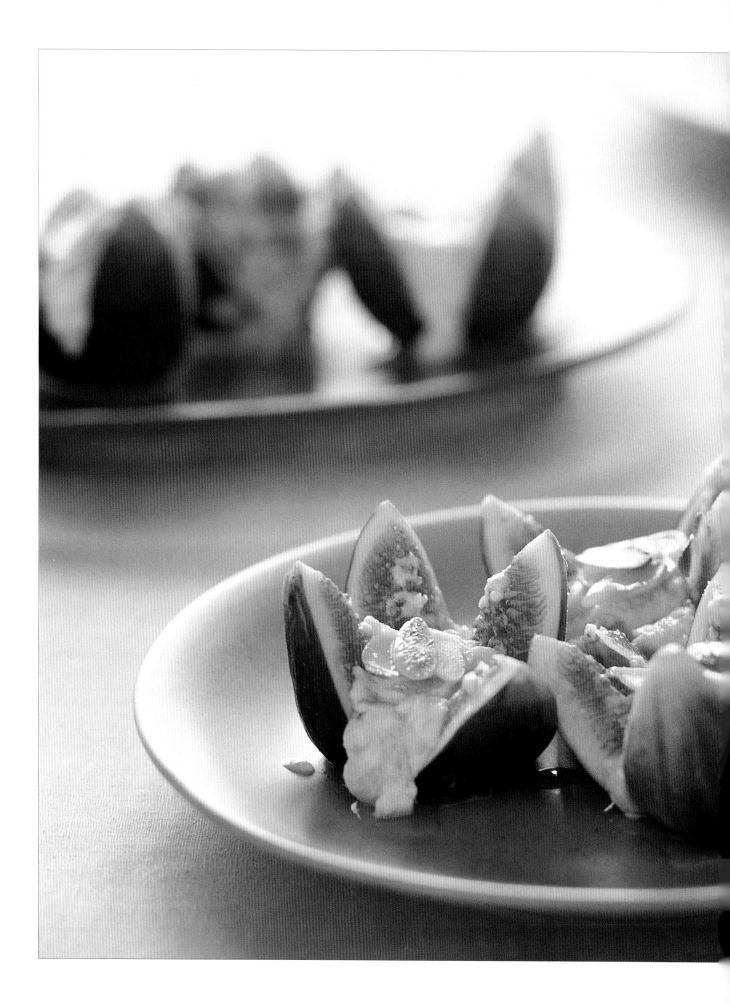

DESSERTS AND SWEET TREATS

GRILLED FIGS WITH RICOTTA

Preparation time: 10 minutes
Total cooking time: 10 minutes
Serves 4

2 tablespoons honey
1 cinnamon stick
3 tablespoons flaked almonds
4 large (or 8 small) fresh figs
125 g (1/2 cup) low-fat ricotta cheese
1/2 teaspoon vanilla essence
2 tablespoons icing (confectioners')
 sugar, sifted
pinch ground cinnamon
1/2 teaspoon finely grated
 orange zest

1 Place the honey and cinnamon stick in a small saucepan with 80 ml (1/3 cup) water. Bring to the boil, then reduce the heat and simmer gently for 6 minutes, or until thickened and reduced by half. Lift out the cinnamon stick with a pair of tongs, then stir in the flaked almonds.

2 Preheat the grill (broiler) to moderately hot and grease a shallow ovenproof dish large enough to fit all the figs side by side. Slice the figs into quarters from the top to within 1 cm (1/2 inch) of the bottom, keeping them attached at the base. Arrange in prepared dish.

3 Combine the ricotta, vanilla, icing sugar, ground cinnamon and orange zest in a small bowl. Divide the filling among the figs, spooning it into their cavities. Spoon the syrup over the top. Place under the grill and cook until the juices start to come out from the figs and the almonds are lightly toasted. Cool for 2–3 minutes. Spoon the juices and any fallen almonds from the bottom of the dish over the figs and serve.

NUTRITION PER SERVE
Fat 5.5 g; Protein 5 g; Carbohydrate 23.5 g; Dietary Fibre 2 g; Cholesterol 13 mg; 680 kJ (160 Cal)

Cut each fig into quarters from the top, without cutting through the base.

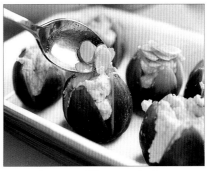

Spoon the ricotta filling into the fig cavity, then spoon some syrup on top.

FRUIT EN PAPILOTTE WITH YOGHURT

Preparation time: 15 minutes
Total cooking time: 15 minutes
Serves 4

1 large ripe mango
4 passionfruit
100 ml (3½ fl oz) orange juice
75 g (⅓ cup) caster (superfine) sugar
4 bananas
1 tablespoon lemon juice
1 vanilla bean

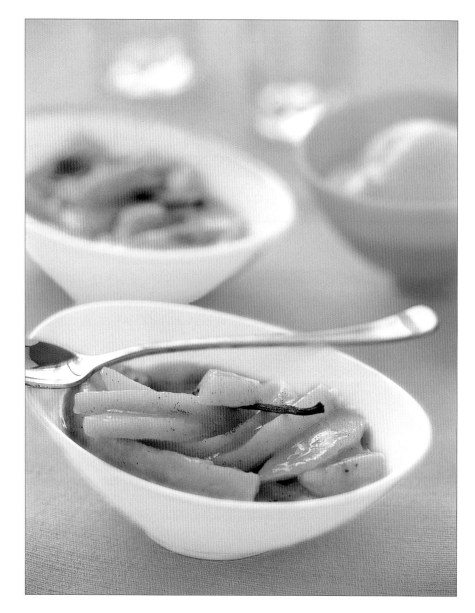

1 Preheat the oven to 180°C (350°F/Gas 4). Cut the mango down each side of the centre stone. Using a large metal spoon, remove the flesh from the skin. Remove the remaining flesh from around the stone. Halve the passionfruit and remove the pulp. Pass the pulp through a sieve, pressing down well to loosen the pulp. Discard the seeds.
2 Blend the orange juice, sugar, passionfruit pulp and a quarter of the mango in a food processor or blender until smooth.
3 Fold four double layers of foil (about 30 cm or 12 inches long). Place a 25 cm (10 inch) square piece of baking paper on top of the foil. Cut the bananas in half lengthways and place 2 halves on each piece of foil. Divide the remaining mango pieces among the four portions then sprinkle with the lemon juice.
4 Cut the vanilla bean in half lengthways, then cut each piece in half. Scrape the seeds onto the fruit then place a piece of the empty pod on top. Spoon on the fruit syrup.

5 Leaving a 2 cm (¾ inch) gap between the fruit and the foil, fold the foil neatly over to create a parcel. Place on a baking tray and bake for 12 minutes.
6 To serve, open the parcels carefully and transfer the fruit to a serving

bowl or place the opened parcel on a plate. Serve with low-fat yoghurt or ice cream on the side.

NUTRITION PER SERVE
Fat 0.5 g; Protein 3 g; Carbohydrate 48.5 g; Dietary Fibre 5.5 g; Cholesterol 0 mg; 860 kJ (205 Cal)

Remove the mango flesh from the skin using a large metal spoon.

Place a piece of the empty vanilla pod on top of the mango slices.

Neatly fold in the sides, then fold the paper and foil over the fruit to create a parcel.

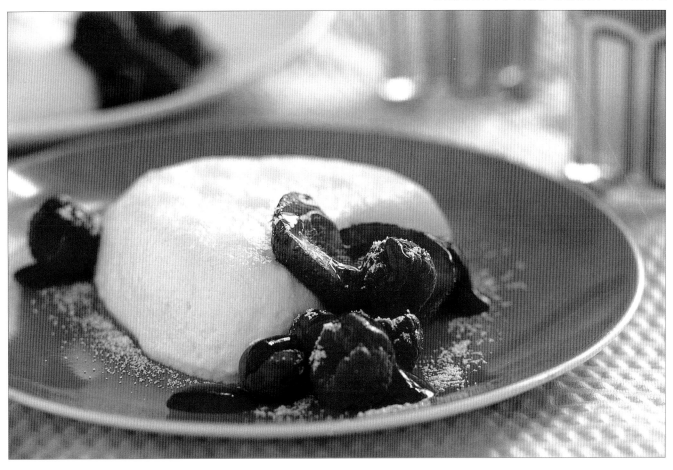

COEUR A LA CREME WITH BERRIES

Preparation time: 20 minutes + overnight refrigeration
Total cooking time: Nil
Serves 4

100 g (3¹/2 oz) low-fat ricotta cheese
65 g (2¹/2 oz) fat-reduced cream cheese
65 g (2¹/2 oz) light sour cream
2 tablespoons icing (confectioners') sugar
1 egg white
170 g (6 oz) mixed berries (strawberries, blueberries, raspberries)
icing (confectioners') sugar, extra, to dust

1 Beat the ricotta, cream cheese and sour cream with 1 tablespoon icing sugar until mixed. Beat the egg white in a separate clean bowl until stiff peaks form, then carefully fold into cheese mixture with a metal spoon.
2 Line four ceramic heart-shaped moulds with a square of dampened muslin. Fill with the cheese mixture.

Bring the remaining muslin up over the top to cover and lightly press. Put the moulds on a tray and refrigerate for 6 hours, or preferably overnight.
3 Blend half the berries and the remaining sugar in a food processor until combined. Strain.
4 To serve, unmould the crèmes onto a plate and place a pile of berries to the side. Drizzle with the purée and dust with icing sugar.

NUTRITION PER SERVE
Fat 8 g; Protein 6 g; Carbohydrate 10 g; Dietary Fibre 1.5 g; Cholesterol 29 mg; 570 kJ (135 Cal)

Gently fold the stiffly beaten egg white into the cheese mixture.

Spoon the cheese mixture into the heart-shaped moulds.

Blend the berries and sugar in a food processor until combined.

APPLE AND PEAR SORBET

Preparation time: 10 minutes +
　freezing
Total cooking time: 10 minutes
Serves 4–6

4 large green apples, peeled, cored
　and chopped
4 pears, peeled, cored and chopped
1 piece of lemon zest (1.5 cm x 4 cm
　or 5/8 inch x 1 1/2 inch)
1 cinnamon stick
60 ml (1/4 cup) lemon juice
4 tablespoons caster (superfine) sugar
2 tablespoons Calvados or poire
　William liqueur (optional)

1 Place the apple and pear in a large deep saucepan with the lemon zest, cinnamon stick and enough water to just cover the fruit. Cover and poach the fruit gently over medium–low heat for 6–8 minutes, or until tender. Remove the lemon zest and cinnamon stick. Place the fruit in a food processor and blend with the lemon juice until smooth.
2 Place the sugar in a saucepan with 80 ml (1/3 cup) water; bring to the boil. Simmer for 1 minute. Add the fruit purée and liqueur and mix well.
3 Pour into a shallow metal tray and freeze for 2 hours, or until the mixture is frozen around the edges. Transfer to a food processor or bowl and blend or beat until smooth. Pour back into the tray and return to the freezer. Repeat this process three times. For the final freezing, place in an airtight container—cover the surface with a piece of greaseproof paper and cover with a lid. Serve in small glasses or bowls.

NUTRITION PER SERVE (6)
Fat 0.5 g; Protein 1 g; Carbohydrate 42 g; Dietary Fibre 4.5 g; Cholesterol 0 mg; 730 kJ (175 Cal)

COOK'S FILE
Notes: The length of cooking time to poach the apple and pear will depend on the ripeness of the fruit.
Pour an extra nip of Calvados over the sorbet to serve, if desired.

Check if the fruit is tender by using the tip of a sharp knife.

Blend the partially frozen mixture in a food processor until smooth.

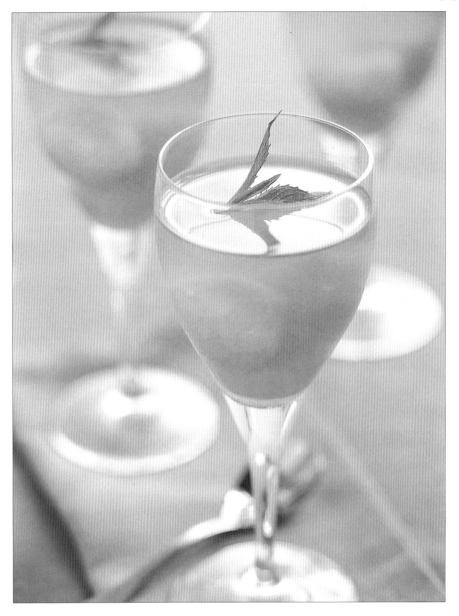

After soaking, squeeze the sheets of gelatine to remove any excess water.

Stir the gelatine sheets into the hot liquid until they have dissolved.

Divide the lychees among the wine glasses, gently dropping them into the jelly mixture.

GINGER AND LYCHEE JELLY

Preparation time: 10 minutes +
 4 hours setting
Total cooking time: 5 minutes
Serves 6

565 g (1 lb 4 oz) can lychees
500 ml (2 cups) clear apple juice
 (no added sugar)
80 ml (1/3 cup) strained lime juice
2 tablespoons caster (superfine) sugar
3 cm x 3 cm (1 1/4 inch x 1 1/4 inch)
 piece fresh ginger, peeled and
 thinly sliced
4 sheets gelatine (about 5 g or 1/8 oz)
mint to garnish

1 Drain the syrup from the lychees and reserve 250 ml (1 cup) of the syrup. Discard the remaining syrup. Place the reserved syrup, apple juice, lime juice, sugar and ginger in a saucepan. Bring to the boil, then reduce the heat and simmer for 5 minutes. Strain into a heatproof bowl.
2 Place the gelatine sheets in a large bowl of cold water and soak for 2 minutes, or until they soften. Squeeze out the excess water, then add to the syrup. Stir until the gelatine has completely dissolved. Leave to cool.
3 Pour 2 tablespoons of the jelly mixture into each of six 150 ml (5 fl oz) stemmed wine glasses, and

divide the lychees among the wine glasses. Refrigerate until the jelly has set. Spoon the remaining jelly over the fruit and refrigerate until set. Before serving, garnish with mint leaves.

NUTRITION PER SERVE
Fat 0 g; Protein 1 g; Carbohydrate 31 g; Dietary Fibre 0.5 g; Cholesterol 0 mg; 530 kJ (125 Cal)

COOK'S FILE
Note: Sprinkle 1 tablespoon slivered almonds among the jelly, if desired.

CHOCOLATE AND ORANGE SELF-SAUCING PUDDINGS

Preparation time: 15 minutes
Total cooking time: 35 minutes
Serves 4

2 tablespoons cocoa powder
125 g (1 cup) self-raising flour
60 g (2¼ oz) low-fat cream cheese
1 teaspoon finely grated orange zest
125 g (½ cup) caster (superfine) sugar
125 ml (½ cup) skim milk
80 ml (⅓ cup) freshly squeezed
 orange juice
95 g (½ cup) soft brown sugar
1 tablespoon cocoa powder, extra
icing (confectioners') sugar, to dust

1 Preheat the oven to 180°C (350°F/Gas 4). Sift the cocoa powder with the flour, at least twice. Using a wooden spoon, blend the cream cheese, orange zest and caster sugar until smooth.
2 Fold the flour mixture and milk alternately into the cream cheese mixture and stir in the orange juice. Pour the mixture into four greased 310 ml (1¼ cup) ramekins.
3 Combine the brown sugar and extra cocoa and sprinkle evenly over the surface of the puddings. Carefully pour 80 ml (⅓ cup) boiling water over the back of a spoon onto each pudding. Place on a baking tray and bake for 35 minutes, or until firm. Dust with icing sugar and serve.

NUTRITION PER SERVE
Fat 3.5 g; Protein 6.5 g; Carbohydrate 51.5 g; Dietary Fibre 1.5 g; Cholesterol 8.5 mg; 1100 kJ (265 Cal)

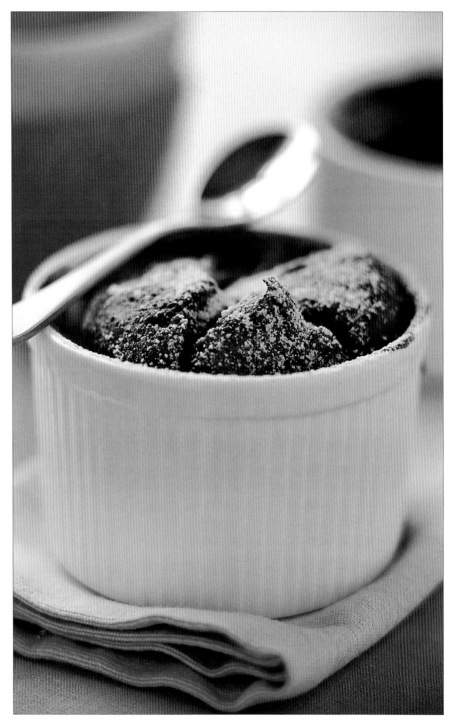

Blend the cream cheese, orange zest and sugar until smooth.

Evenly pour the pudding mixture into the ramekins, scraping the bowl with a spatula.

Gently pour the boiling water over the back of a spoon onto each pudding.

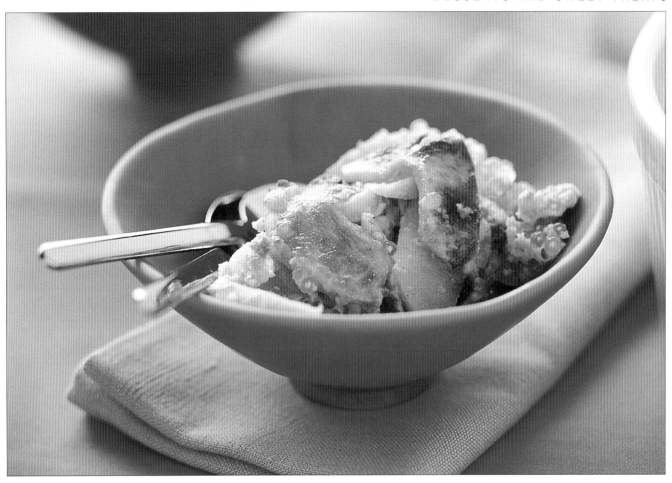

APPLE SAGO PUDDING

Preparation time: 15 minutes
Total cooking time: 50 minutes
Serves 4

90 g (1/3 cup) caster (superfine) sugar
100 g (1/2 cup) sago
600 ml (21 fl oz) fat-reduced milk
55 g (1/3 cup) sultanas
1 teaspoon vanilla essence
pinch ground nutmeg
1/4 teaspoon ground cinnamon

2 eggs, lightly beaten
250 g (9 oz; about 3 small ripe
 apples), peeled, cored and very
 thinly sliced
1 tablespoon soft brown sugar

1 Preheat the oven to 180°C
(350°F/Gas 4). Grease a
1.5 litre (6 cup) ceramic soufflé dish.
Place the sugar, sago, milk, sultanas
and 1/4 teaspoon salt in a saucepan.
Heat the mixture, stirring often.
Bring to the boil, then reduce the
heat and simmer for 5 minutes.

2 Stir in the vanilla essence, nutmeg,
cinnamon, egg and the apple slices,
then pour into the prepared dish.
Sprinkle with the brown sugar and
bake for 45 minutes, or until set and
golden brown.

NUTRITION PER SERVE
Fat 5 g; Protein 9.5 g; Carbohydrate 70 g;
Dietary Fibre 2 g; Cholesterol 101 mg;
1495 kJ (355 Cal)

COOK'S FILE
Note: If you prefer, you can use skim
milk instead of fat-reduced milk.

*Bring the sugar, sago, milk, sultanas and
salt to the boil, stirring frequently.*

*Stir in the vanilla, ground spices, egg and
apple slices.*

*Sprinkle the surface of the pudding with the
brown sugar.*

Beat the egg mixture, flour, lemon juice, zest and passionfruit pulp until combined.

Carefully mould a piece of filo pastry into each muffin hole.

Pour the lemon and passionfruit mixture into the pastry cases.

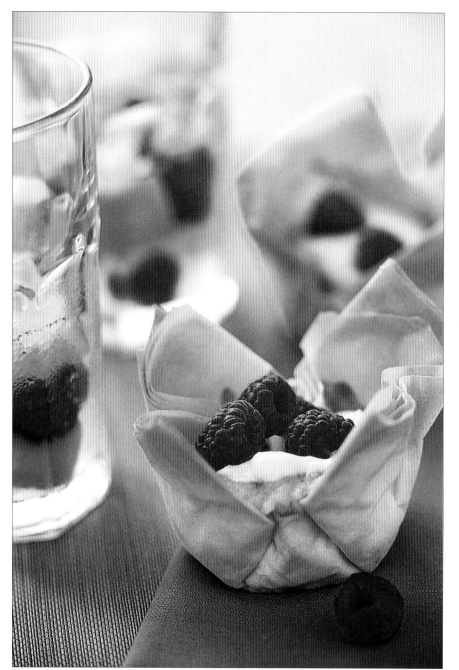

INDIVIDUAL LEMON AND PASSIONFRUIT TARTS WITH RASPBERRIES

Preparation time: 15 minutes
Total cooking time: 25 minutes
Makes 6

60 g (2½ oz) low-fat margarine
90 g (⅓ cup) caster (superfine) sugar
2 eggs
2 tablespoons self-raising flour, sifted
60 ml (¼ cup) lemon juice
1 teaspoon grated lemon zest

1 passionfruit, pulp removed
3 sheets filo pastry
125 g (4½ oz) fresh raspberries

1 Preheat the oven to 180°C (350°F/Gas 4). Beat the margarine and sugar until light and creamy. Add the eggs one at a time, beating well after each addition.
2 Add the flour, lemon juice, zest and passionfruit pulp and beat until well combined.
3 Fold each sheet of filo pastry in half from the short end up. Fold again and cut in half. Carefully line

six 125 ml (½ cup) muffin holes with a piece of pastry. Pour in the lemon mixture and bake for 20–25 minutes, or until set. Serve topped with the fresh raspberries and, if desired, whipped light cream.

NUTRITION PER SERVE
Fat 6 g; Protein 3.5 g; Carbohydrate 9 g;
Dietary Fibre 2 g; Cholesterol 60 mg;
435 kJ (105 Cal)

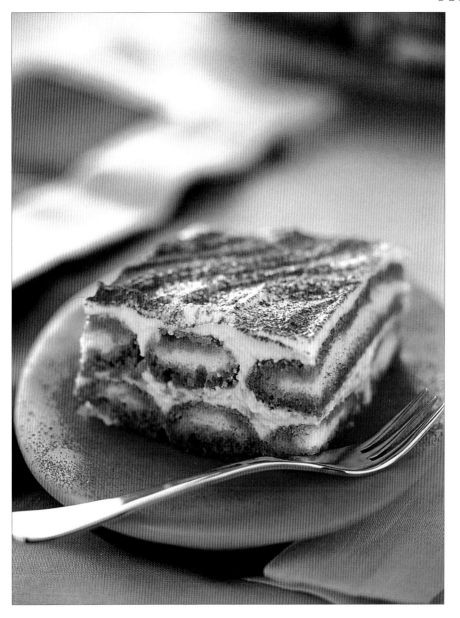

Beat the ricotta, fromage frais, sugar and vanilla until smooth.

Dip the sponge finger biscuits in the coffee and Marsala mixture.

Arrange half the coffee-soaked biscuits in a single layer over the base of the dish.

TIRAMISU

Preparation time: 20 minutes +
 overnight refrigeration
Total cooking time: Nil
Serves 6

500 g (1 lb 2 oz) low-fat ricotta cheese
2 x 200 g (7 oz) tubs low-fat French
 vanilla fromage frais
1¹/₂ tablespoons caster (superfine) sugar
1 teaspoon vanilla essence
185 ml (³/4 cup) strongly brewed
 coffee, cooled
185 ml (³/4 cup) Marsala
250 g (9 oz) thin sponge finger biscuits
1 tablespoon unsweetened Dutch
 cocoa powder

1 Beat the ricotta, fromage frais, sugar and vanilla essence with electric beaters in a bowl until smooth. Combine the coffee and Marsala in a large shallow dish.
2 Dip half the biscuits, a few at a time, into the coffee mixture for a few seconds until both sides become moist but not soggy. Arrange the biscuits in a single layer over the base of a 2 litre (8 cup) serving dish. Spread half the ricotta mixture over the biscuits, then repeat another layer with the remaining dipped biscuits and ricotta mixture.
3 Cover with plastic wrap and refrigerate for 6 hours or preferably overnight. Dust with the cocoa powder before serving.

Spread half the ricotta mixture over the biscuits with a spatula.

NUTRITION PER SERVE
Fat 9.5 g; Protein 18 g; Carbohydrate 41.5 g; Dietary Fibre 0.5 g; Cholesterol 101.5 mg; 1490 kJ (355 Cal)

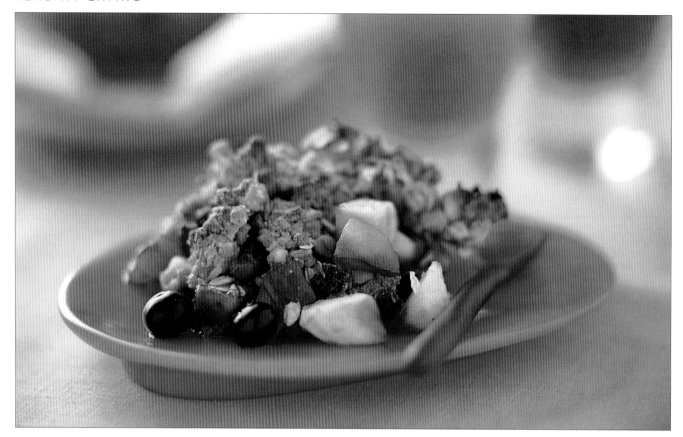

APPLE, BLUEBERRY AND RHUBARB CRUMBLE

Preparation time: 20 minutes
Total cooking time: 40 minutes
Serves 6

5 Granny Smith apples (1 kg or
 2lb 4 oz), peeled and diced
250 g (2 cups) diced rhubarb
1 tablespoon lemon juice
125 g (1/2 cup) sugar
2 tablespoons cornflour (cornstarch)
125 ml (1/2 cup) apple juice
1 teaspoon grated orange zest
150 g (1 cup) blueberries, fresh or frozen

Crumble
65 g (2/3 cup) rolled oats
100 g (2/3 cup) plain wholemeal
 (whole-wheat) flour
60 g (1/3 cup) soft brown sugar
1/2 teaspoon ground cinnamon
45 g (1/3 cup) chopped macadamia nuts
80 g (2¾ oz) butter, melted

1 Preheat the oven to 180°C (350°F/ Gas 4). Grease a 2 litre (8 cup) rectangular 20 x 30 cm or 8 inch x 12 inch) ovenproof dish. Combine the apple and rhubarb in a bowl, drizzle with lemon juice and sprinkle with half the sugar. Leave for 5 minutes.
2 Combine the cornflour with the apple juice until smooth, then add to the rhubarb and apple mixture with the orange zest and remaining sugar. Toss the blueberries through until combined, then spoon the fruit mixture into the prepared dish.
3 To make the crumble, place the oats, flour, brown sugar, cinnamon and nuts in a bowl. Add the butter and rub it in with your fingertips, mixing thoroughly. Sprinkle the crumble over the fruit and bake for 40 minutes, or until crisp and golden.

NUTRITION PER SERVE
Fat 18 g; Protein 5 g; Carbohydrate 75.5 g; Dietary Fibre 7.5 g; Cholesterol 33 mg; 1975 kJ (470 Cal)

Sprinkle half the sugar over the combined pieces of apple and rhubarb.

Stir the blueberries through the apple, rhubarb, sugar and orange zest.

Rub the butter through the crumble mixture with your fingertips.

BAKED LEMON CHEESECAKE

Preparation time: 10 minutes +
 5 hours 30 minutes refrigeration
Total cooking time: 45 minutes
Serves 8

100 g (3¹/2 oz) plain sweet biscuits,
 crushed
75 g (2¹/2 oz) low-fat canola
 margarine, melted
300 g (10¹/2 oz) low-fat ricotta cheese
200 g (7 oz) low-fat cream cheese
125 g (¹/2 cup) caster (superfine) sugar
80 ml (¹/3 cup) lemon juice
2 tablespoons grated lemon zest
1 egg
1 egg white

1 Preheat the oven to 160°C (315°F/Gas 2–3). Lightly grease an 18 cm (7 inch) springform tin and line the base with baking paper. Combine the crushed biscuits and margarine and press into the base of the tin. Refrigerate for 30 minutes.
2 Beat the ricotta, cream cheese, sugar, lemon juice and 3 teaspoons of lemon zest with electric beaters until smooth. Beat in the egg and egg white.
3 Pour the mixture into the tin, then sprinkle the surface with remaining lemon zest. Bake for 45 minutes—the centre will still be a little wobbly. Leave to cool, then refrigerate for at least 5 hours before serving.

NUTRITION PER SERVE
Fat 15.5 g; Protein 8 g; Carbohydrate 26.5 g; Dietary Fibre 0.5 g; Cholesterol 52.5 mg; 1150 kJ (275 Cal)

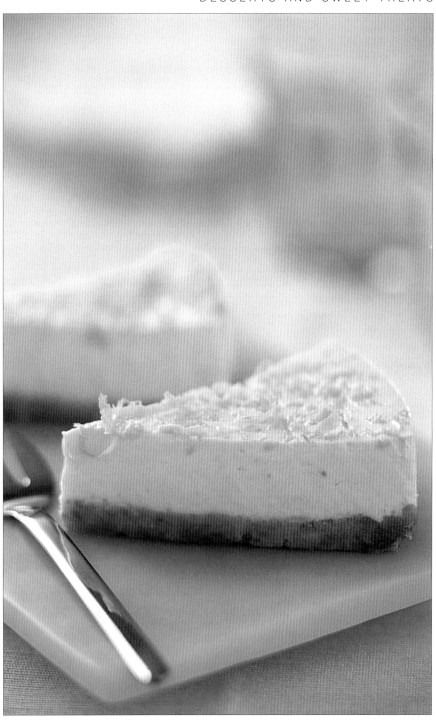

Press the crushed biscuit mixture into the base of the prepared tin.

Beat the ricotta, cream cheese, sugar, lemon juice and zest until smooth.

Pour the filling mixture into the tin, scraping the bowl with a spatula.

ALMOND, ORANGE AND CARDAMOM BISCOTTI

Preparation time: 20 minutes
Total cooking time: 1 hour
Makes 40

2 eggs
155 g (2/3 cup) firmly packed soft
 brown sugar
125 g (1 cup) self-raising flour
90 g (3/4 cup) plain (all-purpose) flour
125 g (4½ oz) almonds
1 tablespoon finely grated orange zest
¼ teaspoon ground cardamom

1 Preheat the oven to 160°C (315°F/Gas 2–3). Line an oven tray with baking paper.
2 Beat the eggs and sugar in a bowl with electric beaters until pale and creamy. Sift the self-raising and plain flours into the bowl, then add the almonds, orange zest and cardamom and mix to a soft dough.
3 Turn out the dough onto a lightly floured work surface. Divide the mixture into two portions, shaping into two 5 cm x 20 cm (2 inch x 8 inch) loaves.
4 Bake for 35–40 minutes, or until lightly golden. Transfer to a wire rack to cool. Cut the loaves into 1 cm (¼ inch) diagonal slices with a large serrated bread knife. The biscotti will be crumbly on the edges so work slowly and, if possible, try to hold the sides as you cut.
5 Arrange the slices on baking trays in a single layer. Return to the oven for 10 minutes on each side. Don't worry if they don't seem fully dry as they will become crisp on cooling. Allow the biscotti to cool completely before serving. Store in an airtight container for 2–3 weeks.

NUTRITION PER BISCOTTI
Fat 2 g; Protein 1.5 g; Carbohydrate 8 g; Dietary Fibre 0.5 g; Cholesterol 9 mg; 230 kJ (55 Cal)

Divide the soft dough in half and form into two loaves.

Cut each loaf into diagonal slices with a large serrated knife.

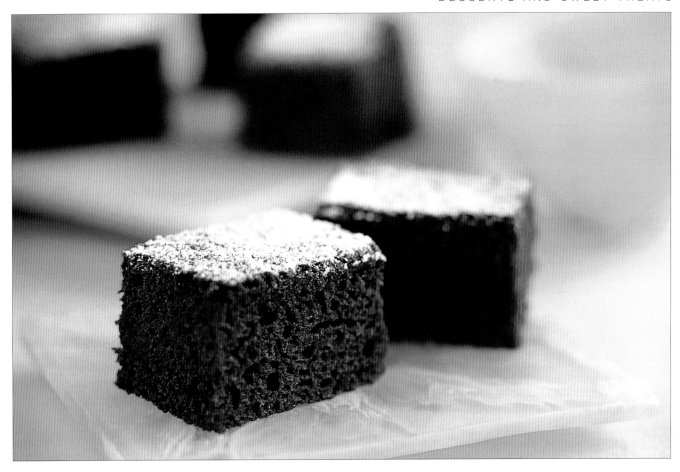

BROWNIES

Preparation time: 15 minutes
Total cooking time: 40 minutes
Makes 18

60 g (1/2 cup) self-raising flour
60 g (1/2 cup) plain (all-purpose) flour
60 g (1/2 cup) cocoa powder
1/2 teaspoon bicarbonate of soda
230 g (1 1/4 cups) soft brown sugar
2 eggs
250 ml (1 cup) buttermilk
2 teaspoons vanilla essence

2 tablespoons oil
icing (confectioners') sugar, to dust

1 Preheat the oven to 180°C (350°F/Gas 4). Lightly grease a 28 cm x 18 cm (11 inch x 7 inch) shallow tin and line the base with baking paper, extending over the two long sides.
2 Sift the flours, cocoa powder, bicarbonate of soda and a pinch of salt into a mixing bowl, then stir in the sugar. Whisk the eggs, buttermilk, vanilla and oil in a jug.

3 Gently stir the egg mixture into the dry ingredients until combined—do not overbeat. Pour into the tin and bake for 40 minutes, or until it springs back to a light touch in the centre. Leave in the tin for 5 minutes, then turn out onto a wire rack to cool completely.
4 To serve, cut into 18 squares and dust with icing sugar. Store in an airtight container for up to 3 days.

NUTRITION PER BROWNIE
Fat 3.5 g; Protein 2.5 g; Carbohydrate 19 g; Dietary Fibre 0.5 g; Cholesterol 21.5 mg; 485 kJ (115 Cal)

Line the tin with baking paper, leaving it hanging over the two long sides.

Gently stir the egg mixture into the dry ingredients until combined.

The brownies are cooked if the centre springs back when lightly touched.

MANDARIN ICE

Preparation time: 10 minutes +
 freezing
Total cooking time: 10 minutes
Serves 4–6

10 mandarins
125 g (1/2 cup) caster (superfine) sugar

1 Squeeze the mandarins to make
500 ml (2 cups) juice and strain.
2 Place the sugar and 250 ml (1 cup)
water in a small saucepan. Stir over
low heat until the sugar has dissolved
and simmer for 5 minutes. Remove
from the heat and cool slightly.
3 Stir the mandarin juice into the
sugar syrup, then pour into a shallow
metal tray. Freeze for 2 hours, or

until frozen. Transfer to a food
processor and blend until slushy.
Return to the freezer and repeat the
process three more times.

NUTRITION PER SERVE (6)
Fat 0 g; Protein 0.5 g; Carbohydrate 5.5 g;
Dietary Fibre 0 g; Cholesterol 0 mg;
105 kJ (25 Cal)

*Squeeze the mandarins (as you would other
citrus fruits) to give 2 cups of juice.*

*Stir the mandarin juice into the saucepan of
sugar water.*

*Blend the frozen mixture in a food processor
until slushy.*

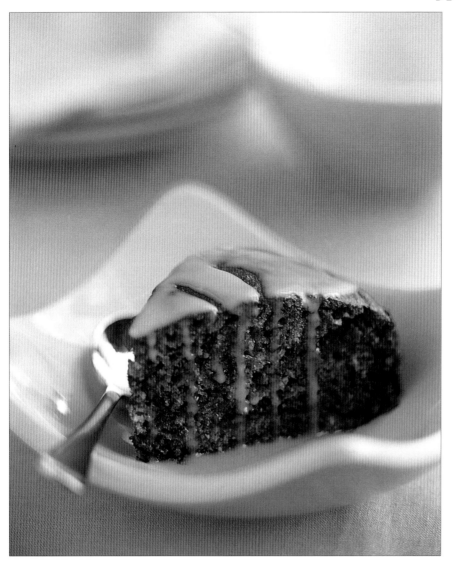

Fold in the flours alternately with the date mixture in two batches.

Pour the pudding mixture into the prepared cake tin.

Stir the sauce continually with a wooden spoon until it thickens slightly.

STICKY DATE PUDDING

Preparation time: 15 minutes
Total cooking time: 1 hour
Serves 8

280 g (1 1/2 cups) chopped dates
1 teaspoon vanilla essence
2 teaspoons bicarbonate of soda
90 g (3 1/2 oz) low-fat margarine
95 g (1/2 cup) soft brown sugar
2 eggs
150 g (5 1/2 oz) wholemeal (wholewheat) self-raising flour, sifted
60 g (1/2 cup) self-raising flour, sifted

Sauce
185 ml (3/4 cup) low-fat evaporated milk
95 g (1/2 cup) soft brown sugar
1 tablespoon margarine
1 teaspoon custard powder

1 Preheat the oven to moderate 180°C (350°F/Gas 4). Lightly grease and line the base and side of a 20 cm (8 inch) round cake tin.

2 Place the dates and 375 ml (1 1/2 cups) water in a saucepan. Bring to the boil then reduce the heat and simmer for 5 minutes, or until soft. Stir in the vanilla essence and bicarbonate of soda and set aside to cool to room temperature.

3 Beat the margarine and sugar with electric beaters until pale and creamy. Gradually add the eggs, beating well after each addition—the mixture may look curdled at this stage, but a spoonful of flour will bring it back together. Fold in the flours and the date mixture in two batches, using a metal spoon.

4 Pour the mixture into the prepared tin. Bake for 50 minutes, or until a skewer comes out clean when inserted into the centre of the pudding. Cool in the tin for 10–15 minutes.

5 To make the sauce, heat the evaporated milk, brown sugar and margarine in a saucepan until almost boiling. Combine the custard powder and 1 teaspoon water until smooth, then gradually add to the sauce, stirring continually over medium heat until it thickens slightly. Serve warm with the pudding.

NUTRITION PER SERVE
Fat 7 g; Protein 7 g; Carbohydrate 44 g; Dietary Fibre 4.5 g; Cholesterol 46 mg; 1115 kJ (265 Cal)

PLUM COBBLER

Preparation time: 20 minutes
Total cooking time: 40 minutes
Serves 4

825 g (1lb 13 oz) can pitted dark
 plums
1 tablespoon honey
2 ripe pears, peeled, cored and
 cut into eighths

Topping
250 g (1 cup) self-raising flour
1 tablespoon caster (superfine) sugar
1/4 teaspoon ground cardamom
40 g (1 1/2 oz) chopped chilled butter
60 ml (1/4 cup) low-fat milk
extra milk, for brushing
1 tablespoon caster (superfine) sugar,
 extra
1/4 teaspoon ground cardamom,
 extra

1 Preheat the oven to moderately
hot 200°C (400°F/Gas 6). Grease
an 18 cm (7 inch) round (1.5 litre or
6 cup) ovenproof dish. Drain the
plums, reserving 185 ml (3/4 cup) of
the syrup. Place the syrup, honey and
pear in a large wide saucepan and
bring to the boil. Reduce the heat and
simmer for 8 minutes, or until the
pear is tender. Add the plums.
2 To make the topping, sift the
flour, sugar, cardamom and a pinch
of salt into a large bowl. Rub in the
butter with your fingers until it
resembles fine breadcrumbs. Stir in
the milk using a flat-bladed knife,
mixing lightly to form a soft dough—
add a little more milk if necessary.
Turn onto a lightly floured surface
and form into a smooth ball. Roll out
to a 1 cm (1/2 inch) thickness and
cut into rounds with a 4 cm
(1 1/2 inch) cutter.
3 Spoon the hot fruit into the
prepared dish, then arrange the
circles of dough in an overlapping
pattern over the fruit, on the inside
edge of the dish only—leave the
fruit in the centre exposed. Brush
the dough lightly with the extra
milk. Combine the extra sugar and
cardamom and sprinkle over the

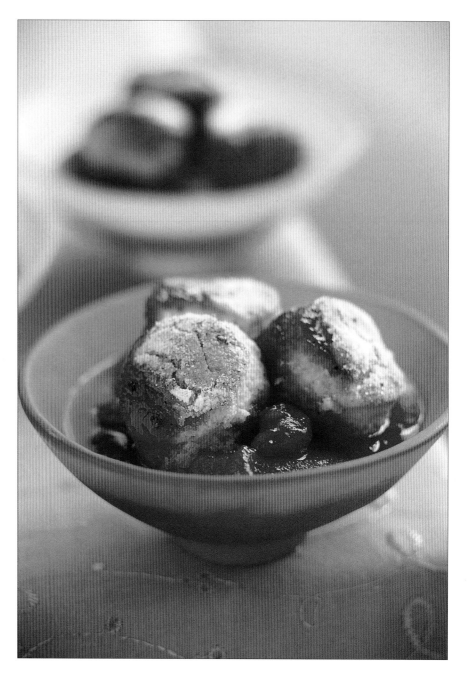

dough. Place the dish on a baking
tray and bake for 30 minutes, or until
the topping is golden and cooked.

NUTRITION PER SERVE
Fat 9 g; Protein 5 g; Carbohydrate 89 g;
Dietary Fibre 5 g; Cholesterol 26 mg;
1880 kJ (450 Cal)

*Cook the pears in the plum syrup until
tender—test with the tip of a sharp knife.*

*Overlap the circles of dough around the
inside edge of the dish.*

APRICOT BREAD AND BUTTER PUDDING

Preparation time: 10 minutes
Total cooking time: 1 hour 25 minutes
Serves 6–8

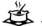 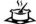

4 thick slices multigrain bread
1 tablespoon low-fat margarine
2 tablespoons apricot jam
40 g (1/4 cup) sultanas
425 g (15 oz) can apricot halves, drained
625 ml (2 1/2 cups) skim milk
1/2 vanilla bean
2 eggs
2 tablespoons caster (superfine) sugar
freshly grated nutmeg, to sprinkle

1 Preheat the oven to 160°C (315°F/Gas 2–3). Spread one side of bread with the margarine and jam, keeping the crusts intact. Sprinkle half the sultanas on the base of a 2 litre (8 cup) rectangular ceramic baking dish. Cut the slices of bread in half and arrange, jam-side up, over the sultanas. Cover with the apricot halves and the remaining sultanas.
2 Place the milk in a saucepan. Split the vanilla bean horizontally and scrape the seeds into the milk, then add the pod. Heat the milk until just below boiling point. Beat the eggs and sugar in a bowl until thick and pale. Gradually add hot milk, stirring constantly. Strain the mixture and gently pour over the bread. Sprinkle lightly with grated nutmeg. Place in a deep baking tray and pour in enough boiling water to come halfway up the sides of the dish. Bake for 1 1/4 hours, or until the custard is set.

NUTRITION PER SERVE (8)
Fat 2.5 g; Protein 6.5 g; Carbohydrate 27 g; Dietary Fibre 2 g; Cholesterol 47.5 mg; 660 kJ (155 Cal)

Sprinkle the remaining sultanas on top of the bread slices.

Strain the hot milk mixture through a fine sieve to remove the vanilla bean.

Place the dish in a baking tray and pour in boiling water to come halfway up the sides.

RED FRUIT SALAD WITH BERRIES

Preparation time: 5 minutes +
 30 minutes cooling +
 1 hour 30 minutes refrigeration
Total cooking time: 5 minutes
Serves 6

Syrup
60 g (¼ cup) caster (superfine) sugar
125 ml (½ cup) dry red wine
1 star anise
1 teaspoon finely chopped lemon zest

250 g (9 oz) strawberries, hulled and
 halved
150 g (5½ oz) blueberries
150 g (5½ oz) raspberries, mulberries
 or other red berries
250 g (9 oz) cherries
5 small red plums (about 250 g or
 9 oz), stones removed and quartered
low-fat yoghurt, to serve

1 To make the syrup, place the
sugar, wine, star anise, lemon zest
and 125 ml (½ cup) water in a small
saucepan. Bring to the boil over
medium heat, stirring to dissolve the
sugar. Boil the syrup for 3 minutes,
then set aside to cool for 30 minutes.
When cool, strain the syrup.
2 Mix the fruit together in a large
bowl and pour on the red wine syrup.
Mix well to coat the fruit in the syrup
and refrigerate for 1 hour 30 minutes.
Serve the fruit dressed with a little
syrup and the yoghurt.

NUTRITION PER SERVE
Fat 0.3 g; Protein 2 g; Carbohydrate
23.5 g; Dietary Fibre 4.5 g; Cholesterol
0 mg; 500 kJ (120 Cal)

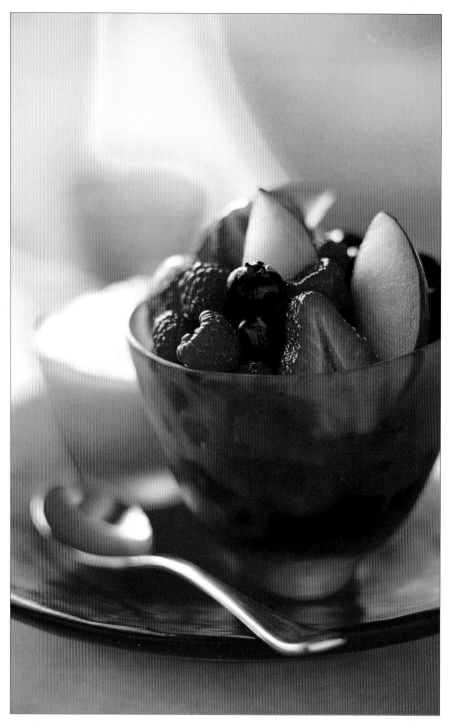

*Remove the stems, then cut the strawberries
in half.*

*Boil the sugar, wine, star anise, lemon zest
and water for 3 minutes.*

*Mix together the strawberries, blueberries,
raspberries, cherries and plums.*

INDEX

INTERNATIONAL GLOSSARY OF INGREDIENTS

capsicum	red or green pepper	tomato paste (Aus.)	tomato purée (UK)
chilli	chile, chili pepper	tomato purée (Aus.)	sieved crushed tomatoes/ passata (UK)
fresh coriander	fresh cilantro		
golden syrup	use dark corn syrup	zucchini	courgette

This edition published in 2003 by Bay Books, an imprint of Murdoch Magazines Pty Limited, GPO Box 1203, Sydney NSW 2001, Australia.

Managing Editor: Rachel Carter **Editor:** Stephanie Kistner **Creative Director:** Marylouise Brammer **Designer:** Michèle Chan **Food Director:** Jane Lawson **Food Editor:** Christine Osmond **Recipe Development:** Alison Adams, Jane Charlton, Ross Dobson, Michelle Earl, Justin Finlay, Jo Glynn, David Herbert, Valli Little, Barbara Lowery, Kate Murdoch, Kim Passenger, Fiona Skinner, Angela Tregonning **Home Economists:** Ross Dobson, David Herbert, Briget Palmer, Tim Smith **Photographers:** Andre Martin, Reg Morrison (steps) **Food Stylist:** Jane Collins **Food Preparation:** Justine Poole, Chris Sheppard, Angela Tregonning, Justin Finlay (steps), Michelle Thrift (steps) **Nutrition and additional text:** Dr Susanna Holt.
Chief Executive: Juliet Rogers. **Publisher:** Kay Scarlett.

The nutritional information provided for each recipe does not include garnishes or accompaniments, such as rice, unless they are included in specific quantities in the ingredients. The values are approximations and can be affected by biological and seasonal variations in food, the unknown composition of some manufactured foods and uncertainty in the dietary database. Nutrient data given are derived primarily from the NUTTAB95 database produced by the Australian New Zealand Food Authority.

ISBN 1 74045 061 2.
Reprinted 2004. Printed by Sing Cheong Printing Co. Ltd. PRINTED IN CHINA.